YOU CAN DRAW
ANYTHING!

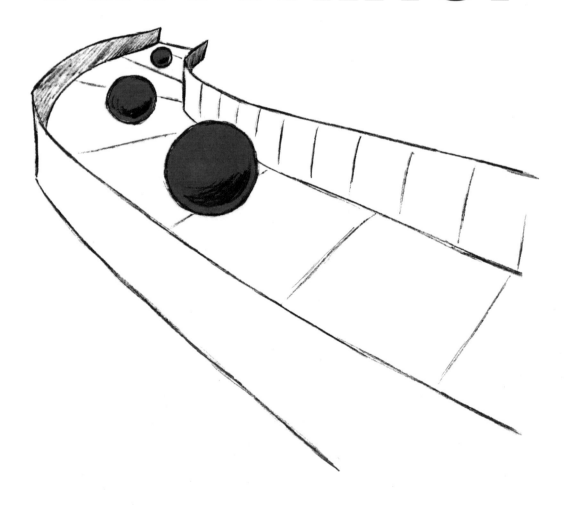

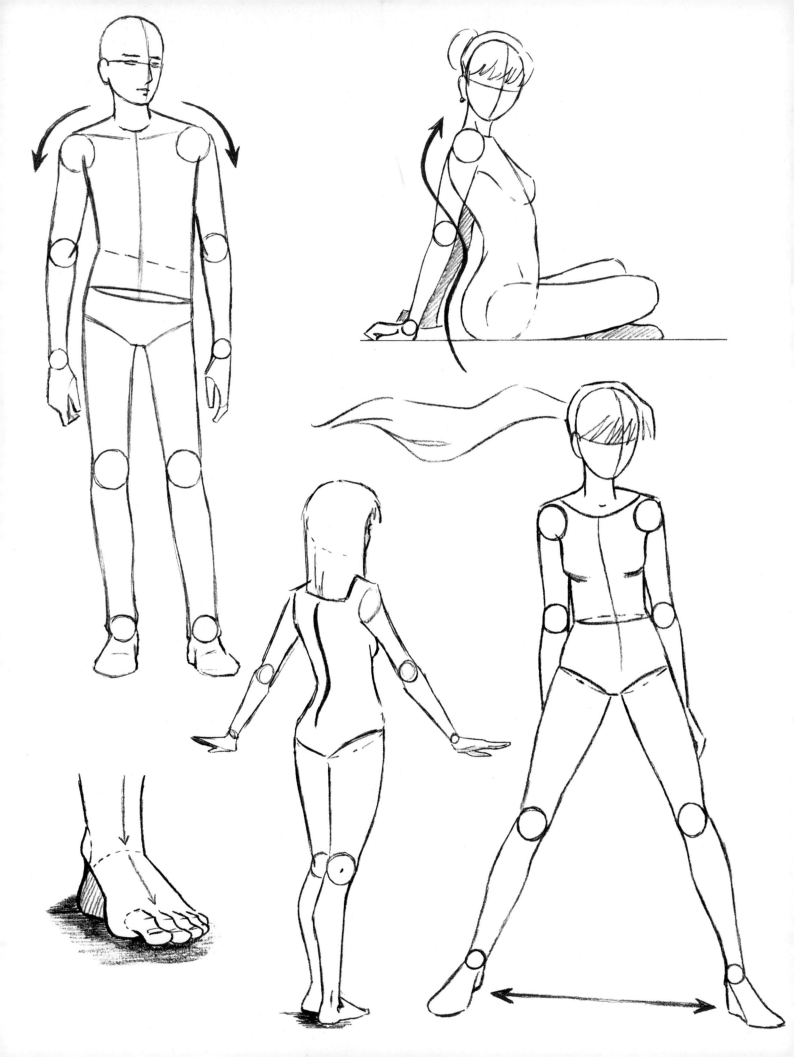

YOU CAN DRAW ANYTHING!

50+ Essential Art Techniques for the Aspiring Artist

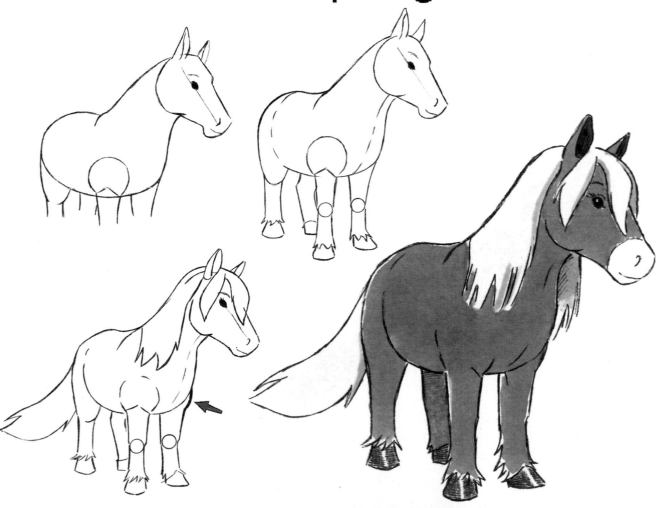

 Get Creative 6

DRAWING WITH Christopher Hart

An imprint of **Get Creative 6**
19 West 21st Street, Suite 601, New York, NY 10010
sixthandspringbooks.com

Senior Editor
MICHELLE BREDESON

Art Director
IRENE LEDWITH

Anime Color
ANZU

Chief Executive Officer
CAROLINE KILMER

President
ART JOINNIDES

Chairman
JAY STEIN

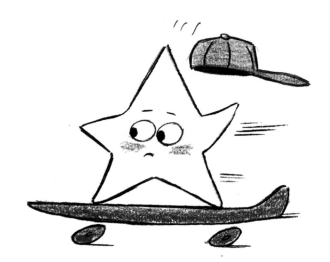

Caution: Children should use only child-safe art supplies.

Library of Congress Cataloging-in-Publication Data
Names: Hart, Christopher, 1957- author.
Title: You can draw anything! : 50+ essential art techniques for the
 aspiring artist / by Christopher Hart.
Description: First edition. | New York, New York : Drawing with
 Christopher Hart, [2021] | Includes index.
Identifiers: LCCN 2020047718 | ISBN 9781684620074 (paperback)
Subjects: LCSH: Drawing--Technique.
Classification: LCC NC730 .H3375 2021 | DDC 741.2--dc23
LC record available at https://lccn.loc.gov/2020047718

Manufactured in China

3 5 7 9 10 8 6 4

christopherhartbooks.com
facebook.com/CARTOONS.MANGA
youtube.com/user/chrishartbooks

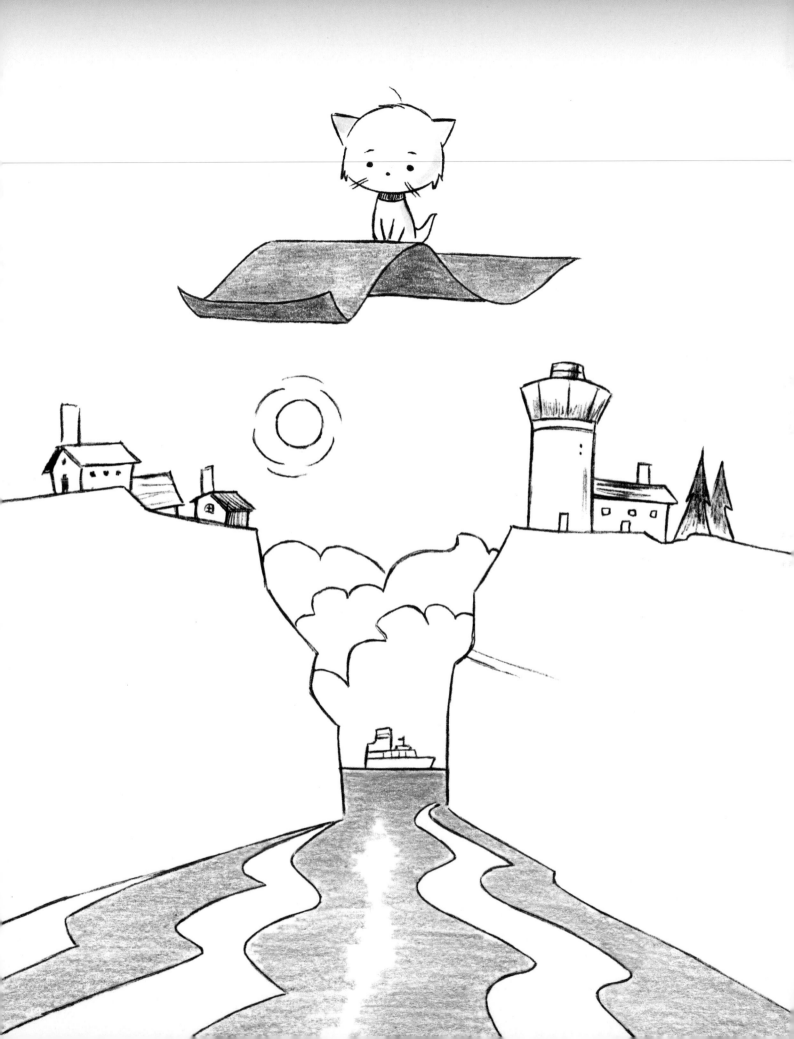

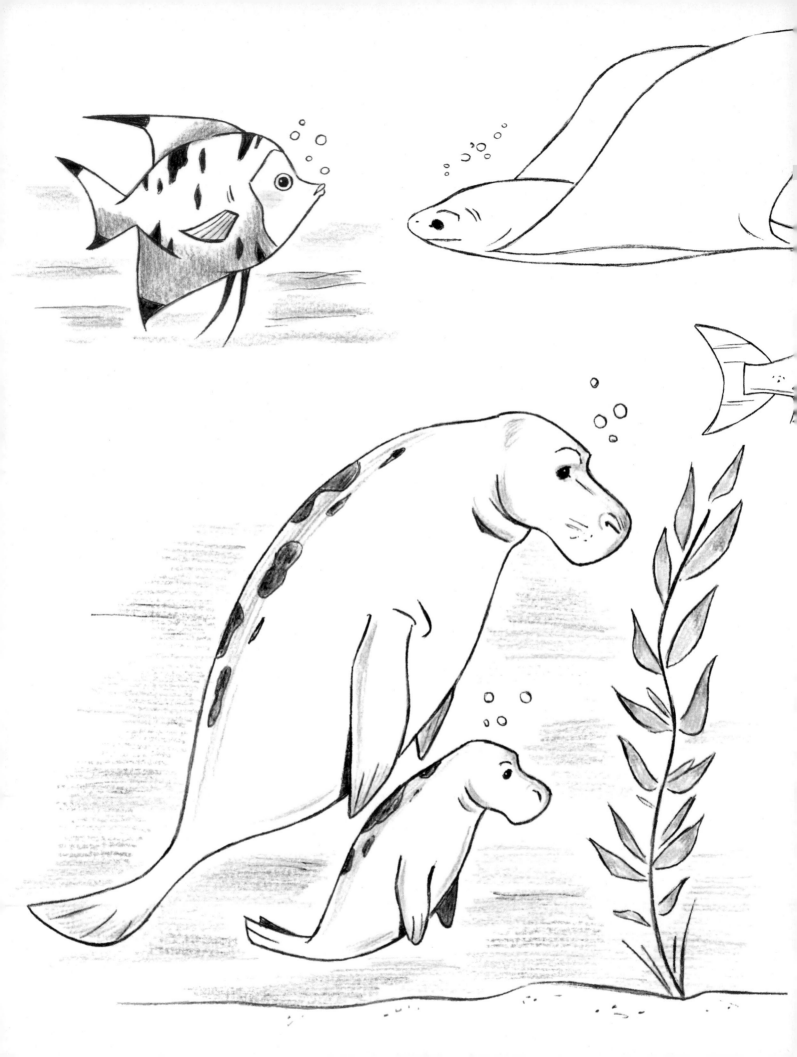

Contents

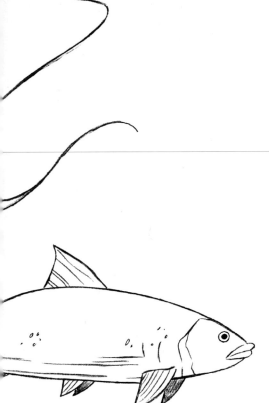

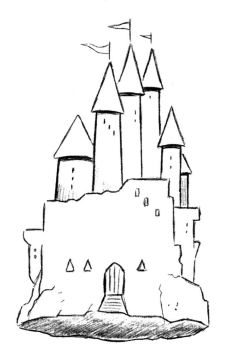

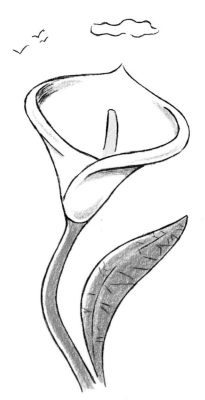

Introduction

If you love to draw, but would like to draw better, then this book is for you. With simple, step-by-step instructions as your guide, you'll learn how to draw many popular subjects, including trees and flowers, animals, people, simple scenes—even anime characters.

I've made things easy by organizing this book into more than 50 manageable drawing projects. By spending a short amount of time each day or each week drawing one of the projects, you will steadily improve. You don't have to complete the projects in order. Feel free to skip around from chapter to chapter. I've also included suggestions for continuing to practice if you're looking for more of a challenge.

You'll learn how to use important principles such as flowing lines, overlapping, and shading. The exercises will introduce you to exciting and practical concepts such as creating a variety of designs from a single starting point. I'll also demonstrate how to design a picture so it makes an impact. Think of this book as a course in art school, but without the bad cafeteria food or arguments over parking spots. This book is designed to raise your level as an artist. Let's start your journey right now!

Easy Techniques for Getting Started

In this chapter, I'll present a wide variety everyday objects like ice-cream cones, boots, and curtains, which are surprisingly interesting to draw. And since these objects are familiar, I think you'll grasp the forms easily. Next, we'll tackle more dramatic projects, such as water and fire, which are fairly simple to draw—with the right techniques. I'll make sure you learn those, too! Get ready to get creative.

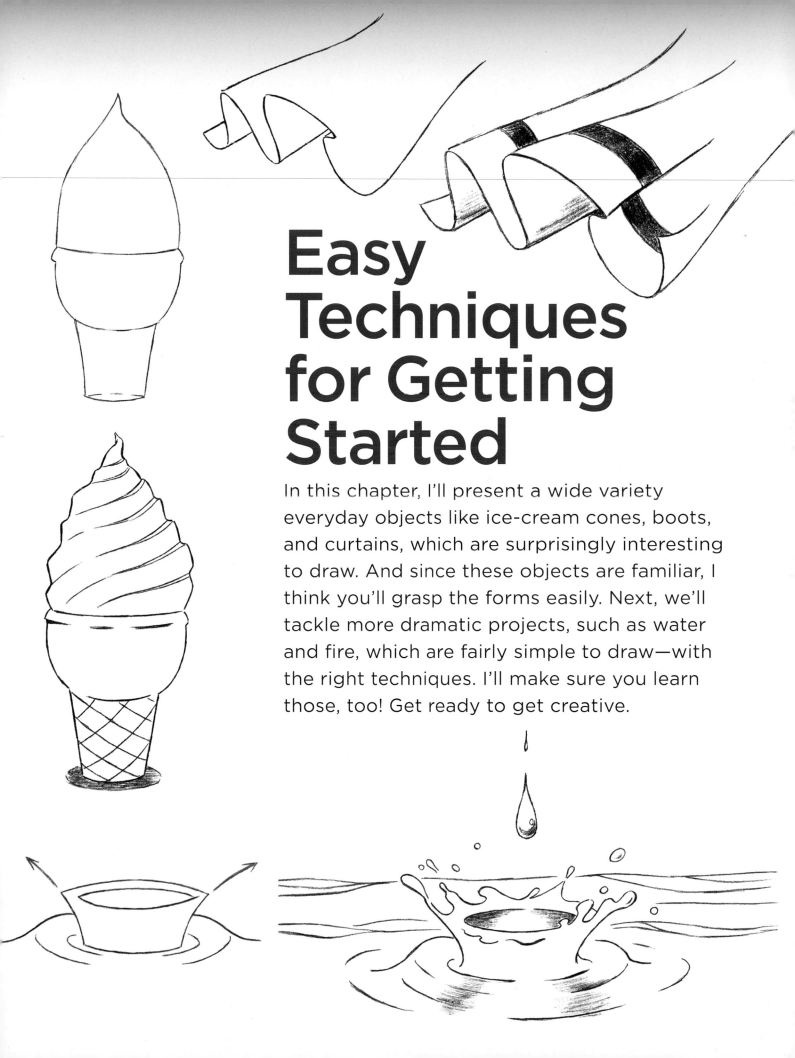

Soft-Serve Swirls

This ice-cream cone is an example of using flowing lines to create a pleasing look. One flowing line is a nice touch. A bunch of flowing lines is a pattern. Make sure that each swirling line follows the path of every other line and maintain an equal distance between them.

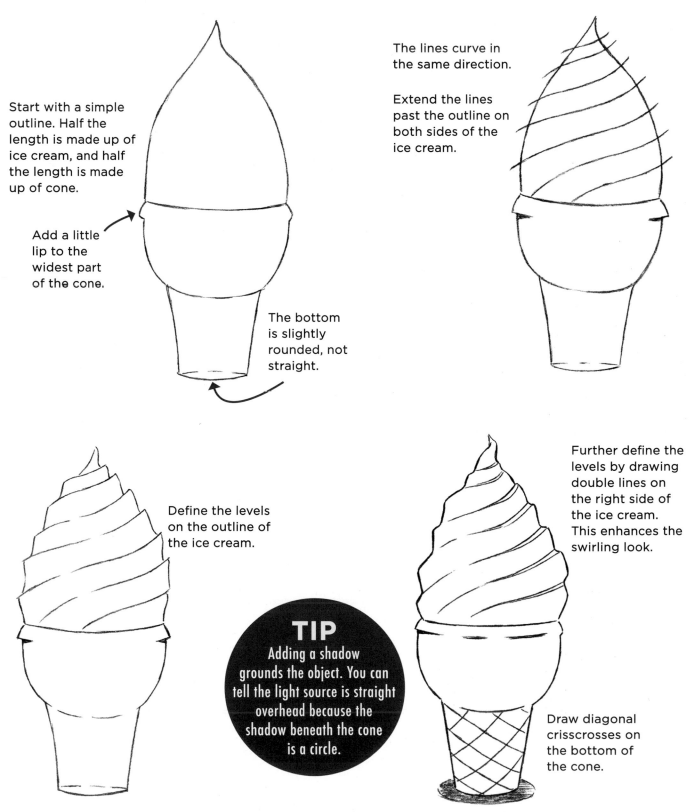

Start with a simple outline. Half the length is made up of ice cream, and half the length is made up of cone.

Add a little lip to the widest part of the cone.

The bottom is slightly rounded, not straight.

The lines curve in the same direction.

Extend the lines past the outline on both sides of the ice cream.

Define the levels on the outline of the ice cream.

TIP
Adding a shadow grounds the object. You can tell the light source is straight overhead because the shadow beneath the cone is a circle.

Further define the levels by drawing double lines on the right side of the ice cream. This enhances the swirling look.

Draw diagonal crisscrosses on the bottom of the cone.

Repeated Shapes

It's important to be consistent when drawing an object with repeated shapes. For example, the two drumheads are the same shape. And the wooden frame of each drum is curved the same way. Even if the viewer doesn't consciously notice your technique, they'll feel that it's constructed logically.

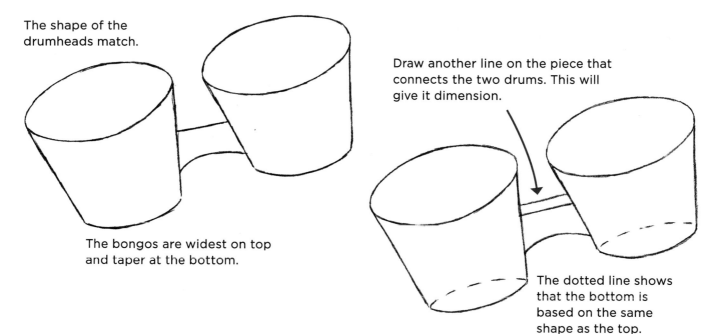

The shape of the drumheads match.

The bongos are widest on top and taper at the bottom.

Draw another line on the piece that connects the two drums. This will give it dimension.

The dotted line shows that the bottom is based on the same shape as the top.

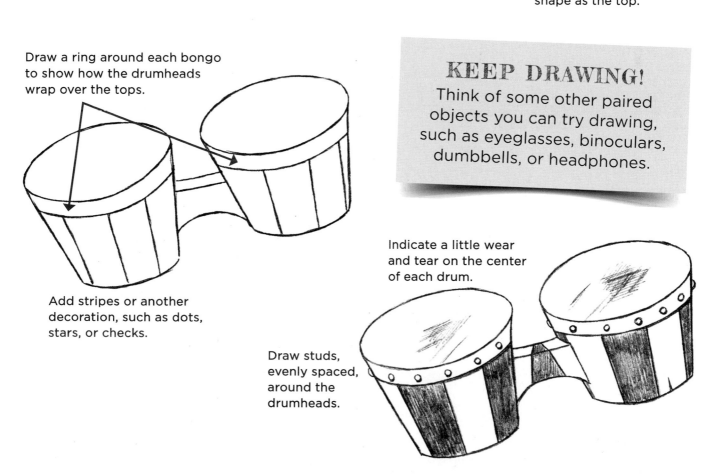

Draw a ring around each bongo to show how the drumheads wrap over the tops.

Add stripes or another decoration, such as dots, stars, or checks.

KEEP DRAWING!
Think of some other paired objects you can try drawing, such as eyeglasses, binoculars, dumbbells, or headphones.

Indicate a little wear and tear on the center of each drum.

Draw studs, evenly spaced, around the drumheads.

Design Details

Without design, the world would be a far less interesting place. Once you have the shape of an object down, you can have fun adding stylish details.

COWBOY BOOT

A cowboy boot has a distinctive shape that offers more than pure practicality. The slopes of the lines, including the arch, come together to give it style. Fortunately for us, a boot is not only appealing to look at, it's also simple to draw.

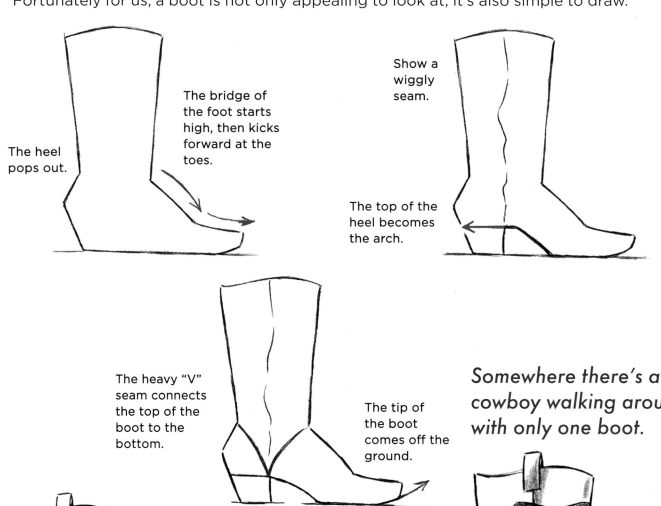

The heel pops out.

The bridge of the foot starts high, then kicks forward at the toes.

Show a wiggly seam.

The top of the heel becomes the arch.

The heavy "V" seam connects the top of the boot to the bottom.

The tip of the boot comes off the ground.

Somewhere there's a cowboy walking around with only one boot.

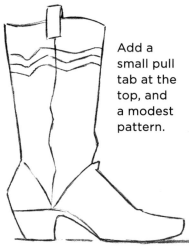

Add a small pull tab at the top, and a modest pattern.

KEEP DRAWING!
Now's your chance to design your own custom cowboy boots. Add more stripes, flowers, snakeskin. If you really want to be authentic, add some spurs.

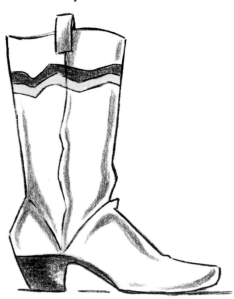

STEAMER TRUNK

Steamer trunks, which were once cheap, are now worth a fortune. I'm hoping the same thing happens to the coffee mug I use every morning. Anyway, the steamer trunk is balanced so that the design on the left side matches the design on the right side. Its visual appeal is therefore based on symmetry, balanced proportions, and the use of diagonal lines.

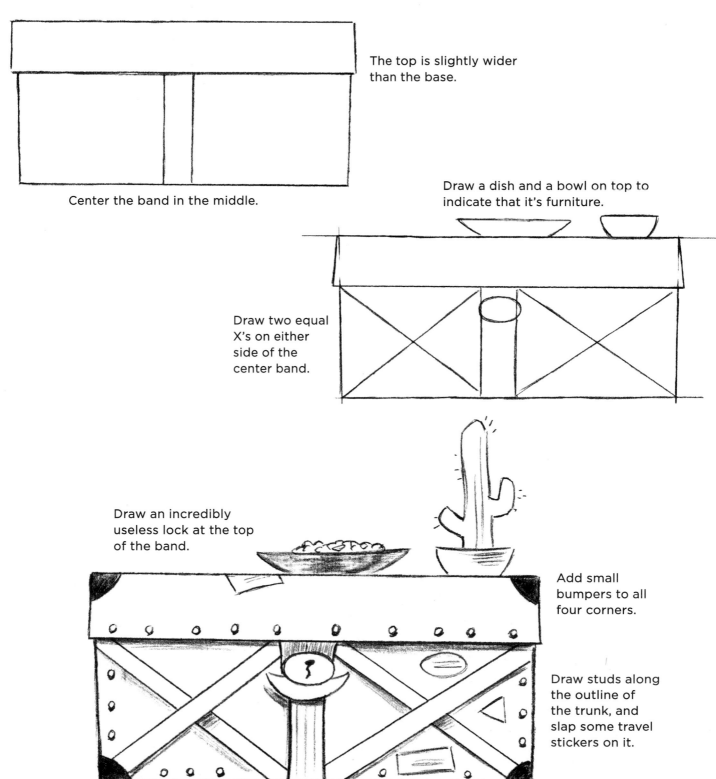

The top is slightly wider than the base.

Center the band in the middle.

Draw a dish and a bowl on top to indicate that it's furniture.

Draw two equal X's on either side of the center band.

Draw an incredibly useless lock at the top of the band.

Add small bumpers to all four corners.

Draw studs along the outline of the trunk, and slap some travel stickers on it.

17

Having Fun with Ordinary Objects

Drawing is about arranging different elements so they work as a whole. As you draw, keep the final image in mind. If you get stuck, take a step back and consider the big picture. The mailbox is a good project. We're so familiar with it we can almost picture it in our minds—and so we let that mental image guide us.

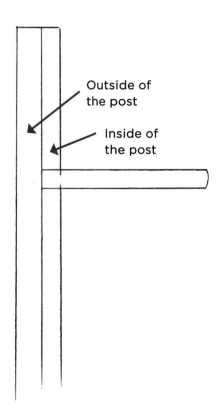

Outside of the post

Inside of the post

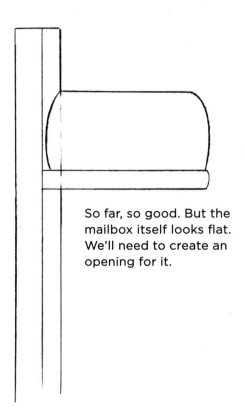

So far, so good. But the mailbox itself looks flat. We'll need to create an opening for it.

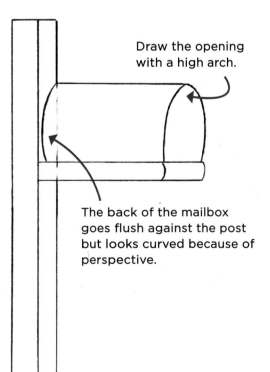

Draw the opening with a high arch.

The back of the mailbox goes flush against the post but looks curved because of perspective.

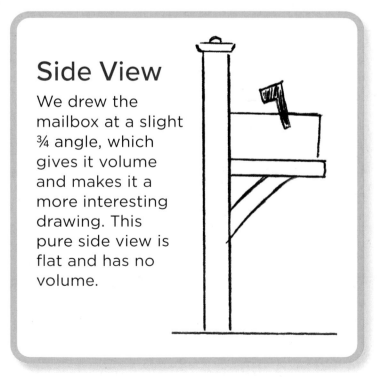

Side View

We drew the mailbox at a slight ¾ angle, which gives it volume and makes it a more interesting drawing. This pure side view is flat and has no volume.

Add a decorative cap on top of the post.

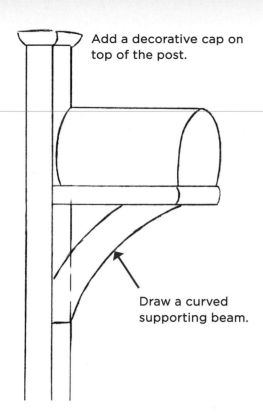

Draw a curved supporting beam.

Yay! More useless coupons!

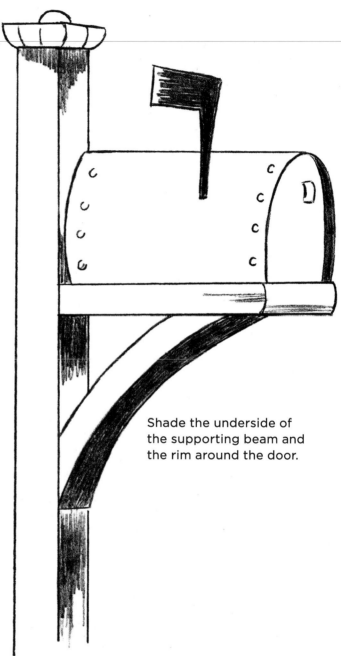

Shade the underside of the supporting beam and the rim around the door.

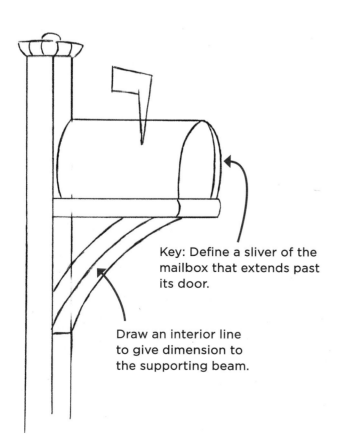

Key: Define a sliver of the mailbox that extends past its door.

Draw an interior line to give dimension to the supporting beam.

KEEP DRAWING!
Test your understanding of this ¾ view by flopping it and drawing it facing the other way. Or even head-on.

Flowing Curtains

The eye likes to follow a flowing line. And any technique that serves to hold the viewer's attention is worth considering. Here's something that really moves: curtains reacting to a breeze. Line flow makes the curtains appear to be billowing. Your curtains can look different from mine. It's the general principle we're after.

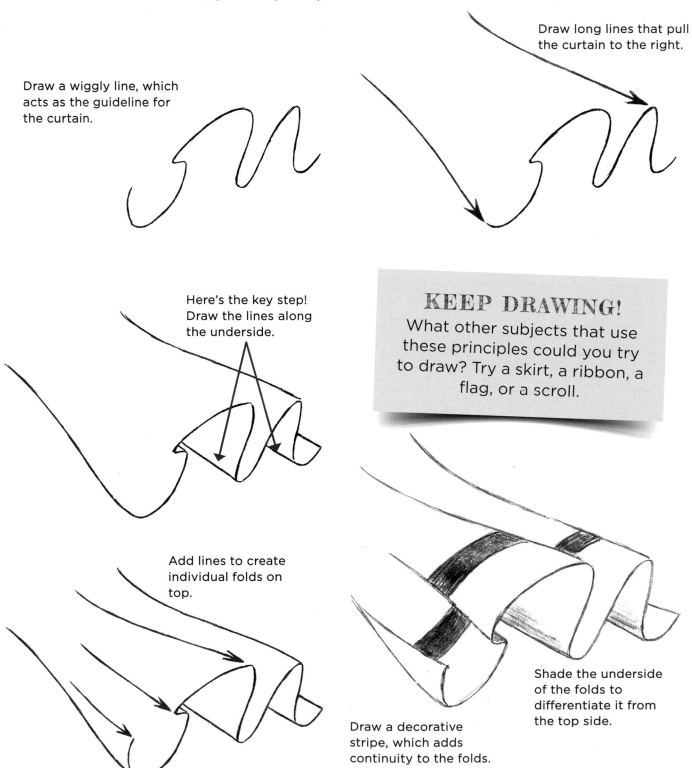

Draw long lines that pull the curtain to the right.

Draw a wiggly line, which acts as the guideline for the curtain.

Here's the key step! Draw the lines along the underside.

KEEP DRAWING!
What other subjects that use these principles could you try to draw? Try a skirt, a ribbon, a flag, or a scroll.

Add lines to create individual folds on top.

Draw a decorative stripe, which adds continuity to the folds.

Shade the underside of the folds to differentiate it from the top side.

Zigzag Strip

Here's a similar idea to the curtains but with straight lines and sharp angles. This simple strip will show you some solid techniques you can use often in your drawings.

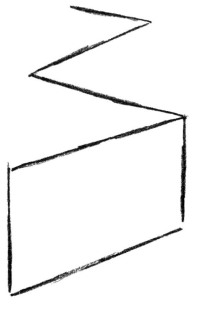

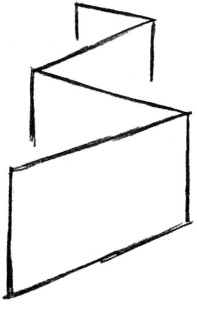

Begin with a zigzag line. It doesn't have to be perfect.

Draw two vertical lines to begin the strip.

Draw a few more vertical lines where the strip goes in different directions.

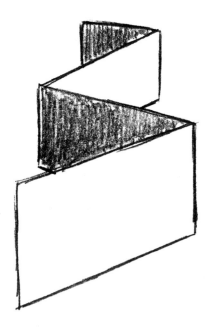

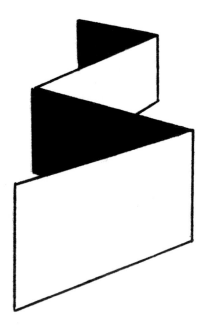

Add some shading to differentiate one side from the other.

If you want, you can draw the strip with a ruler to make it sharper and more precise.

It's Element-ary

According to Aristotle, the four basic elements are earth, air, water, and fire. (His son, Larry Aristotle, added the fifth, plastic, which is widely used for containers.) Here we'll take a look at two of the most fun elements to draw.

HOW TO DRAW WATER

Water is curious in that if doesn't look like much until it moves. But once it does, just a drop of it can produce a dynamic splash. By utilizing a few, simple techniques, we can make the water appear to be fluid, explosive, and rippling.

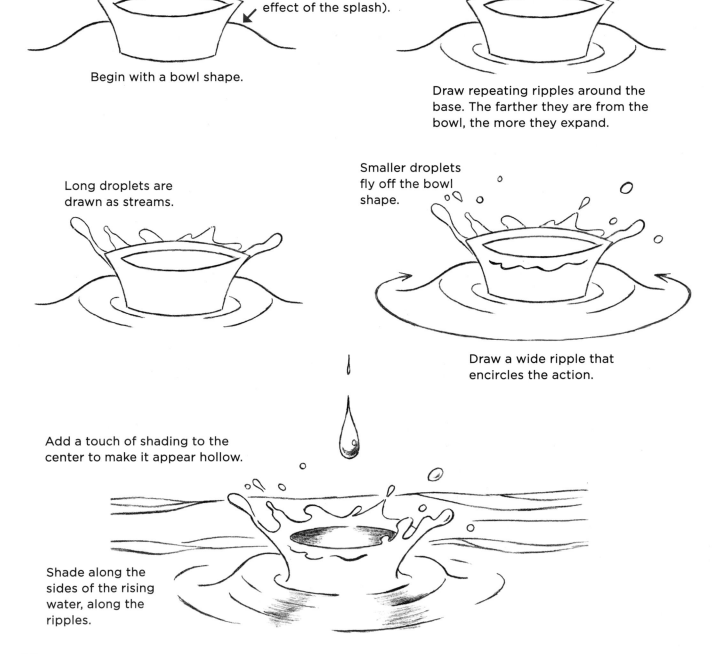

The water swells up at the base of the bowl. (It's a rebound effect of the splash).

Begin with a bowl shape.

Droplets will fly away from the bowl.

Draw repeating ripples around the base. The farther they are from the bowl, the more they expand.

Long droplets are drawn as streams.

Smaller droplets fly off the bowl shape.

Draw a wide ripple that encircles the action.

Add a touch of shading to the center to make it appear hollow.

Shade along the sides of the rising water, along the ripples.

HOW TO DRAW FIRE

Constantly moving and flickering, fire is restless and hypnotic. Each fire is shaped differently. Let's try this tall and slinky flame.

Start with a long squiggly line.

Wrap a second line around the first to create a braided look.

Fill out the stream of fire by adding some flickers inside, and outside, the stream of flames.

Adjust the braids so that they're widest at the bottom.

KEEP DRAWING!
Try drawing other types of flames—a candle, a campfire, a fireplace—or a different bowl or dish for your flames.

Draw a flat bowl at the base.

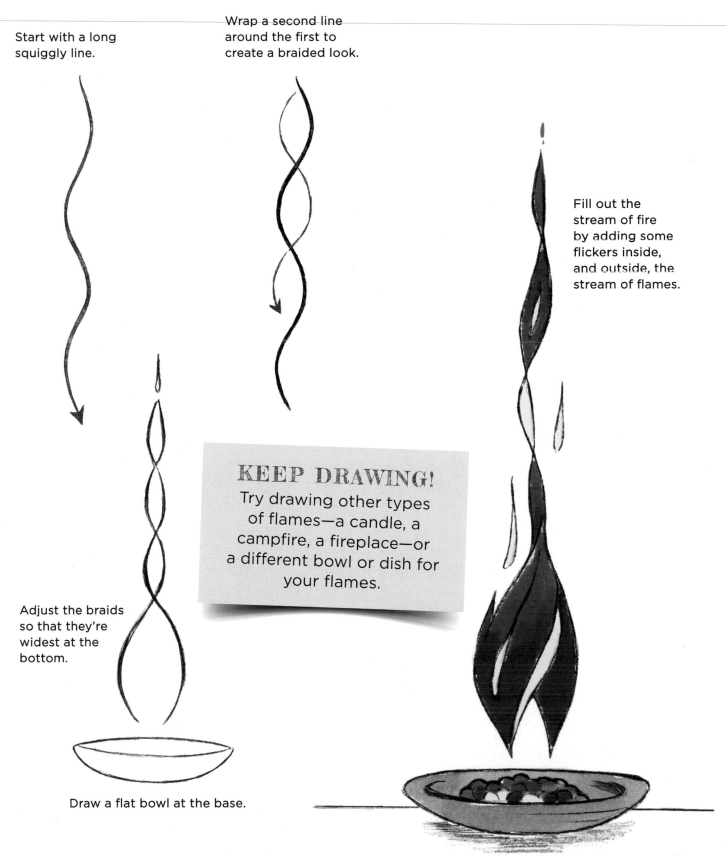

Ballet Slippers

When there's more than one object in a picture, it helps to pause a moment and consider the composition. What are your choices? How could you best arrange the elements? A simple layout is often the strongest one. Let's see how weighing our options results in a better picture.

Weigh the Options!

There are at least three simple ways to configure the shoes. Maybe you could think of a few more.

The slippers are turned away from each other. Looks like they had an argument.

The slippers turn toward each other—but it's not a comfortable fit.

The slippers are a match. This is the one we'll go with!

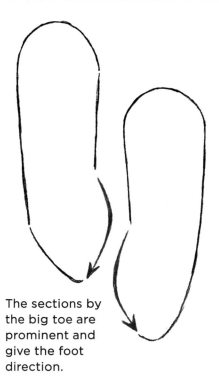

The sections by the big toe are prominent and give the foot direction.

Draw openings that are long, not round.

The top of the slipper curves down, as shown by the dotted lines.

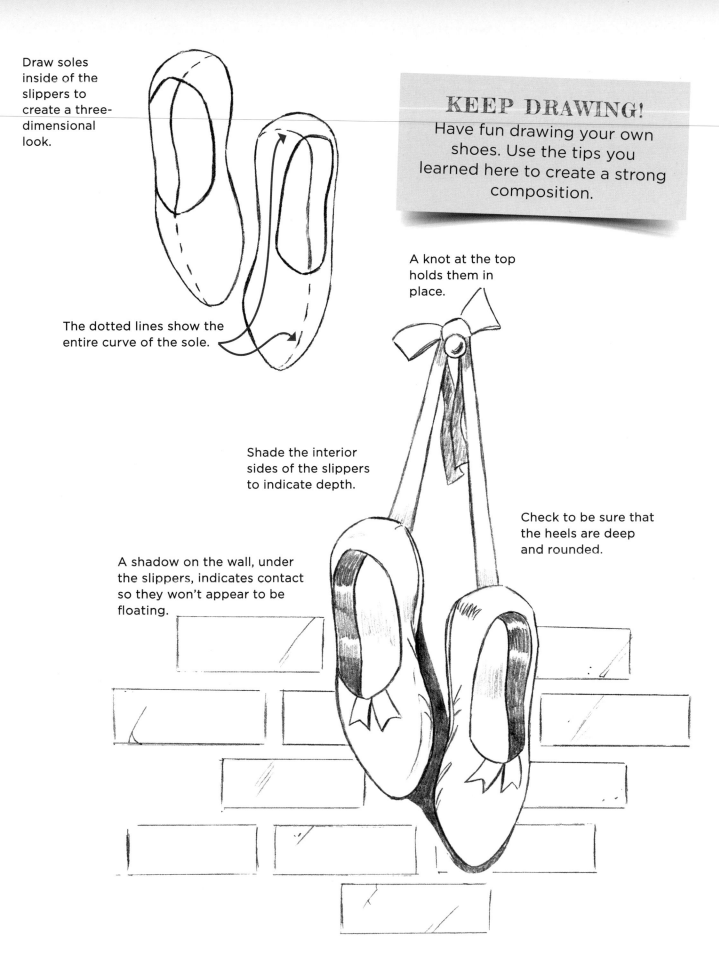

Draw soles inside of the slippers to create a three-dimensional look.

The dotted lines show the entire curve of the sole.

KEEP DRAWING!
Have fun drawing your own shoes. Use the tips you learned here to create a strong composition.

A knot at the top holds them in place.

Shade the interior sides of the slippers to indicate depth.

Check to be sure that the heels are deep and rounded.

A shadow on the wall, under the slippers, indicates contact so they won't appear to be floating.

The Chute: Guiding the Viewer's Eye

An important aspect of drawing is figuring out how to get the viewer to look where you want. A chute accomplishes this on several levels. Like a road, a chute suggests a direction and diminishes into the distance. But unlike a road, a chute has bumpers, which contain the viewer's attention. To see how a chute works, let's give it a try.

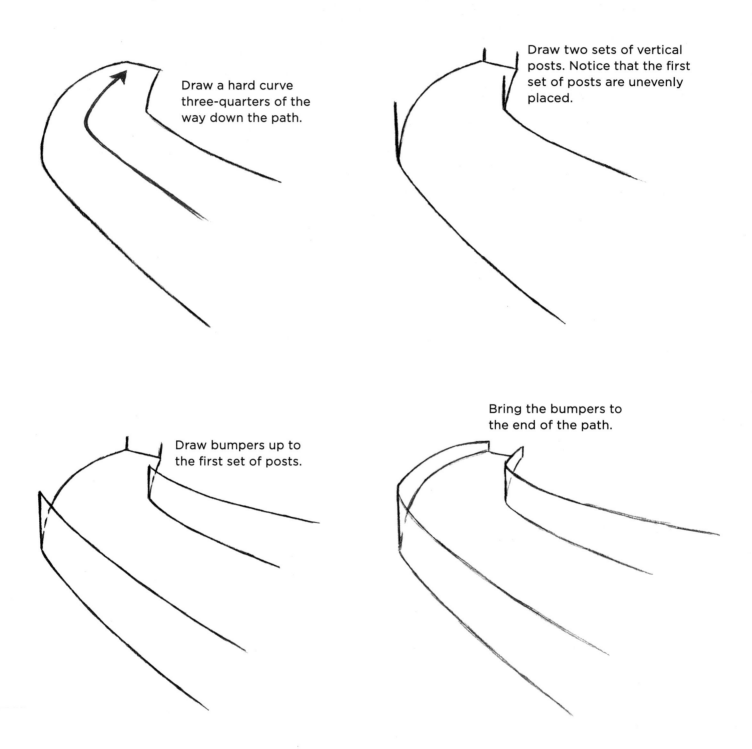

Draw a hard curve three-quarters of the way down the path.

Draw two sets of vertical posts. Notice that the first set of posts are unevenly placed.

Draw bumpers up to the first set of posts.

Bring the bumpers to the end of the path.

Shade the inside of the left bumper and the outside of the right bumper. This creates the idea that the chute is solid.

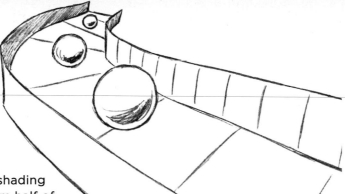

Add a little shading to the bottom half of the spheres.

KEEP DRAWING!
There are lots of objects and scenes you could draw to practice the chute. How about a playground slide, a waterslide, or guardrails bracketing a highway?

TIP
Color, especially a bold color, is another element that can be used to pull the eye in a specific direction. The viewer will focus on the subject.

Is it cheating for me to use bumpers when I bowl? Or to give myself a few extra points each frame?

Shaded Objects

Shading is an important tool. When you shade with a purpose, the drawing ends up with more impact. Here's the key: All you have to do is shade one plane of an object, but not the others. Sound easy? It is.

PYRAMID

No shading, no impact. Try again!

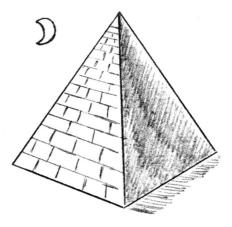

Better, right? We've shaded the right side (a plane). This brings the lighter side into relief, making it look sharper by comparison.

TIP
Shading only one side of an abject and allowing the rest to be hit by light makes it more dynamic.

BRACELET

No one likes to receive an invisible bracelet, which is what this looks like. Let's give it another try.

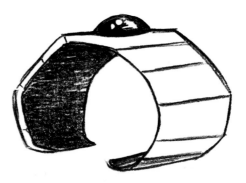

Shading helps the eye understand form. By shading the underside, you help to accentuate the top.

WHEEL

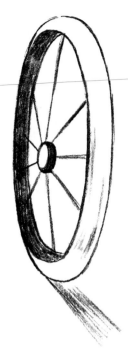

This one is okay, but you can still improve it by using shading.

Shading helps the viewer's eye understand which area is the interior and which is the exterior.

KEEP DRAWING!
Try reversing the placement of the shadow so it appears on the other side. For example, put the shadow on the nearside of the wheel and leave the interior of the rim light.

TWISTING STRIP

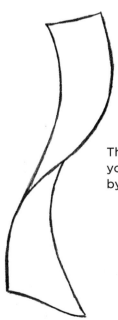

This one is okay, but you can still improve it by using shading.

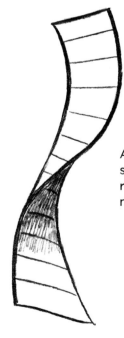

Adding shading to one side and parallel lines reinforces the twisting motion.

Tornado

Here's a fun project to challenge yourself. It incorporates a lot of simple objects, as well as a large, swirling tornado, which is similar to the ice-cream cone we drew earlier. But the tornado also divides the left and right sides of the layout, creating a strong symmetry. We'll look at some of these types of items, such as animals, flowers, and water, later in this book.

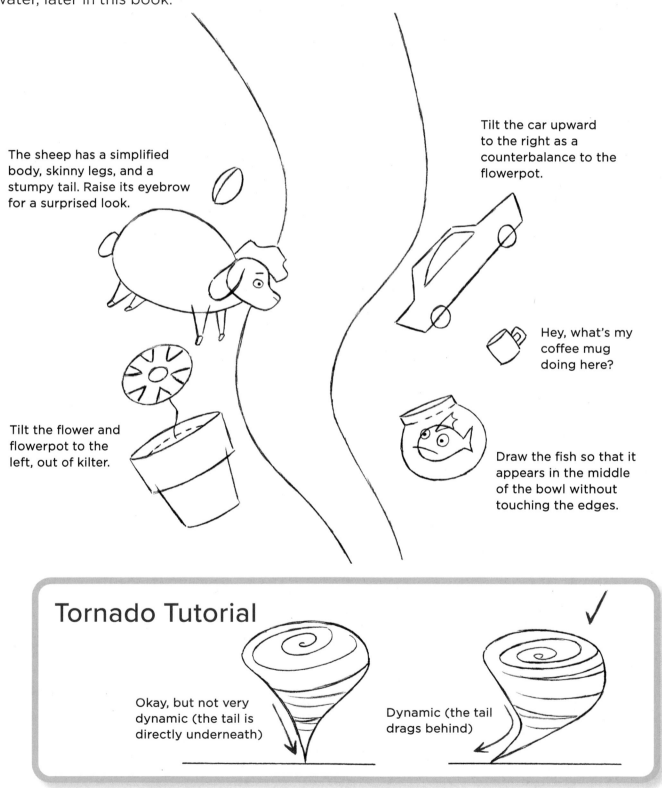

The sheep has a simplified body, skinny legs, and a stumpy tail. Raise its eyebrow for a surprised look.

Tilt the flower and flowerpot to the left, out of kilter.

Tilt the car upward to the right as a counterbalance to the flowerpot.

Hey, what's my coffee mug doing here?

Draw the fish so that it appears in the middle of the bowl without touching the edges.

Tornado Tutorial

Okay, but not very dynamic (the tail is directly underneath)

Dynamic (the tail drags behind)

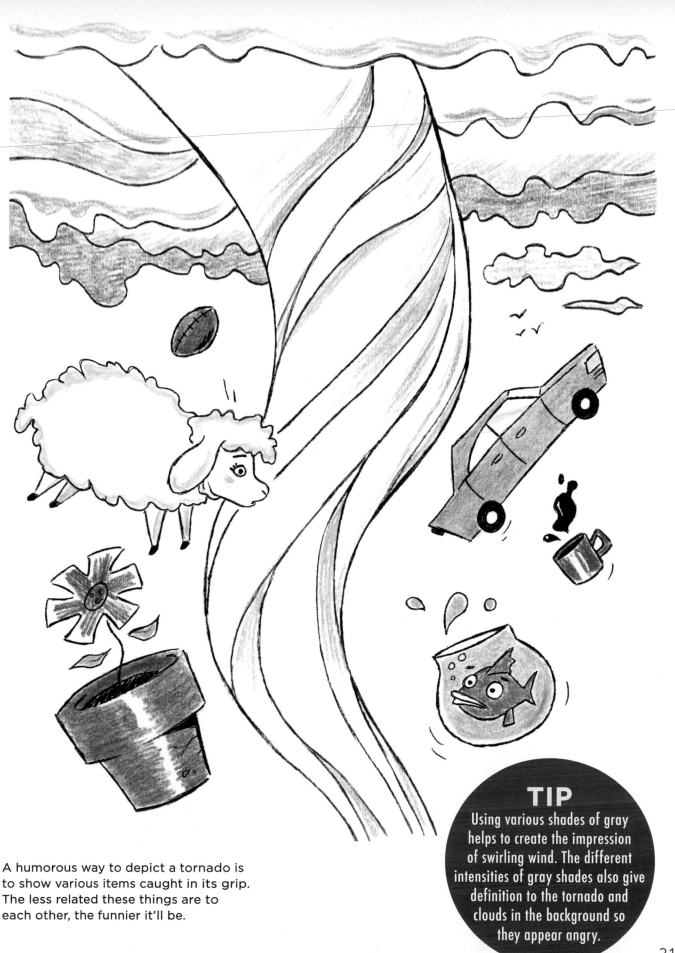

A humorous way to depict a tornado is to show various items caught in its grip. The less related these things are to each other, the funnier it'll be.

TIP

Using various shades of gray helps to create the impression of swirling wind. The different intensities of gray shades also give definition to the tornado and clouds in the background so they appear angry.

Creating Variations

Before we move on to the next chapter, I want to leave you with a fun exercise, which will give you a bunch of creative variations to work on based on a simple design: a star. Stars are good subjects for variations. They have points that can be made to mimic limbs. They also have very little detail, which makes them ready for the addition of decorations, patterns, and props. Draw the examples I present, then borrow some of the elements to create your own versions.

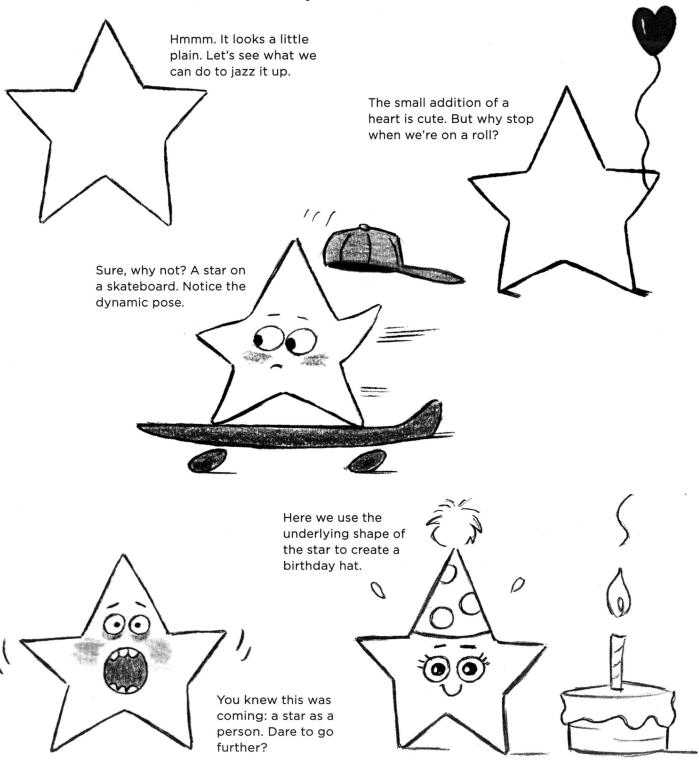

Hmmm. It looks a little plain. Let's see what we can do to jazz it up.

The small addition of a heart is cute. But why stop when we're on a roll?

Sure, why not? A star on a skateboard. Notice the dynamic pose.

Here we use the underlying shape of the star to create a birthday hat.

You knew this was coming: a star as a person. Dare to go further?

We can also surround the star with a blast of energy. This will wake up the viewer!

Who doesn't like a petulant star?

Drawing a frame device around the star turns it into an effective emblem.

Here's a star drawn in three dimensions, in a front view...

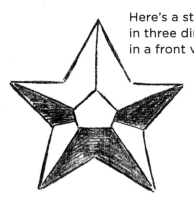

...and another in three dimensions in ¾ view.

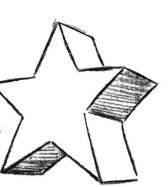

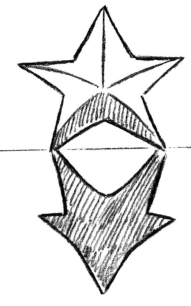

By casting a shadow, you add a sense of presence to the pointy little guy.

How about a star with all the bells and whistles?

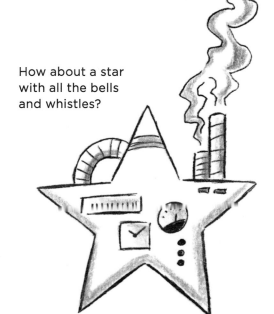

A star, completely off-key. Why can't they learn to sing?

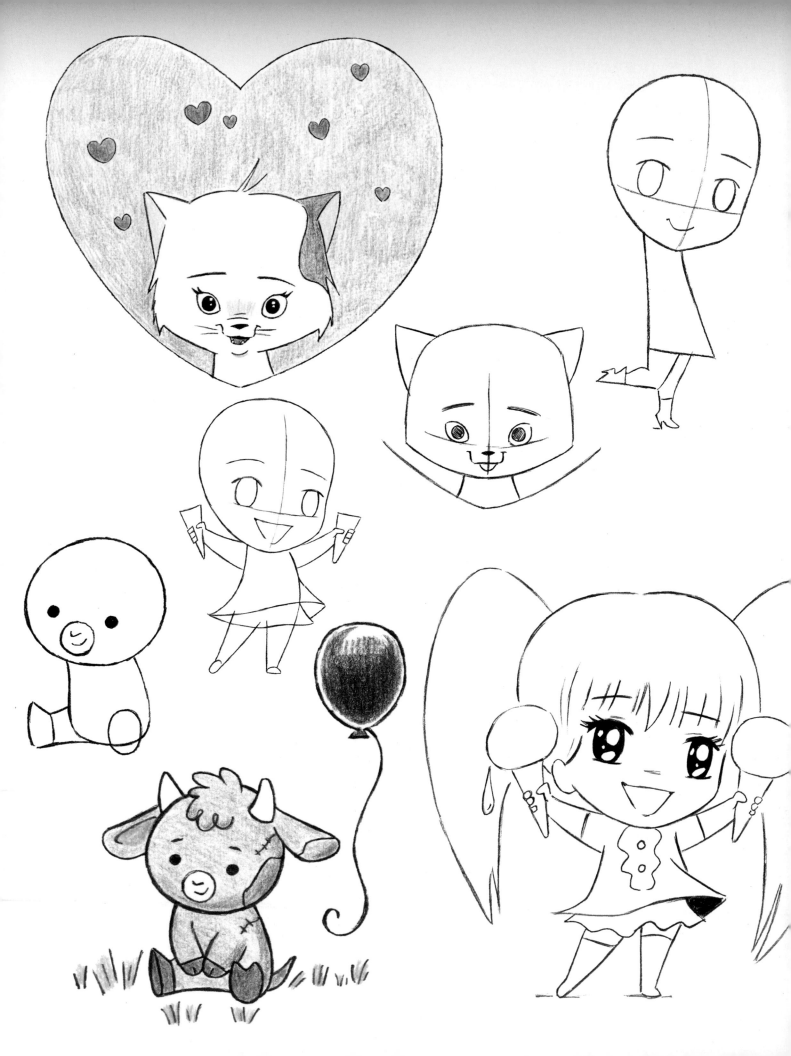

Cute Stuff

In this chapter, I'll introduce you to some adorable cartoon characters in a variety of styles. One of the most popular styles in this section is anime, which is originally from Japan. The drawing techniques you've been learning can easily be applied to it. This will help you to broaden your character-design abilities and to create some original characters of your own.

Magic Carpet Ride

If there's anything cuter than a kitten on a flying carpet, I don't think I could handle it. In this image, the flowing lines are used to show both the top and bottom surfaces of the carpet simultaneously. This makes the carpet look as though it's moving through the air.

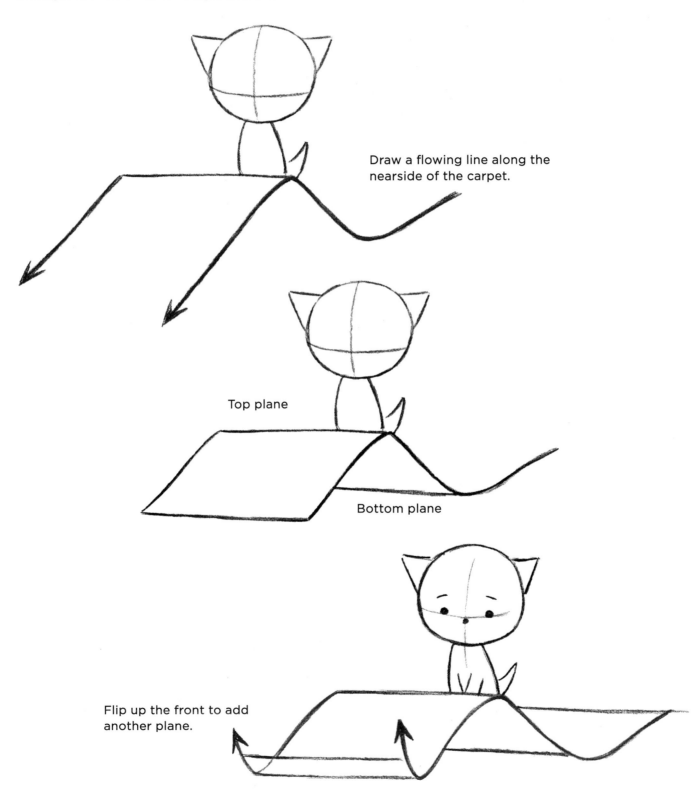

Draw a flowing line along the nearside of the carpet.

Top plane

Bottom plane

Flip up the front to add another plane.

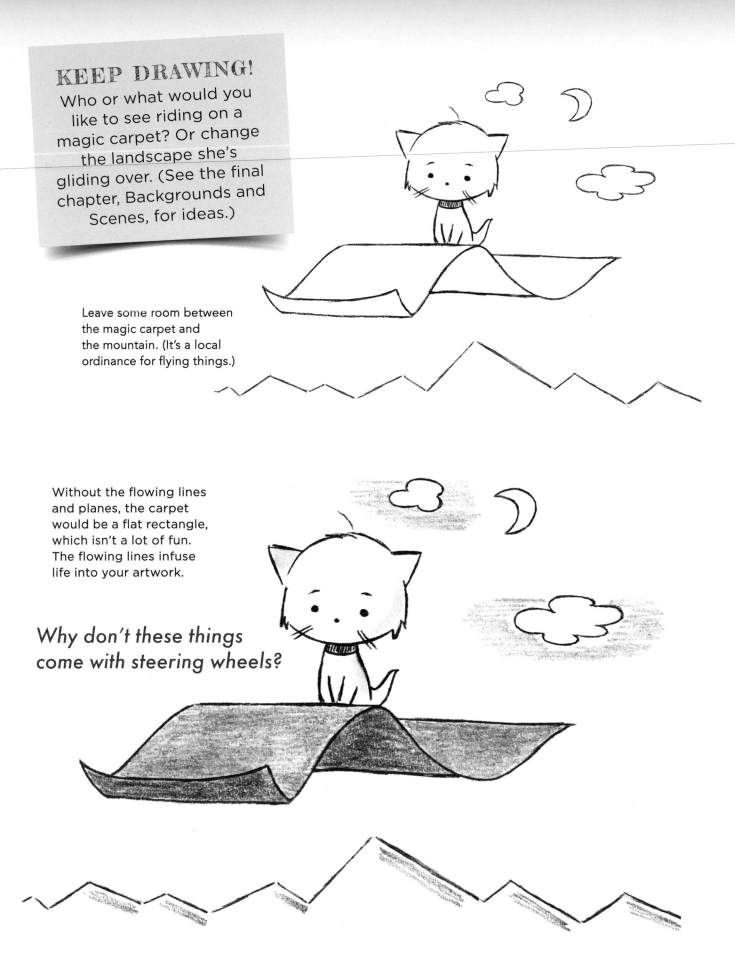

Leave some room between the magic carpet and the mountain. (It's a local ordinance for flying things.)

Without the flowing lines and planes, the carpet would be a flat rectangle, which isn't a lot of fun. The flowing lines infuse life into your artwork.

Why don't these things come with steering wheels?

Simplifying Things

Can you simplify a cartoon too much? Not really. As long as it has personality, a cartoon can use very little detail and still be appealing.

BABY COW

This cow's head is a circle, the body is a pillow-shape, and the eyes are dots. You can't get simpler—or cuter—than that!

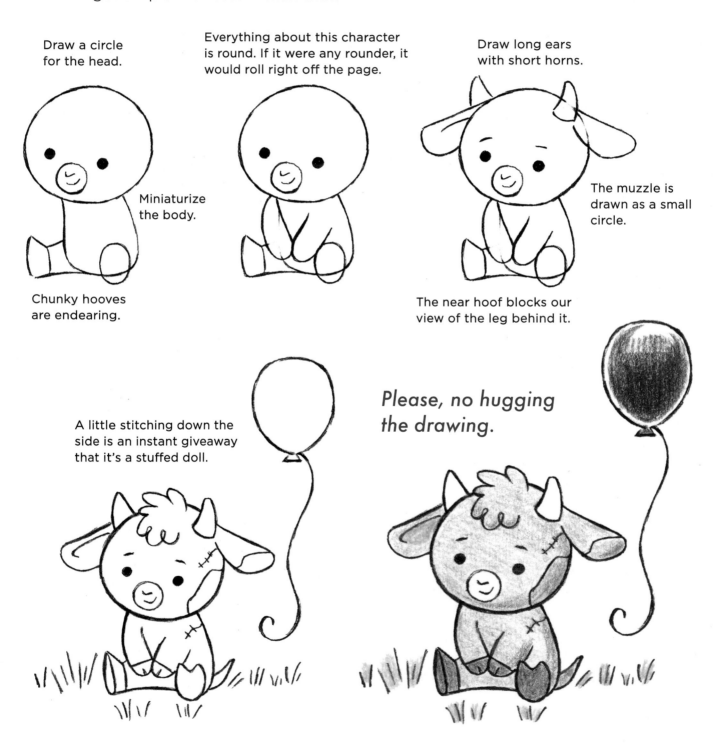

Draw a circle for the head.

Everything about this character is round. If it were any rounder, it would roll right off the page.

Draw long ears with short horns.

Miniaturize the body.

Chunky hooves are endearing.

The muzzle is drawn as a small circle.

The near hoof blocks our view of the leg behind it.

A little stitching down the side is an instant giveaway that it's a stuffed doll.

Please, no hugging the drawing.

PUPPY

When drawing simplified cartoon characters, it's often better to exaggerate the proportions than to draw them correctly.

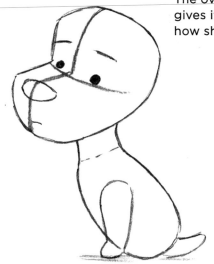

The oversized head on this pup gives it a cartoon quality. Note how short the legs are.

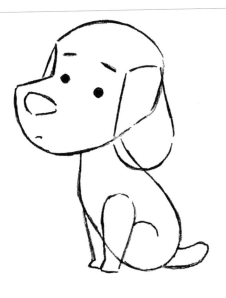

Like the cow, the puppy is made up almost entirely of round lines.

KEEP DRAWING!
To draw a simple and adorable variation, draw his paw on his face, as if he was worried.

Why do people try to hold out against the power of puppy eyes? Just admit defeat, toss him another treat, and get on with your business!

Using Templates

A template is a popular device artists use to guide the viewer's eye to the center of interest. It's usually a simple shape or a graphic icon, such as a circle or heart. It acts like a frame for the character or object you draw inside of it. Let's see how it works.

PORTAL TO ADVENTURE

In this scene, the circle appears to be part of a wacky sci-fi scene, which is a popular genre called steam punk. But it's actually a template, which frames the boy. We can add doodads to the template to further suggest the sci-fi look.

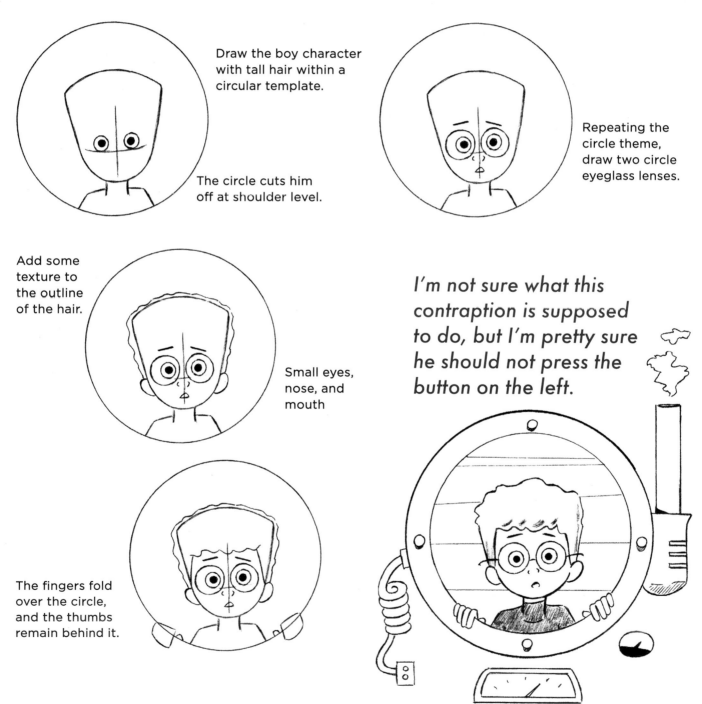

Draw the boy character with tall hair within a circular template.

The circle cuts him off at shoulder level.

Repeating the circle theme, draw two circle eyeglass lenses.

Add some texture to the outline of the hair.

Small eyes, nose, and mouth

I'm not sure what this contraption is supposed to do, but I'm pretty sure he should not press the button on the left.

The fingers fold over the circle, and the thumbs remain behind it.

MORE KITTENS!

A simple heart template is great way to showcase this already adorable kitten.

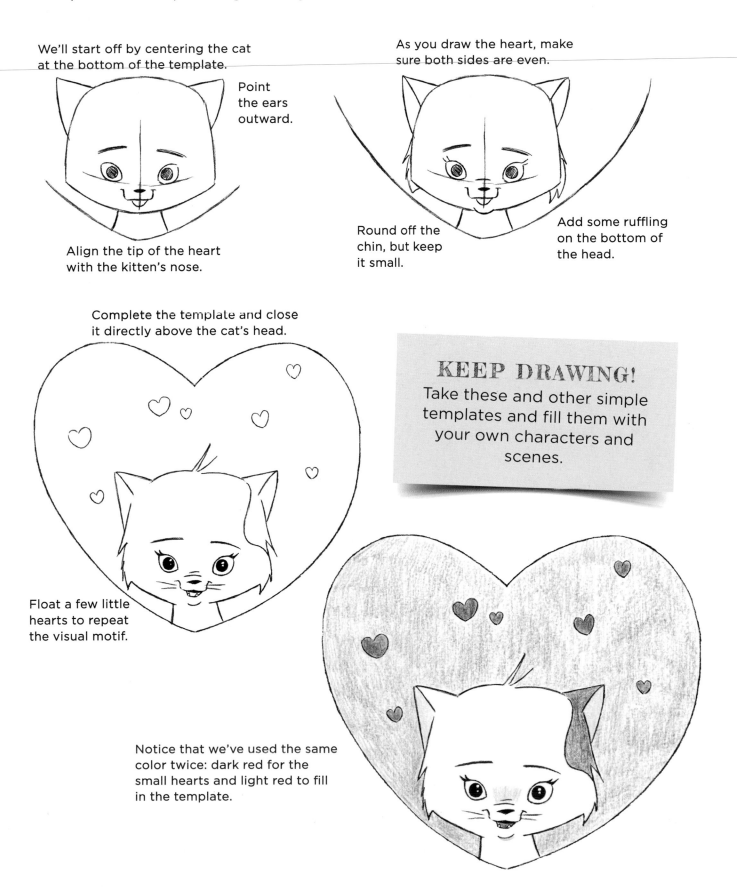

We'll start off by centering the cat at the bottom of the template.

Point the ears outward.

Align the tip of the heart with the kitten's nose.

As you draw the heart, make sure both sides are even.

Round off the chin, but keep it small.

Add some ruffling on the bottom of the head.

Complete the template and close it directly above the cat's head.

Float a few little hearts to repeat the visual motif.

KEEP DRAWING!
Take these and other simple templates and fill them with your own characters and scenes.

Notice that we've used the same color twice: dark red for the small hearts and light red to fill in the template.

Anime Style: Cute Kids

We can simplify anime characters by drawing big saucers for eyes, slight bodies, and tiny legs. The less detail you use, the more charming they'll be.

CUTE WALK

The kick of the foot gives this walking pose extra style. Little touches like this make a drawing stand out.

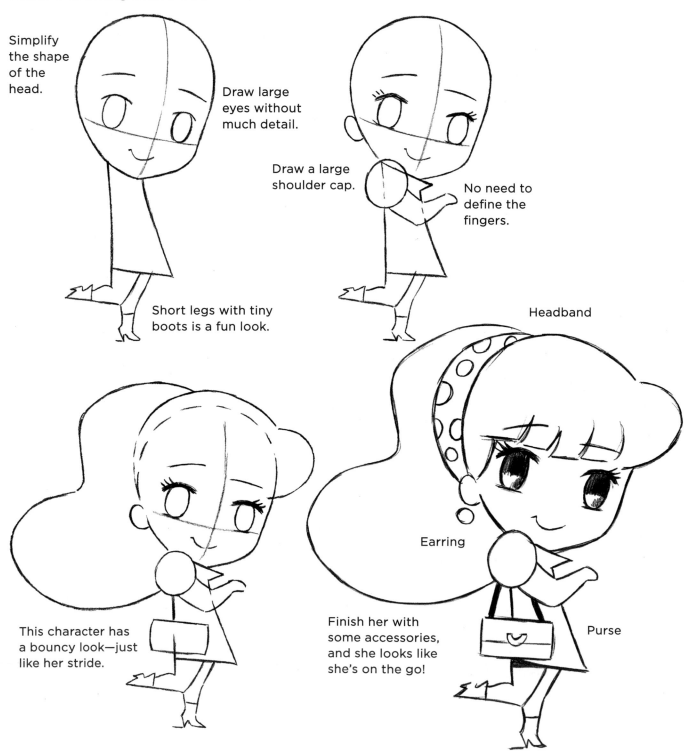

Simplify the shape of the head.

Draw large eyes without much detail.

Draw a large shoulder cap.

No need to define the fingers.

Short legs with tiny boots is a fun look.

Headband

This character has a bouncy look—just like her stride.

Earring

Finish her with some accessories, and she looks like she's on the go!

Purse

HOT SHOT

This character is a popular type in school stories. Self-esteem is usually a good thing, but he has too much of it! The backward tilt of the torso gives this walk attitude. Again, it's those small adjustments that bring out a character's personality.

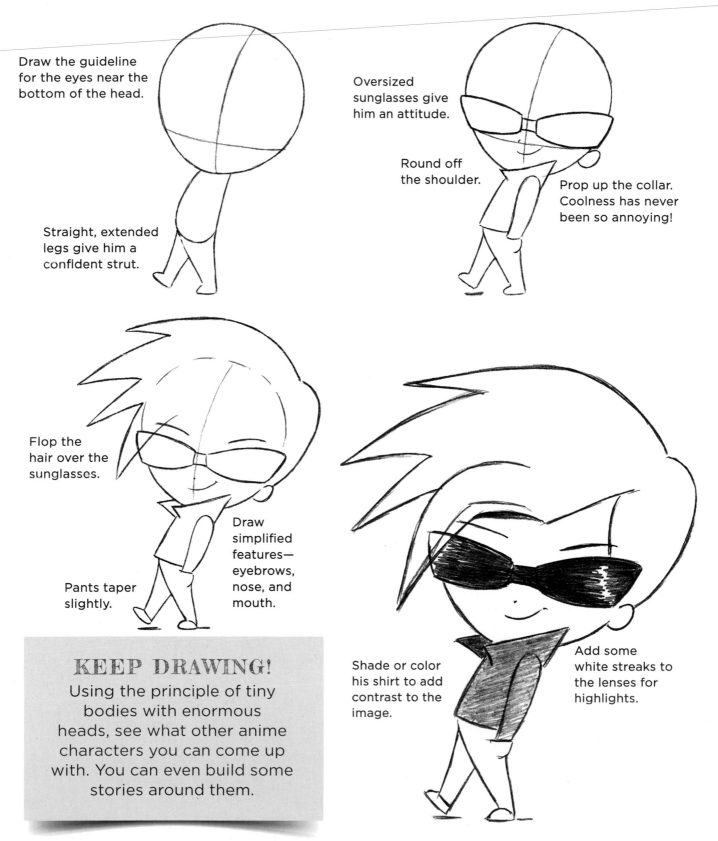

Draw the guideline for the eyes near the bottom of the head.

Straight, extended legs give him a confident strut.

Oversized sunglasses give him an attitude.

Round off the shoulder.

Prop up the collar. Coolness has never been so annoying!

Flop the hair over the sunglasses.

Pants taper slightly.

Draw simplified features—eyebrows, nose, and mouth.

Shade or color his shirt to add contrast to the image.

Add some white streaks to the lenses for highlights.

KEEP DRAWING!

Using the principle of tiny bodies with enormous heads, see what other anime characters you can come up with. You can even build some stories around them.

Little Friends

Simplified characters are often drawn with exaggerated heads but slim or small bodies. This gives them a quirky look that is prominent in animated films. It's fun to invent a pair of friends who both have this look.

KITTY AND ME

What's the emblem on the cat's forehead? Who knows? Sometimes you just have to add a cool detail.

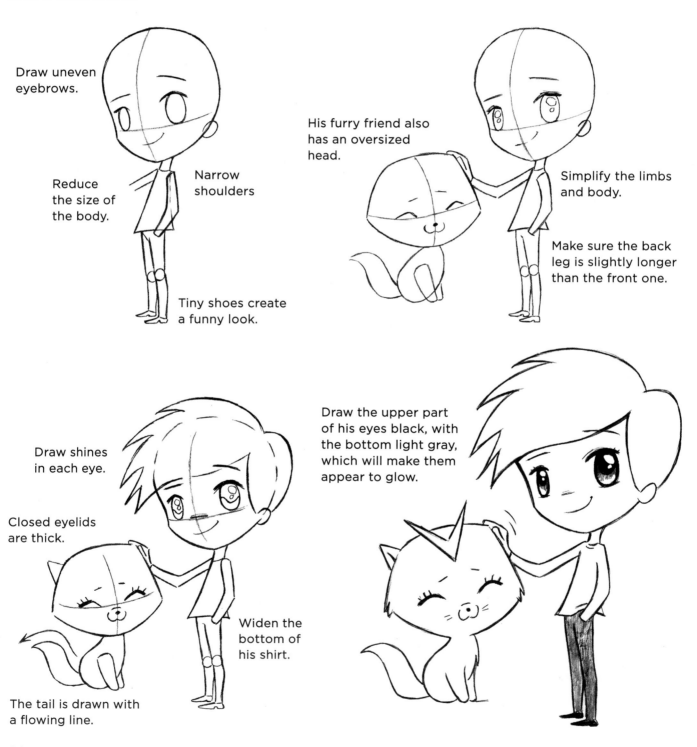

Draw uneven eyebrows.

Reduce the size of the body.

Narrow shoulders

Tiny shoes create a funny look.

His furry friend also has an oversized head.

Simplify the limbs and body.

Make sure the back leg is slightly longer than the front one.

Draw shines in each eye.

Closed eyelids are thick.

The tail is drawn with a flowing line.

Widen the bottom of his shirt.

Draw the upper part of his eyes black, with the bottom light gray, which will make them appear to glow.

LOOK WHAT I FOUND!

When your character lifts something, pushes something, or pulls something, her posture compensates. If the body didn't compensate, the object would appear to be weightless.

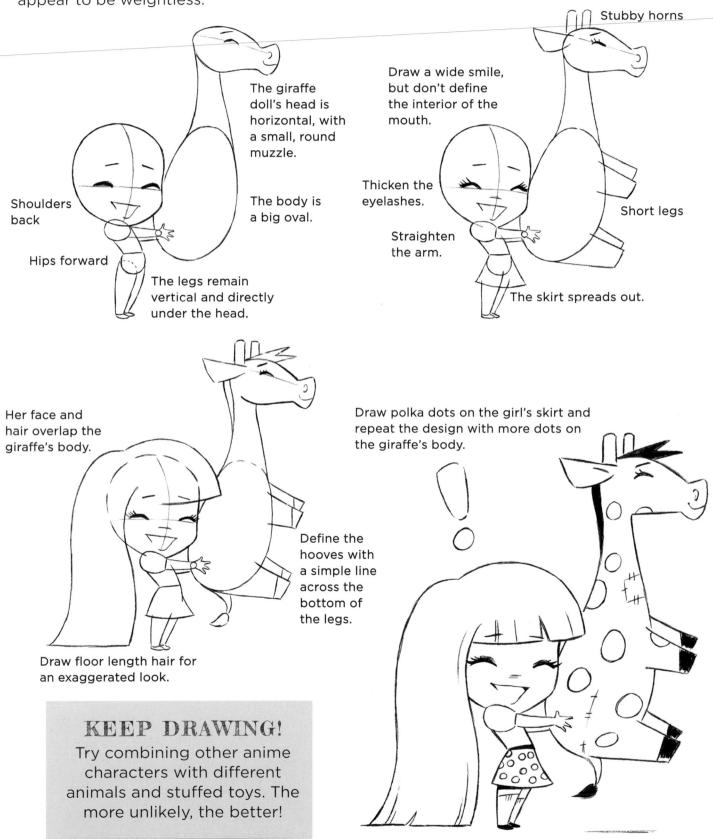

The giraffe doll's head is horizontal, with a small, round muzzle.

Shoulders back

The body is a big oval.

Hips forward

The legs remain vertical and directly under the head.

Stubby horns

Draw a wide smile, but don't define the interior of the mouth.

Thicken the eyelashes.

Straighten the arm.

Short legs

The skirt spreads out.

Her face and hair overlap the giraffe's body.

Define the hooves with a simple line across the bottom of the legs.

Draw floor length hair for an exaggerated look.

Draw polka dots on the girl's skirt and repeat the design with more dots on the giraffe's body.

KEEP DRAWING!
Try combining other anime characters with different animals and stuffed toys. The more unlikely, the better!

Extra Cuteness!

Here are two more anime characters for you to try. Because you can never draw too many anime characters!

NOT SHARING!

For some reason, ice cream makes kids insanely happy. Popcorn, too. The next tier down is luncheon meat. No one ever jumped for joy over sliced ham. But then, no one ever got a brain freeze over it either.

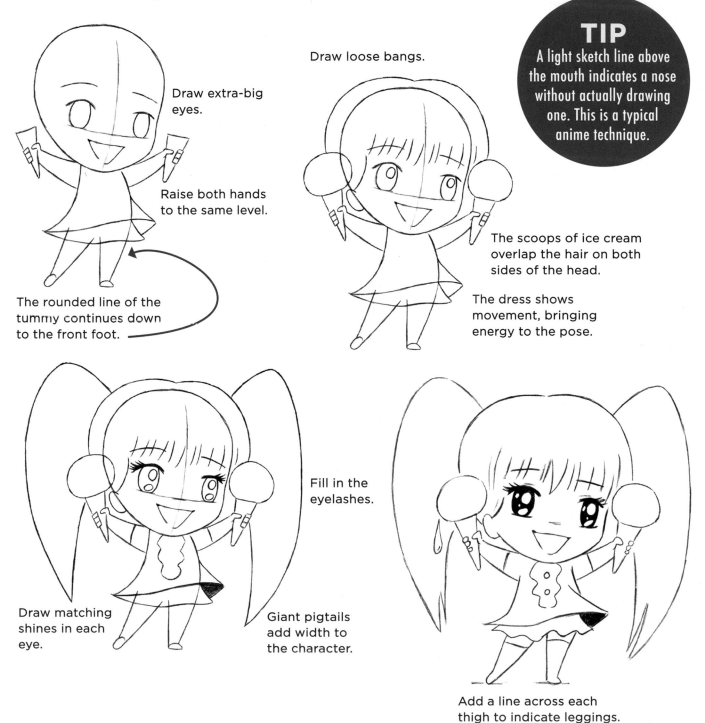

Draw extra-big eyes.

Raise both hands to the same level.

The rounded line of the tummy continues down to the front foot.

Draw loose bangs.

TIP
A light sketch line above the mouth indicates a nose without actually drawing one. This is a typical anime technique.

The scoops of ice cream overlap the hair on both sides of the head.

The dress shows movement, bringing energy to the pose.

Draw matching shines in each eye.

Fill in the eyelashes.

Giant pigtails add width to the character.

Add a line across each thigh to indicate leggings.

MY BUDDY AND ME

The girl is the larger of the two, so she can take bigger strides. The pup, being little and ever-so-eager, has to scurry on all fours to keep up with her. But he doesn't mind—they're pals!

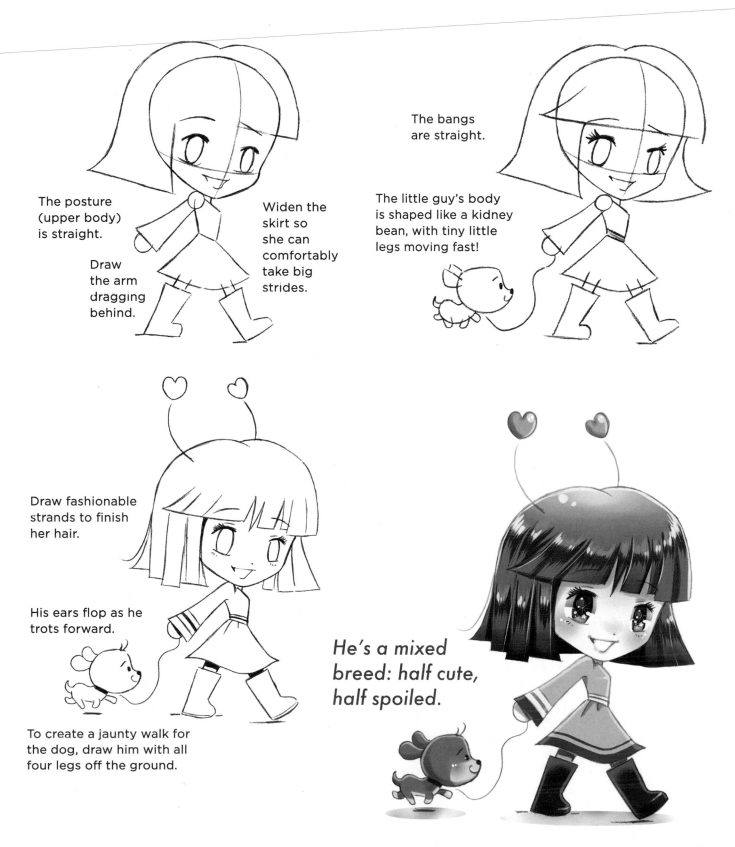

The posture (upper body) is straight.

Draw the arm dragging behind.

Widen the skirt so she can comfortably take big strides.

The bangs are straight.

The little guy's body is shaped like a kidney bean, with tiny little legs moving fast!

Draw fashionable strands to finish her hair.

His ears flop as he trots forward.

To create a jaunty walk for the dog, draw him with all four legs off the ground.

He's a mixed breed: half cute, half spoiled.

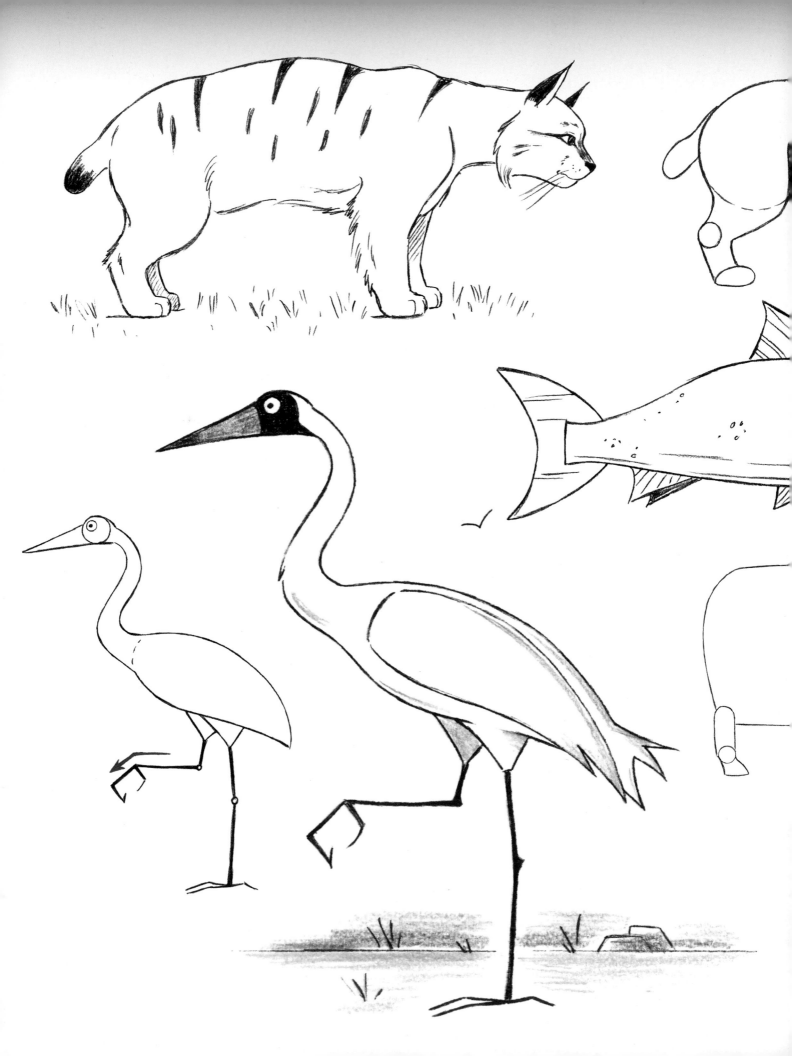

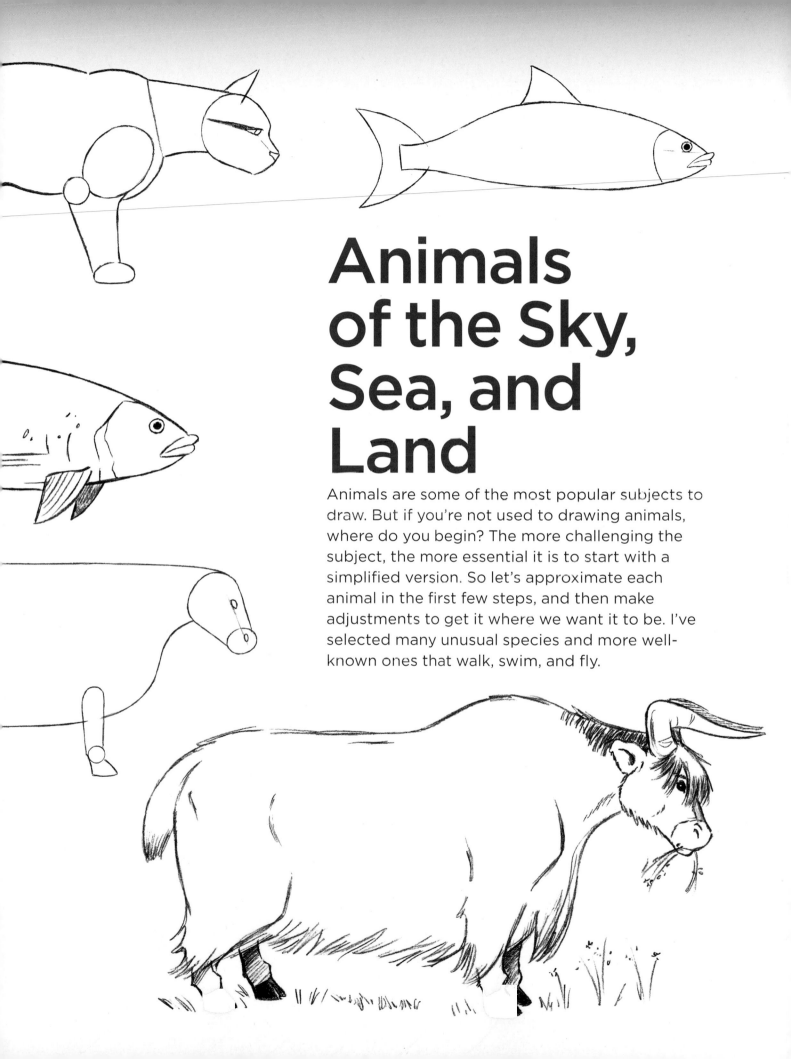

Animals of the Sky, Sea, and Land

Animals are some of the most popular subjects to draw. But if you're not used to drawing animals, where do you begin? The more challenging the subject, the more essential it is to start with a simplified version. So let's approximate each animal in the first few steps, and then make adjustments to get it where we want it to be. I've selected many unusual species and more well-known ones that walk, swim, and fly.

Birds: Two Types

There are a zillion types of birds, or a zillion and a half, if you accidentally count a bunch of them twice. Birds live all over world, even in extreme environments. And their shapes are different everywhere in order to adapt to the challenges.

CARDINAL

One particularly vibrant bird is the cardinal. You may have seen this intense little fellow flying near your house. He's drawn with a short, triangular beak and a dark face mask. But his signature look comes from his blazing red feathers and the crest on the top of his head.

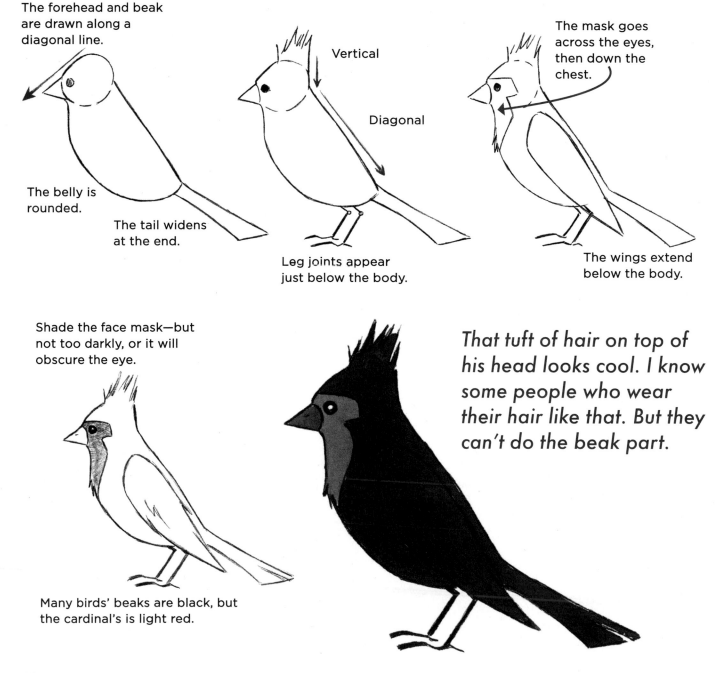

The forehead and beak are drawn along a diagonal line.

The belly is rounded.

The tail widens at the end.

Vertical

Diagonal

Leg joints appear just below the body.

The mask goes across the eyes, then down the chest.

The wings extend below the body.

Shade the face mask—but not too darkly, or it will obscure the eye.

Many birds' beaks are black, but the cardinal's is light red.

That tuft of hair on top of his head looks cool. I know some people who wear their hair like that. But they can't do the beak part.

WHOOPING CRANE

Cranes have a long, winding neck. They're a chiropractor's dream. But what's odd looking about them is also what makes them graceful. Their proportions are balanced. Half their length is the head and neck, and the other half is the body and tail.

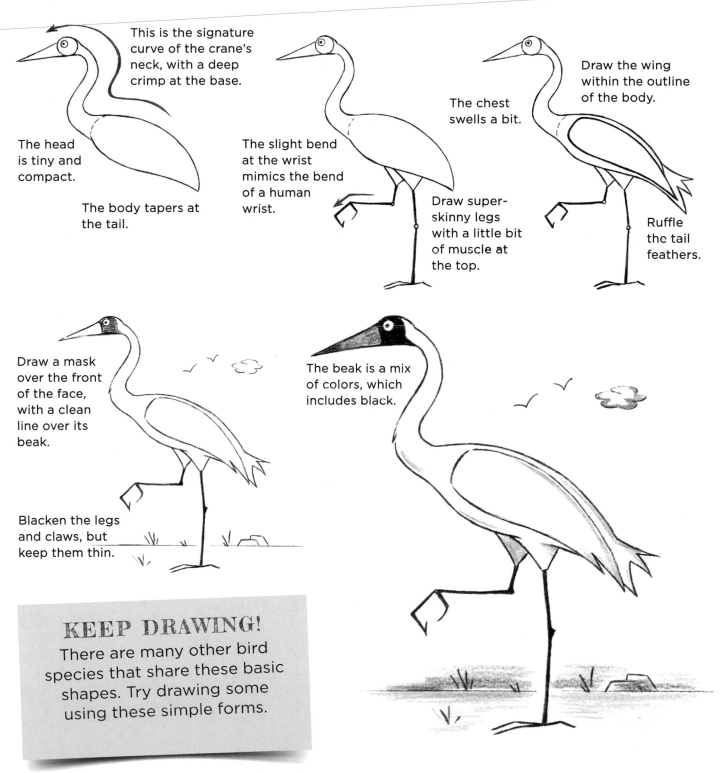

This is the signature curve of the crane's neck, with a deep crimp at the base.

The head is tiny and compact.

The body tapers at the tail.

The slight bend at the wrist mimics the bend of a human wrist.

The chest swells a bit.

Draw super-skinny legs with a little bit of muscle at the top.

Draw the wing within the outline of the body.

Ruffle the tail feathers.

Draw a mask over the front of the face, with a clean line over its beak.

Blacken the legs and claws, but keep them thin.

The beak is a mix of colors, which includes black.

KEEP DRAWING!
There are many other bird species that share these basic shapes. Try drawing some using these simple forms.

More Birds

Here are two more types of birds to try drawing. First we'll look at drawing a flying dove, and then, one of the cutest birds around: the puffin.

BIRD IN FLIGHT

How do you draw a bird in flight? First, sketch the basic shape of the head and body. Next, sketch the guidelines of the bones, which will give the feathers form and direction.

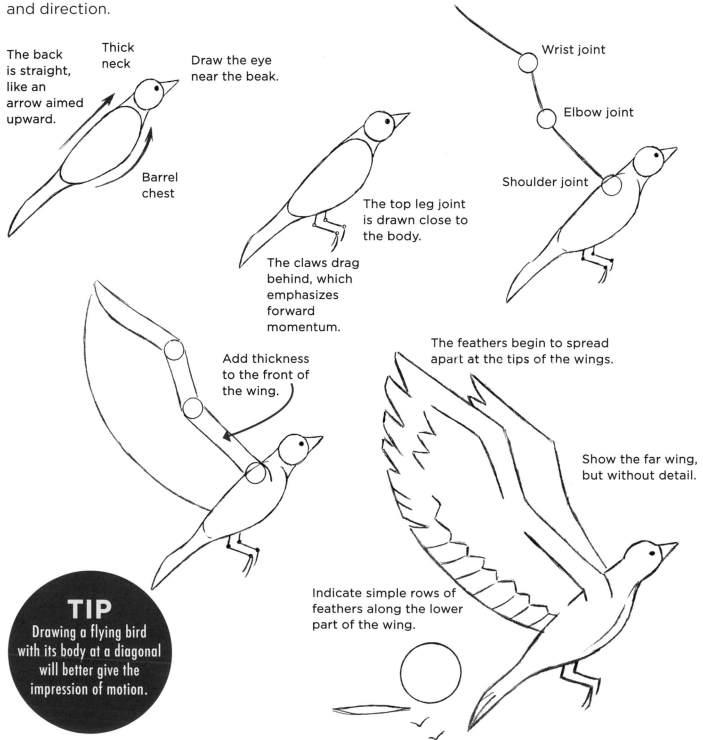

The back is straight, like an arrow aimed upward.

Thick neck

Draw the eye near the beak.

Barrel chest

The top leg joint is drawn close to the body.

The claws drag behind, which emphasizes forward momentum.

Wrist joint

Elbow joint

Shoulder joint

Add thickness to the front of the wing.

The feathers begin to spread apart at the tips of the wings.

Show the far wing, but without detail.

Indicate simple rows of feathers along the lower part of the wing.

TIP
Drawing a flying bird with its body at a diagonal will better give the impression of motion.

PUFFINS

It's hard not to like a puffin. If I had a puffin, we'd be best friends. I'd make a krill barbecue for him every weekend, even though I hate krill. A puffin's beak is wider at the base than on most penguins. Why is that? Because it's not a penguin! But it looks similar.

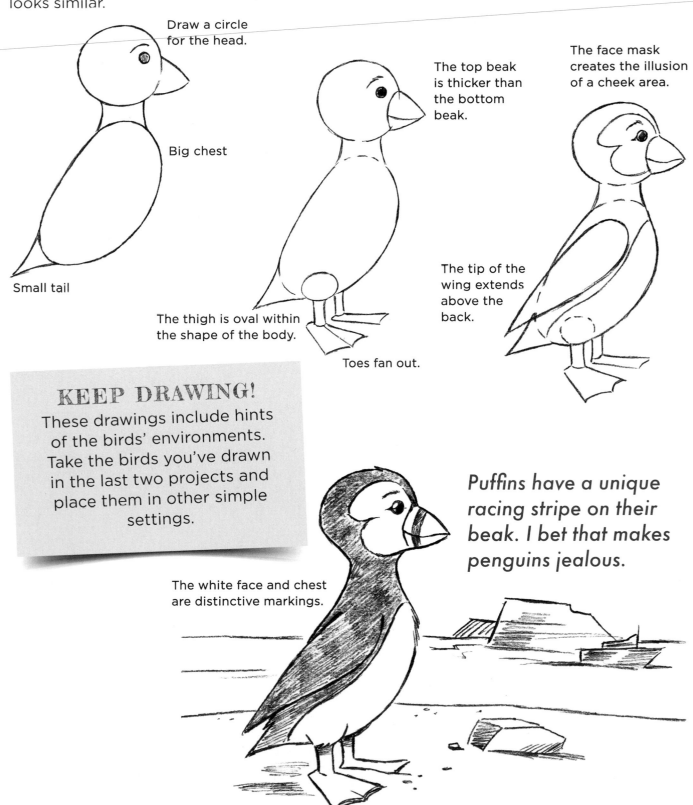

Draw a circle for the head.

Big chest

Small tail

The top beak is thicker than the bottom beak.

The thigh is oval within the shape of the body.

Toes fan out.

The face mask creates the illusion of a cheek area.

The tip of the wing extends above the back.

KEEP DRAWING!
These drawings include hints of the birds' environments. Take the birds you've drawn in the last two projects and place them in other simple settings.

The white face and chest are distinctive markings.

Puffins have a unique racing stripe on their beak. I bet that makes penguins jealous.

53

Aquatic Creatures: Fish

Water-based creatures are fascinating. Their structure is so different from land-based animals. Land animals have prominent shoulders, elbows, and knee joints, but not so with fish. Therefore, even though sea animals are intriguing, they're not so complex. Let's have fun with them!

TROUT

The trout is a classic. It lives in the wilderness, where it makes its home in freshwater lakes and streams. It has balanced proportions, both sturdy and long. It also has an interesting mix of fins.

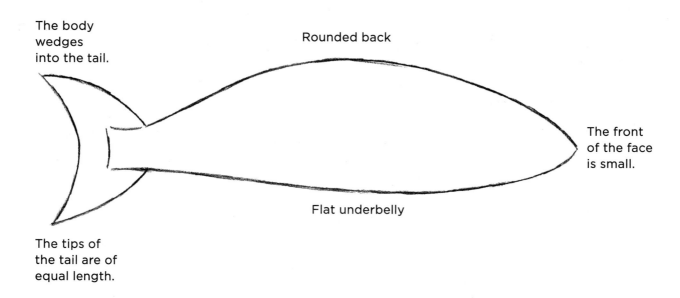

The body wedges into the tail.

Rounded back

The front of the face is small.

Flat underbelly

The tips of the tail are of equal length.

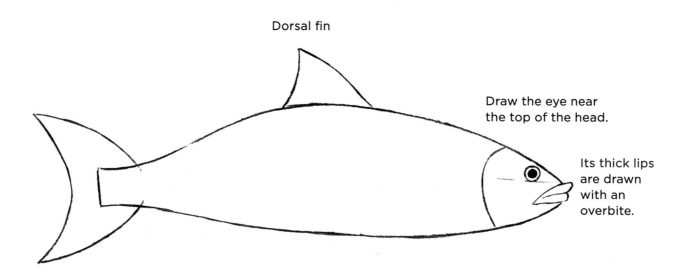

Dorsal fin

Draw the eye near the top of the head.

Its thick lips are drawn with an overbite.

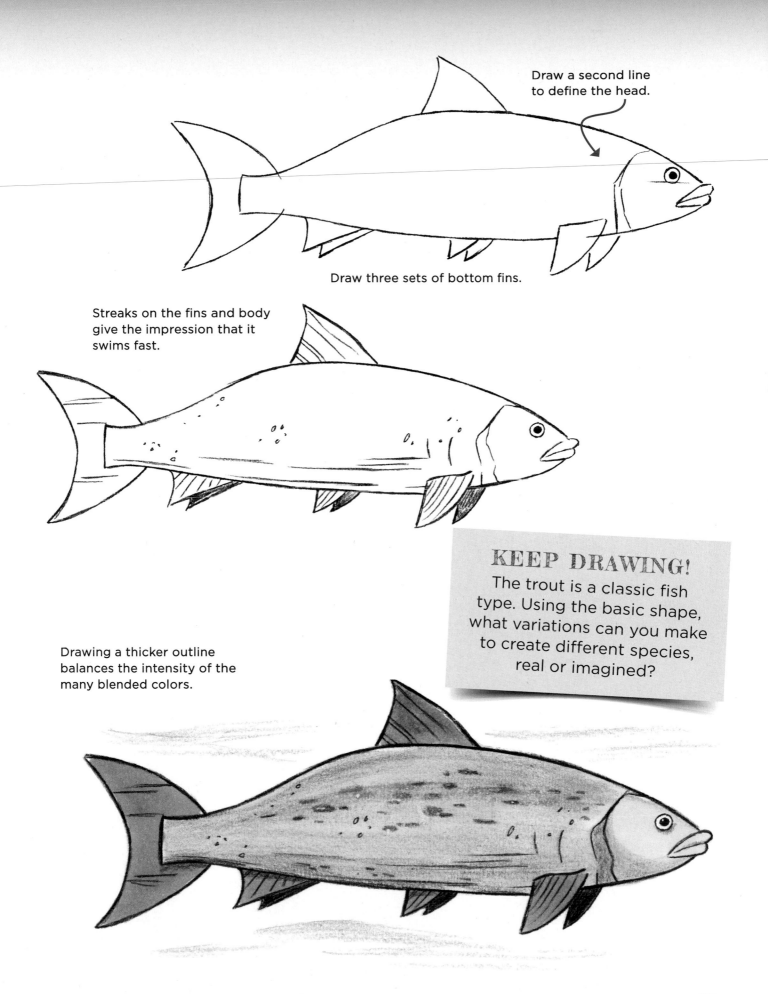

Draw a second line to define the head.

Draw three sets of bottom fins.

Streaks on the fins and body give the impression that it swims fast.

KEEP DRAWING!
The trout is a classic fish type. Using the basic shape, what variations can you make to create different species, real or imagined?

Drawing a thicker outline balances the intensity of the many blended colors.

ANGELFISH

The angelfish is a popular flat fish. Its prominent fins make it stand out. You've seen these popular types in animated movies and in aquariums. They're lively and easy to draw. And they make appealing subjects for artists.

The top of the tail is longer than the bottom of the tail.

Draw a small eye close to the edge of the outline of the body.

The mouth swings upward and is punctuated by small lips.

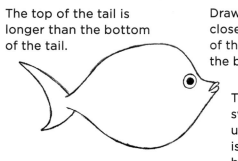

The dorsal fin brushes back in an aerodynamic manner.

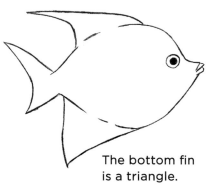

The bottom fin is a triangle.

Draw a simple, open face mask.

Add a small side-fin, for steering.

Draw a couple of weird, dangling things. Looks like they could use a trim.

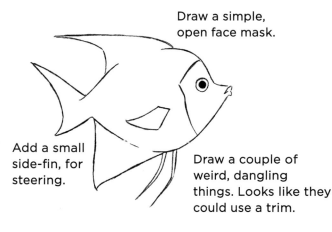

Darken the tips of the fins.

Their markings are irregularly shaped.

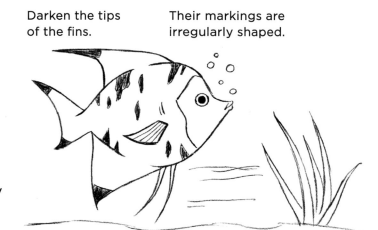

Whenever I see fish swimming, I get the distinct sense that they have no idea where they're going, but are nonetheless intent on getting there.

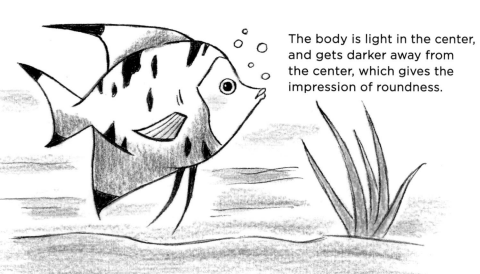

The body is light in the center, and gets darker away from the center, which gives the impression of roundness.

STINGRAY

Stingrays are mysterious-looking animals. Everyone at the aquarium wants to see them. But no one swimming in the ocean wants to. They're one of the least cuddly fish. I doubt mom stingrays hug baby stingrays, which is probably why they grow up to be so mean.

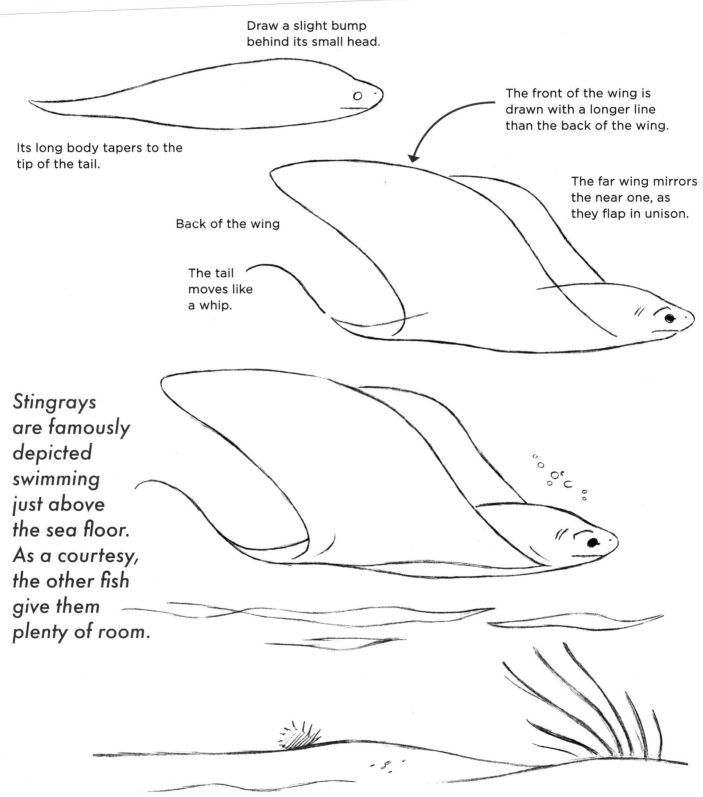

Draw a slight bump behind its small head.

Its long body tapers to the tip of the tail.

The front of the wing is drawn with a longer line than the back of the wing.

Back of the wing

The far wing mirrors the near one, as they flap in unison.

The tail moves like a whip.

Stingrays are famously depicted swimming just above the sea floor. As a courtesy, the other fish give them plenty of room.

Aquatic Creatures: Manatees

Manatee are known as "sea cows" because they look so similar to the domesticated bovine, I guess. The fins, tail, and the living-in-the-ocean part look pretty different to me, but what do I know? Manatees do more floating than swimming. Sounds good to me.

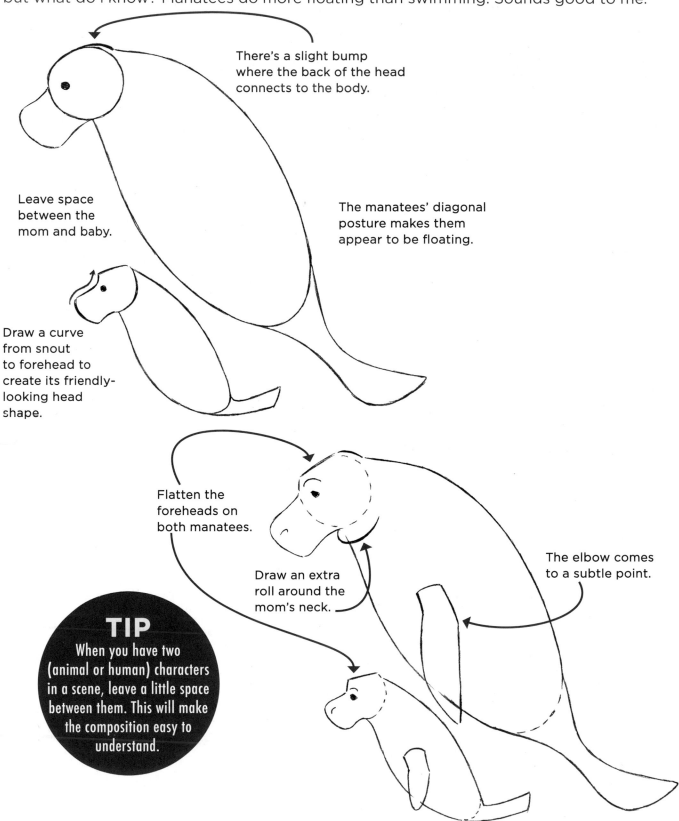

There's a slight bump where the back of the head connects to the body.

Leave space between the mom and baby.

The manatees' diagonal posture makes them appear to be floating.

Draw a curve from snout to forehead to create its friendly-looking head shape.

Flatten the foreheads on both manatees.

Draw an extra roll around the mom's neck.

The elbow comes to a subtle point.

TIP
When you have two (animal or human) characters in a scene, leave a little space between them. This will make the composition easy to understand.

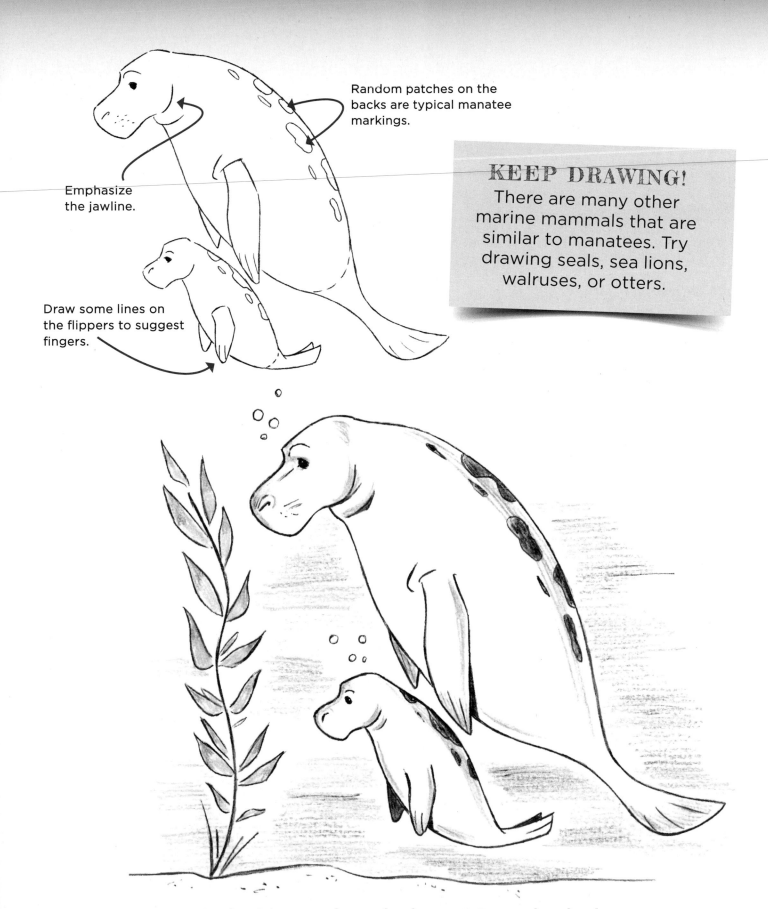

Random patches on the backs are typical manatee markings.

Emphasize the jawline.

Draw some lines on the flippers to suggest fingers.

KEEP DRAWING!
There are many other marine mammals that are similar to manatees. Try drawing seals, sea lions, walruses, or otters.

Today's special is salty leaves. To make the leaves look weightless, draw them pointing up. The water current does that to underwater flora.

Land Mammals

In the next few sections, I'll present some common and not-so-common animals. Since many rare species live in other parts of the world, drawing them is a little like going on an adventure without spending eight hours in a tiny airplane seat. We'll start with two portraits to see the differences and similarities in head shapes.

ZEBRA

Zebras are popular subjects for animal portraits. Their stripes create eye-catching patterns. I like to draw them in a side view so that the stripes are prominent.

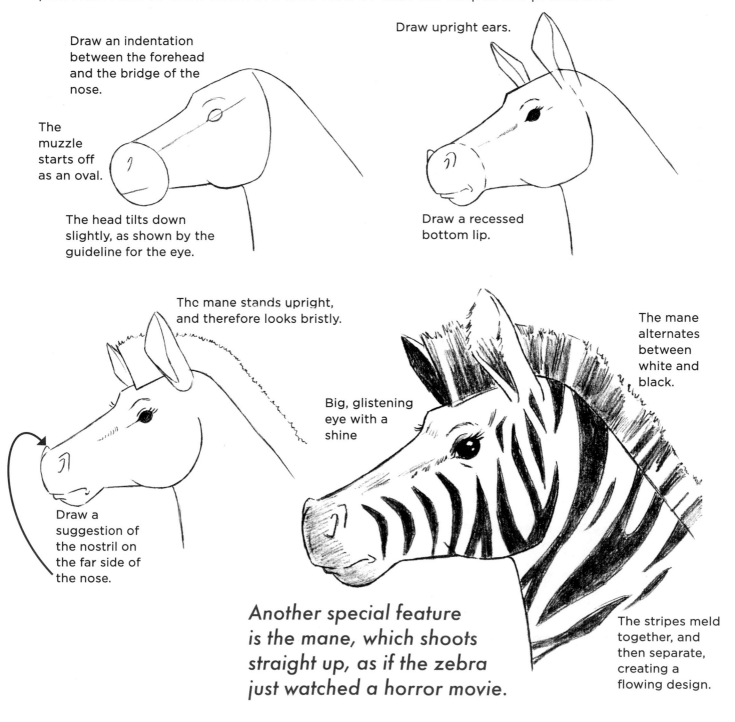

Draw an indentation between the forehead and the bridge of the nose.

The muzzle starts off as an oval.

The head tilts down slightly, as shown by the guideline for the eye.

Draw upright ears.

Draw a recessed bottom lip.

The mane stands upright, and therefore looks bristly.

Draw a suggestion of the nostril on the far side of the nose.

Big, glistening eye with a shine

The mane alternates between white and black.

Another special feature is the mane, which shoots straight up, as if the zebra just watched a horror movie.

The stripes meld together, and then separate, creating a flowing design.

LYNX

The lynx is a cat, but not a "come here, kitty, kitty" type of cat. It's a wild animal. Those ears are amazing, and not that common among big cats. And those stripes aren't exactly tiger stripes. Instead, the lynx has something between a stripe and a spot. That odd-looking ruff on its cheek is also part of its signature look.

The lynx has a boxy head with a short snout and a thick neck, which reflects its power.

The nose is not as small as a house cat's, but not as large as a lion's.

It has a prominent forward-angled chin.

Here's the part where I stop wanting to pet it. Draw two weirdly long, upright ears.

The sides of fur come around the head and toward the front.

The signature look of the lynx is the black hair coming off the tips of the ears.

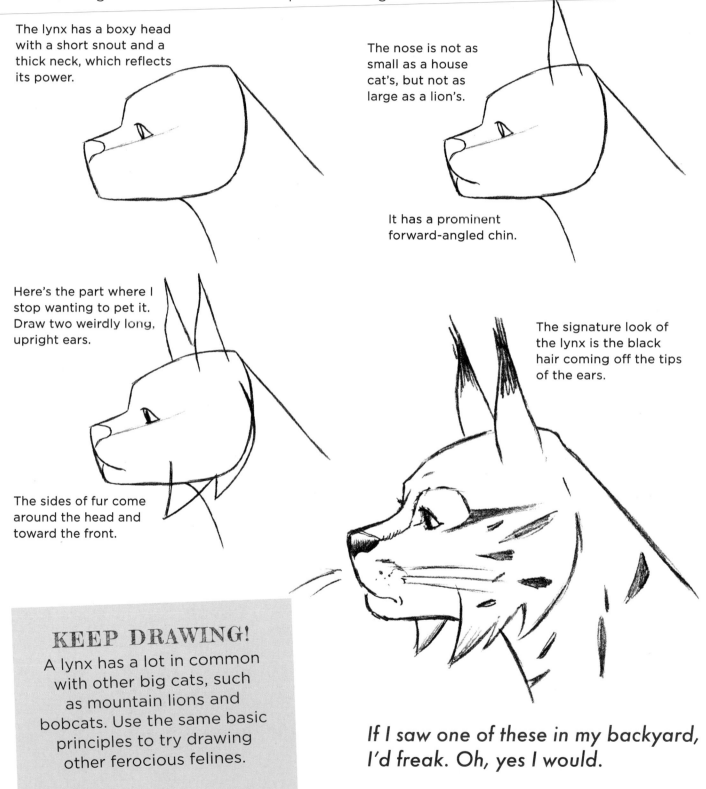

KEEP DRAWING!

A lynx has a lot in common with other big cats, such as mountain lions and bobcats. Use the same basic principles to try drawing other ferocious felines.

If I saw one of these in my backyard, I'd freak. Oh, yes I would.

Lynx: Full Body

We've drawn the lynx's head, now let's draw its body. This is a massive feline. It has a thick body and bear-like paws. It's good practice to draw an uncommon species because it takes us out of our comfort zone. We learn more when we stretch a little.

The middle of the back is curved and rises up.

The tummy is concave, which accentuates the size of the chest.

There's a hump on the back just over the shoulder.

The eye mask is thin and travels to the back of the head.

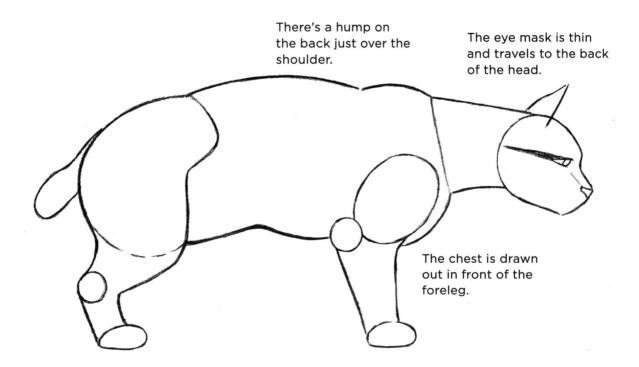

The chest is drawn out in front of the foreleg.

Define those creepy ears and
wisps of fur on the face.

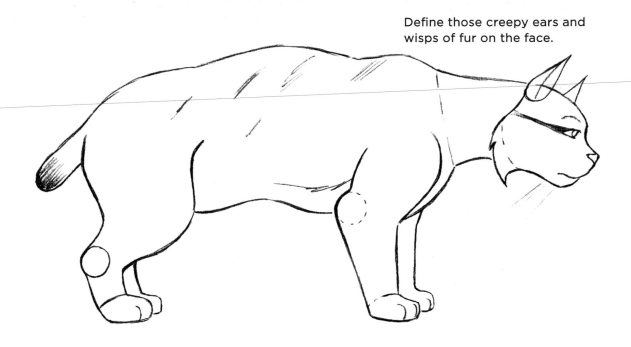

The lynx's stripes are randomly placed,
giving it an unpredictable look.

The tail is
tinged with
black.

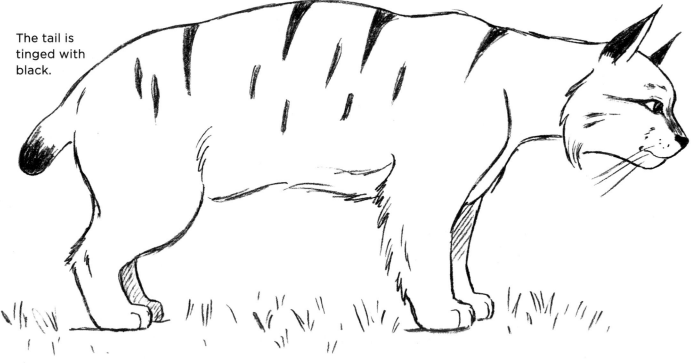

I know what you're thinking: It's so cute.
Can't I just scratch it under the chin?
No, you can't. Bad artist! Bad!

Samoyed

The Samoyed is an astonishingly beautiful spitz-type dog, which basically means it's from cold climates all over the world. It's also known for its smile, which it seems to have most of the time. It's a popular pet with a thick coat of white fur. It is well proportioned, sturdy, and evenly built.

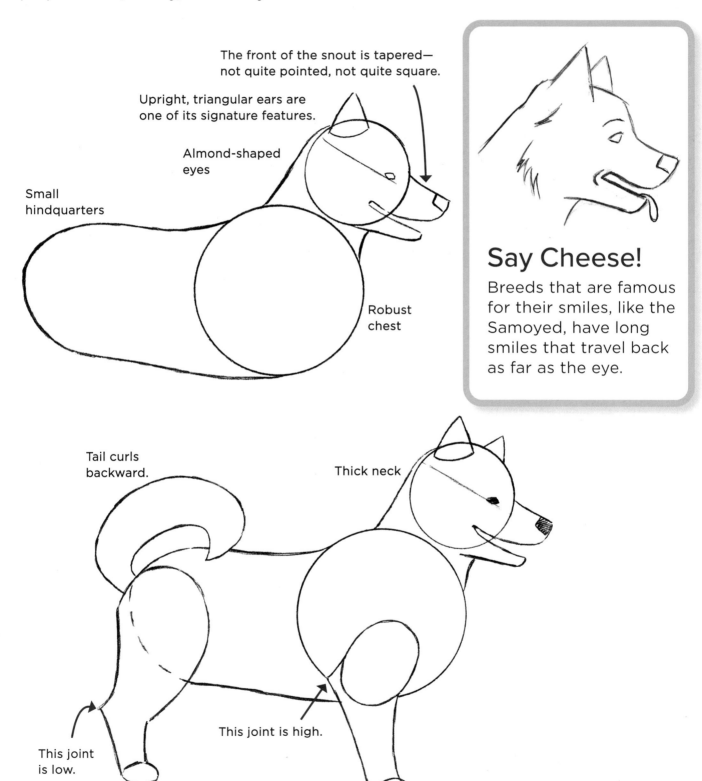

The front of the snout is tapered—not quite pointed, not quite square.

Upright, triangular ears are one of its signature features.

Almond-shaped eyes

Small hindquarters

Robust chest

Say Cheese!

Breeds that are famous for their smiles, like the Samoyed, have long smiles that travel back as far as the eye.

Tail curls backward.

Thick neck

This joint is high.

This joint is low.

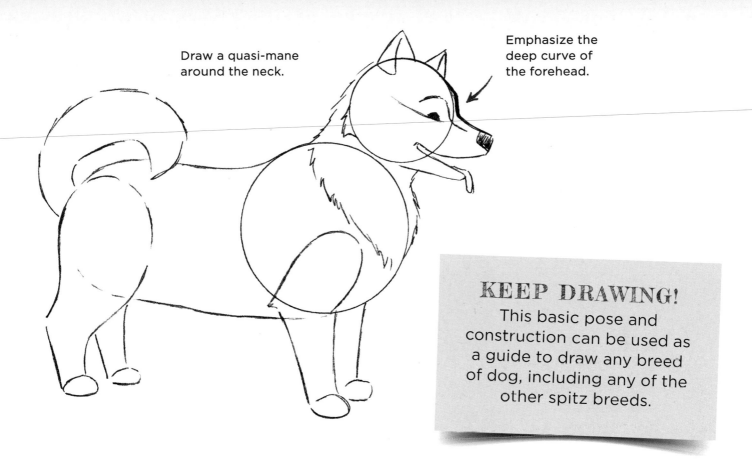

Draw a quasi-mane around the neck.

Emphasize the deep curve of the forehead.

KEEP DRAWING!
This basic pose and construction can be used as a guide to draw any breed of dog, including any of the other spitz breeds.

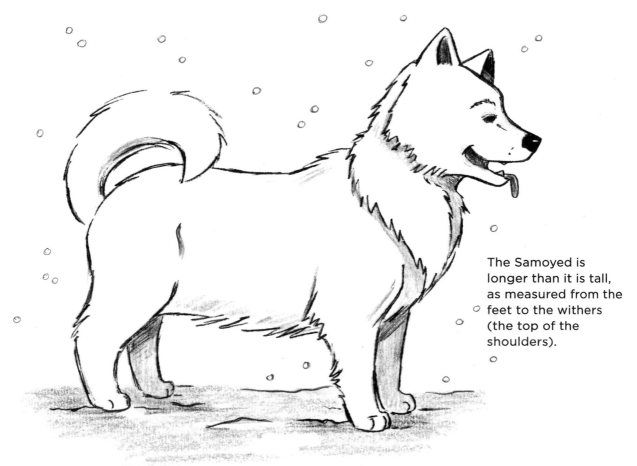

The Samoyed is longer than it is tall, as measured from the feet to the withers (the top of the shoulders).

Shetland Pony

Shetland ponies originated in the Shetland Islands, off Scotland. Although Shetland ponies are loved by children, they were originally bred to be working horses, hence their sturdy appearance. Their manes and tails are extra long and will flow in a strong breeze.

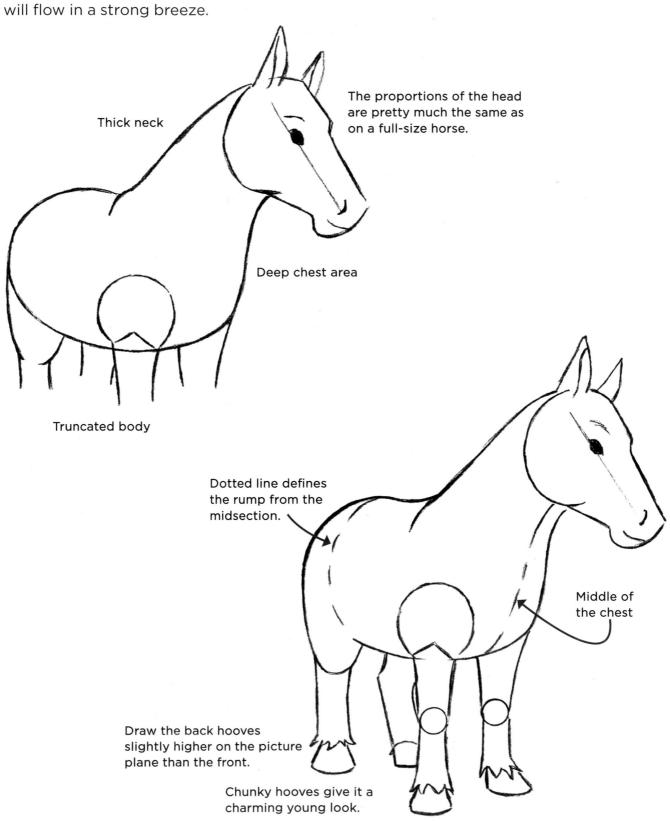

Thick neck

The proportions of the head are pretty much the same as on a full-size horse.

Deep chest area

Truncated body

Dotted line defines the rump from the midsection.

Middle of the chest

Draw the back hooves slightly higher on the picture plane than the front.

Chunky hooves give it a charming young look.

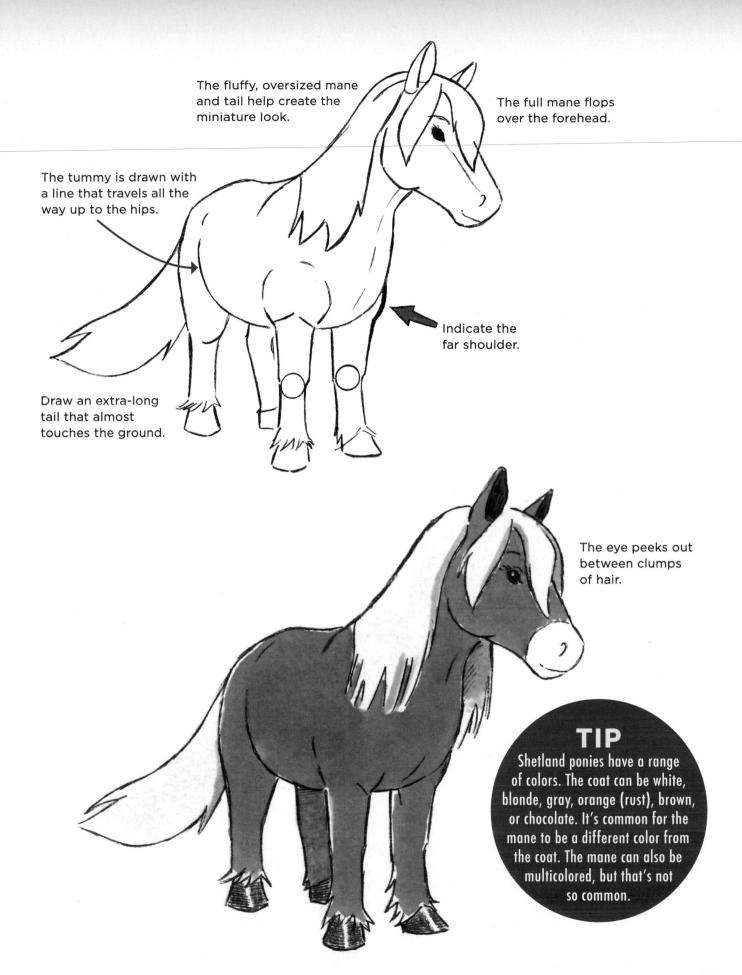

The fluffy, oversized mane and tail help create the miniature look.

The full mane flops over the forehead.

The tummy is drawn with a line that travels all the way up to the hips.

Indicate the far shoulder.

Draw an extra-long tail that almost touches the ground.

The eye peeks out between clumps of hair.

TIP

Shetland ponies have a range of colors. The coat can be white, blonde, gray, orange (rust), brown, or chocolate. It's common for the mane to be a different color from the coat. The mane can also be multicolored, but that's not so common.

Yak

Yaks are massive creatures. They're basically a minivan with legs. They live in the distant land of the Himalayas. Therefore, if you want to have a yak for a pet, you're going to have to live with spotty Wi-Fi. Their powerful build allows them to carry heavy loads across mountainous terrain, and their thick fur keeps them warm at high altitudes.

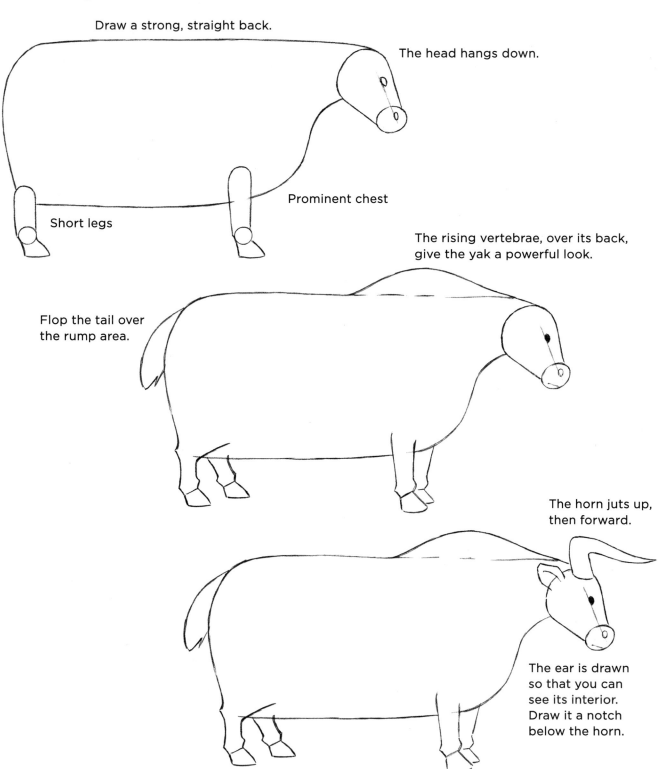

Draw a strong, straight back.

The head hangs down.

Prominent chest

Short legs

The rising vertebrae, over its back, give the yak a powerful look.

Flop the tail over the rump area.

The horn juts up, then forward.

The ear is drawn so that you can see its interior. Draw it a notch below the horn.

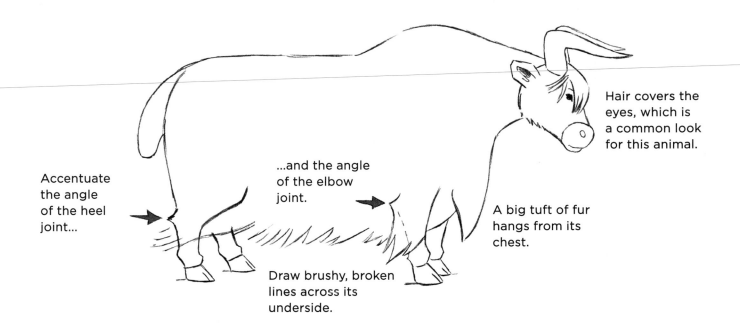

Hair covers the eyes, which is a common look for this animal.

Accentuate the angle of the heel joint...

...and the angle of the elbow joint.

A big tuft of fur hangs from its chest.

Draw brushy, broken lines across its underside.

KEEP DRAWING!
Draw a few of the yak's close relatives, such as oxen, bison, and mountain goats.

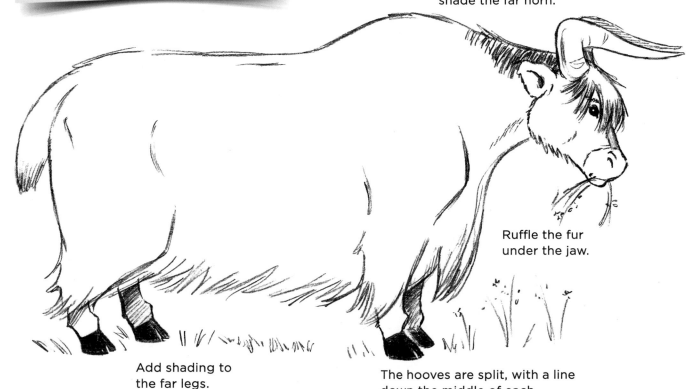

Add a suggestion of a mane to the back of the neck and shade the far horn.

Ruffle the fur under the jaw.

Add shading to the far legs.

The hooves are split, with a line down the middle of each.

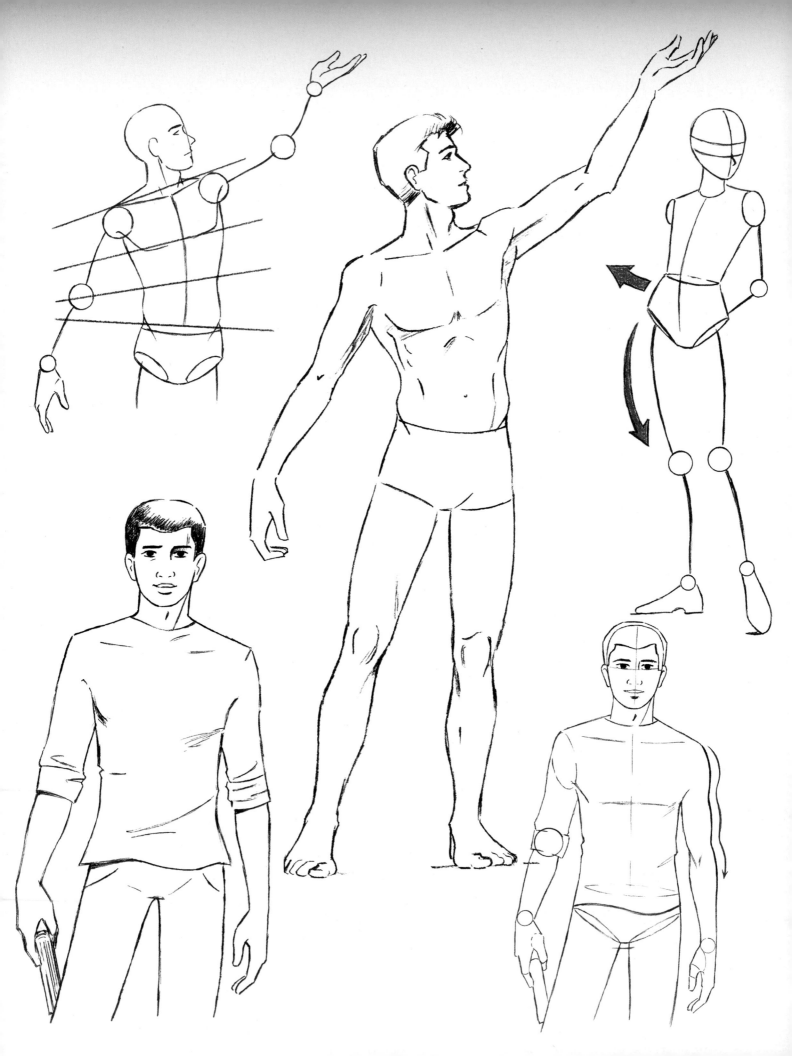

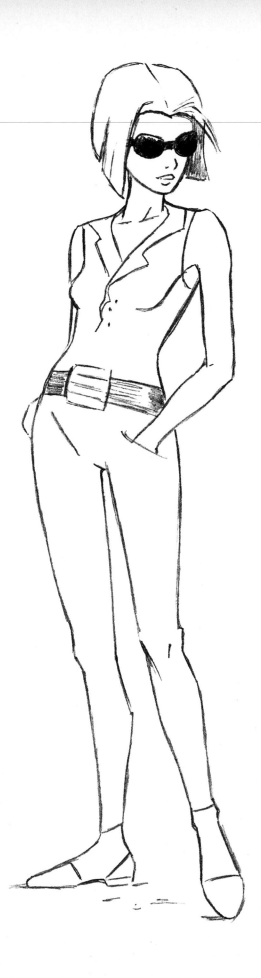

Drawing People

There's no place where proportions and a solid construction are more important than when drawing the human figure. If it looks right from the start, it will look right at the end. Therefore, we'll focus on the initial steps before we clean up and refine the drawing. It's how the pros draw—and now, you can draw that way, too!

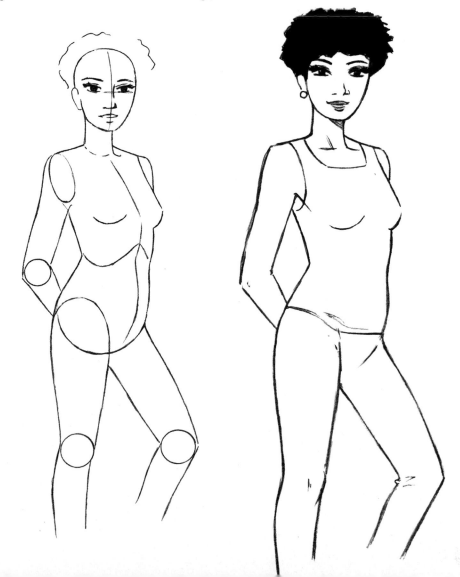

Gesture Drawings

A gesture pose is a pose that captures an attitude or a stance in the least number of lines. It's a great way to start a character. But you'll want to follow up these simple constructions in order to make them finished drawings. Keep in mind that the simpler you make the first steps, the more appealing the final step will be.

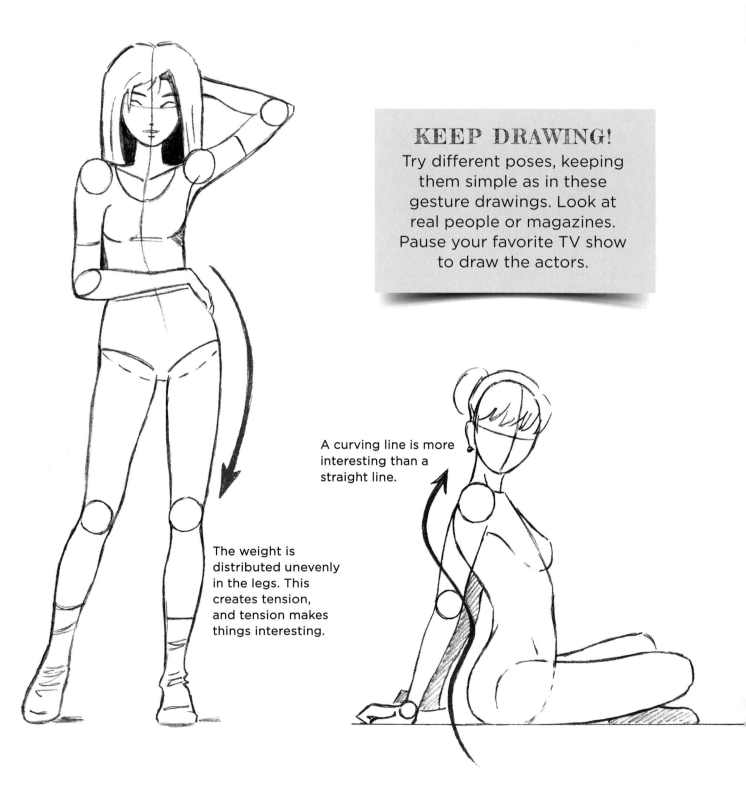

KEEP DRAWING!
Try different poses, keeping them simple as in these gesture drawings. Look at real people or magazines. Pause your favorite TV show to draw the actors.

A curving line is more interesting than a straight line.

The weight is distributed unevenly in the legs. This creates tension, and tension makes things interesting.

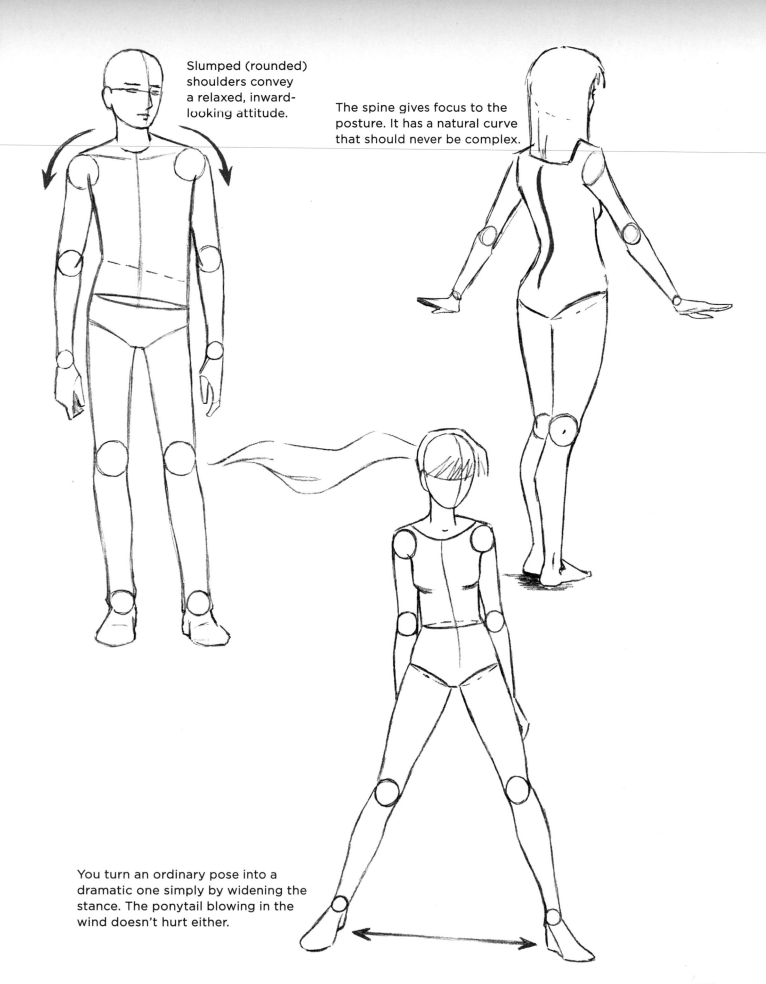

Slumped (rounded) shoulders convey a relaxed, inward-looking attitude.

The spine gives focus to the posture. It has a natural curve that should never be complex.

You turn an ordinary pose into a dramatic one simply by widening the stance. The ponytail blowing in the wind doesn't hurt either.

Heroic Pose

The overall pose is usually better when it's simple. Once the pose is established, the details will complement the drawing, not complicate it.

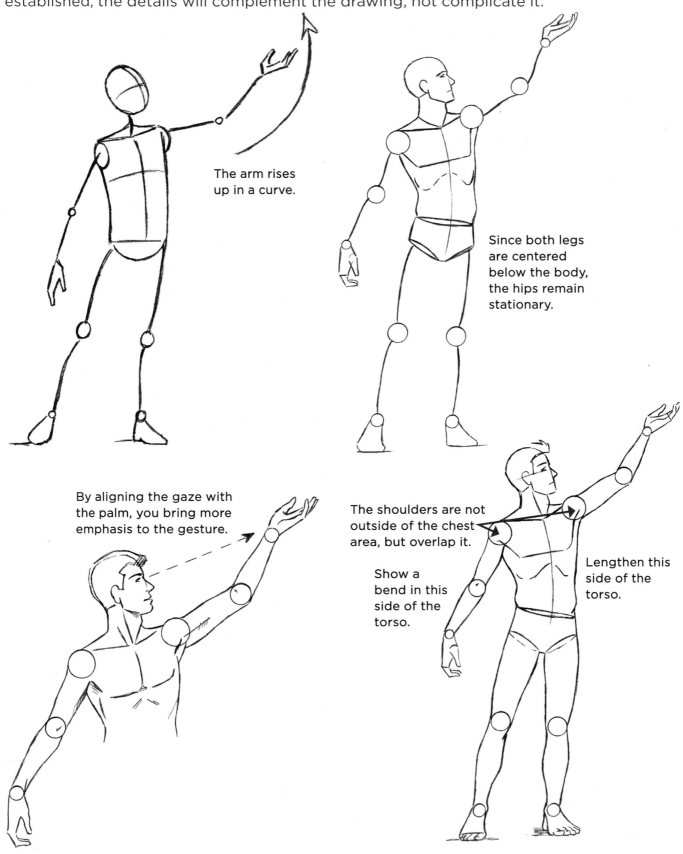

The arm rises up in a curve.

Since both legs are centered below the body, the hips remain stationary.

By aligning the gaze with the palm, you bring more emphasis to the gesture.

The shoulders are not outside of the chest area, but overlap it.

Show a bend in this side of the torso.

Lengthen this side of the torso.

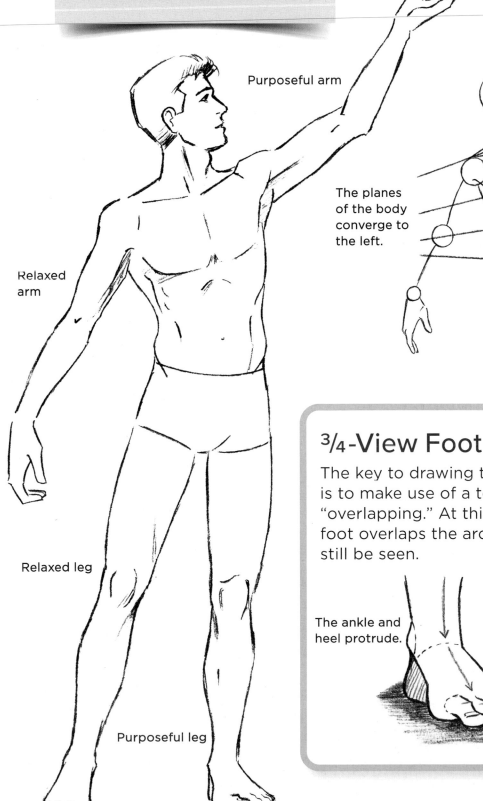

Purposeful arm

The planes of the body converge to the left.

Relaxed arm

Relaxed leg

Purposeful leg

¾-View Foot

The key to drawing the foot in a ¾ view is to make use of a technique called "overlapping." At this angle, the ball of the foot overlaps the arch, but the heel can still be seen.

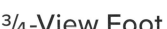

The ankle and heel protrude.

The bridge of the foot is drawn on a diagonal.

Planting the foot firmly on the ground creates stability in the pose.

Simple Poses

The key to drawing gesture poses is making them look as though the arms, body, and legs are working together to create a purposeful pose.

CASUAL LOOK

Every stretching or twisting action causes an offsetting reaction. Sometimes this is the most appealing aspect of a pose. Placing her arms behind her causes her back to bend in and the front of her body to stretch out. This results in a push-pull dynamic.

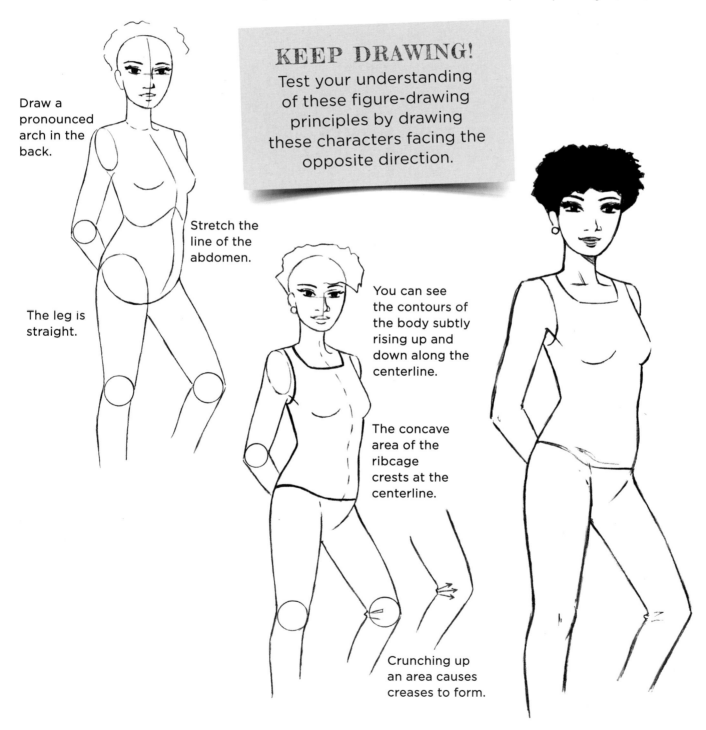

Draw a pronounced arch in the back.

The leg is straight.

Stretch the line of the abdomen.

KEEP DRAWING!
Test your understanding of these figure-drawing principles by drawing these characters facing the opposite direction.

You can see the contours of the body subtly rising up and down along the centerline.

The concave area of the ribcage crests at the centerline.

Crunching up an area causes creases to form.

RELAXED POSE

The problem with simple, symmetrical poses is that they tend to look stiff. This is especially true when two arms are relaxed at the sides. Let me cut to the chase: You can make the arms appear relaxed by bending them slightly at the elbows. That's all there is to it, really. Let's give it a try.

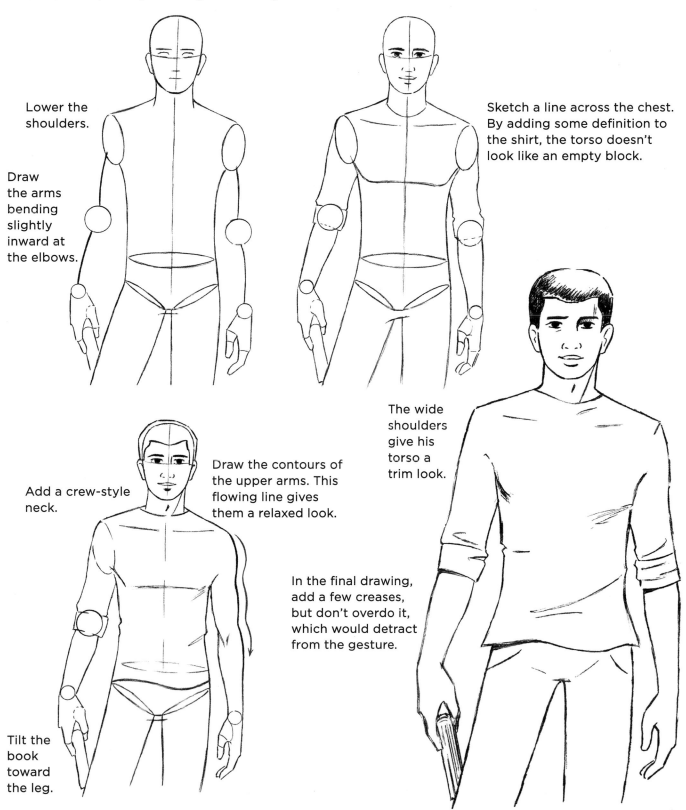

Lower the shoulders.

Draw the arms bending slightly inward at the elbows.

Sketch a line across the chest. By adding some definition to the shirt, the torso doesn't look like an empty block.

Add a crew-style neck.

Draw the contours of the upper arms. This flowing line gives them a relaxed look.

Tilt the book toward the leg.

The wide shoulders give his torso a trim look.

In the final drawing, add a few creases, but don't overdo it, which would detract from the gesture.

Saxophone Player

When adding a prop, it's often best to avoid drawing it within the outline of the body, where it will be harder for the viewer to see clearly. For this character, I've drawn her holding the saxophone away from her body, which allows the viewer's eye to easily capture both images.

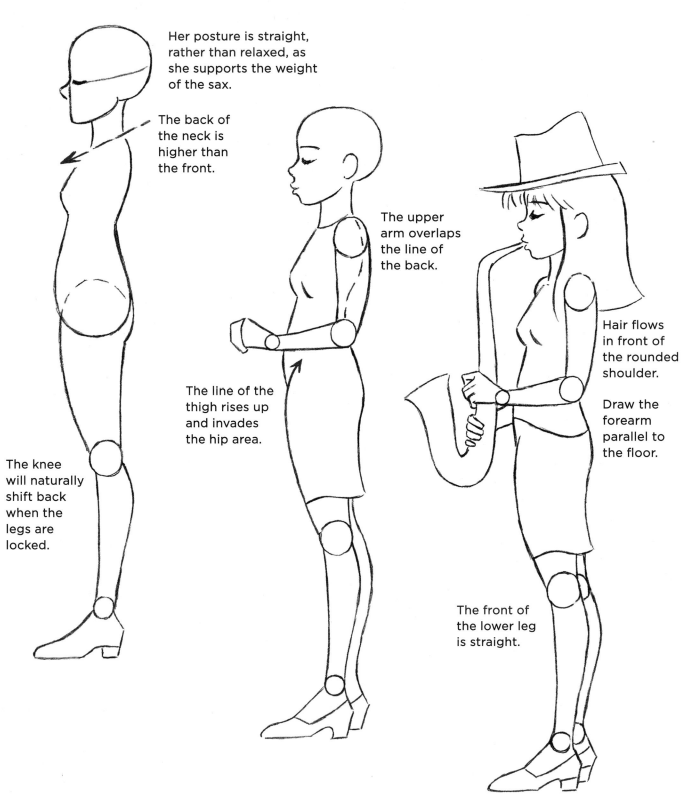

Her posture is straight, rather than relaxed, as she supports the weight of the sax.

The back of the neck is higher than the front.

The upper arm overlaps the line of the back.

The line of the thigh rises up and invades the hip area.

Hair flows in front of the rounded shoulder.

Draw the forearm parallel to the floor.

The knee will naturally shift back when the legs are locked.

The front of the lower leg is straight.

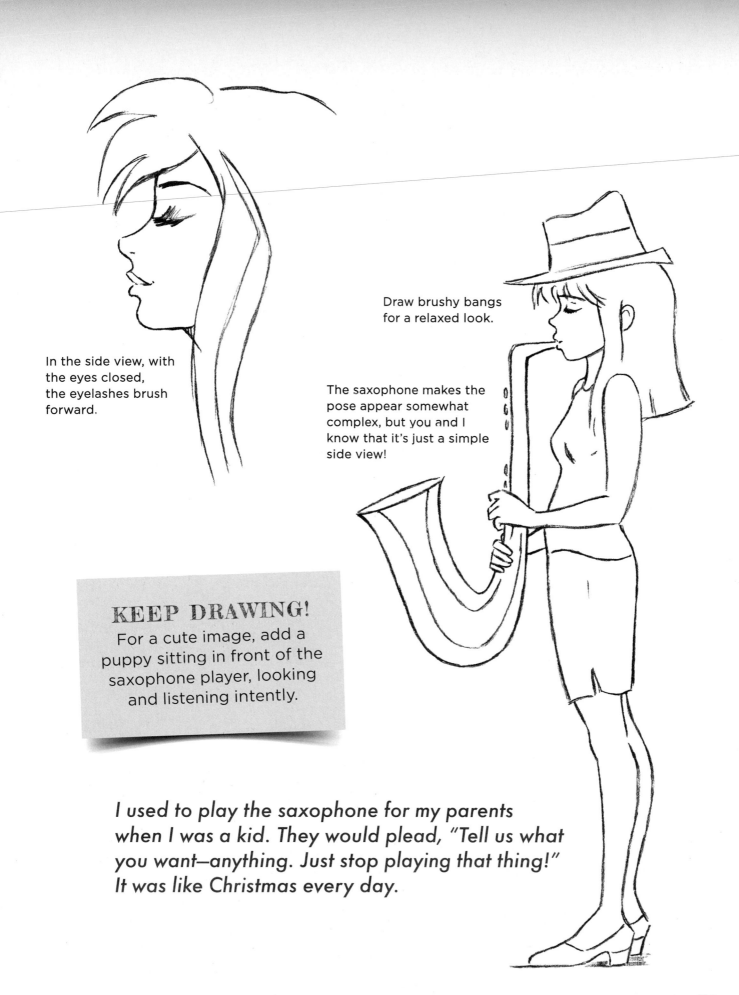

In the side view, with the eyes closed, the eyelashes brush forward.

Draw brushy bangs for a relaxed look.

The saxophone makes the pose appear somewhat complex, but you and I know that it's just a simple side view!

KEEP DRAWING!
For a cute image, add a puppy sitting in front of the saxophone player, looking and listening intently.

I used to play the saxophone for my parents when I was a kid. They would plead, "Tell us what you want—anything. Just stop playing that thing!" It was like Christmas every day.

Stylish Stance

By shifting the hips to one side, you create a stylish stance. In response to the leftward move of the hips, the body tries to maintain its original position by leaning back. That adds more attitude than if it were an evenly balanced stance.

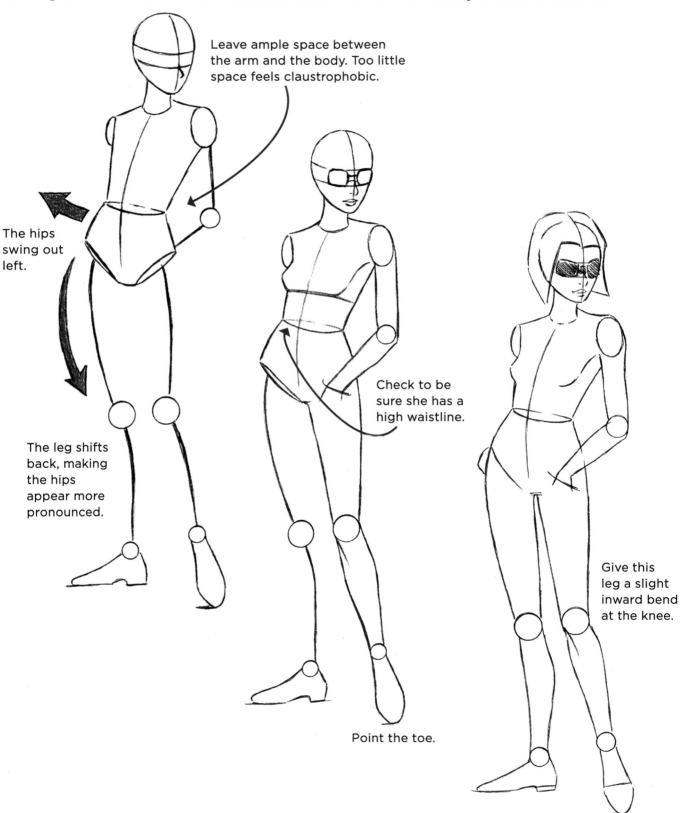

Leave ample space between the arm and the body. Too little space feels claustrophobic.

The hips swing out left.

The leg shifts back, making the hips appear more pronounced.

Check to be sure she has a high waistline.

Point the toe.

Give this leg a slight inward bend at the knee.

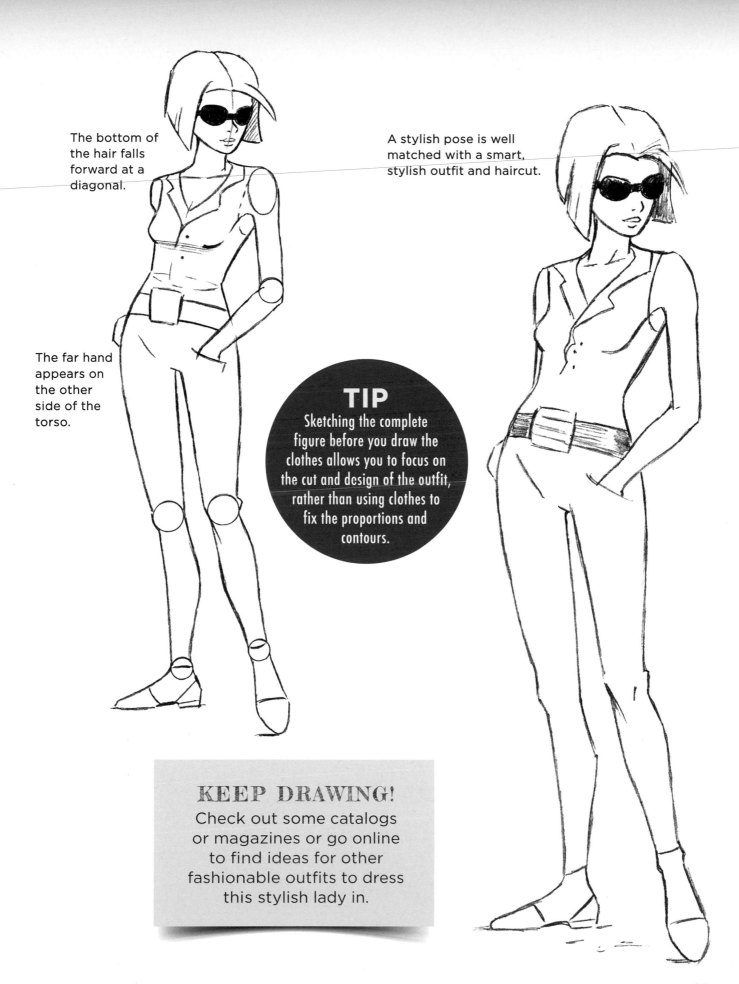

The bottom of the hair falls forward at a diagonal.

A stylish pose is well matched with a smart, stylish outfit and haircut.

The far hand appears on the other side of the torso.

TIP
Sketching the complete figure before you draw the clothes allows you to focus on the cut and design of the outfit, rather than using clothes to fix the proportions and contours.

KEEP DRAWING!
Check out some catalogs or magazines or go online to find ideas for other fashionable outfits to dress this stylish lady in.

Stunning Style

When drawing the face, we focus on a few key areas, which will add the most impact. For example, stylish hair and sunglasses. Another face might emphasize other features, such as eyes or an expression.

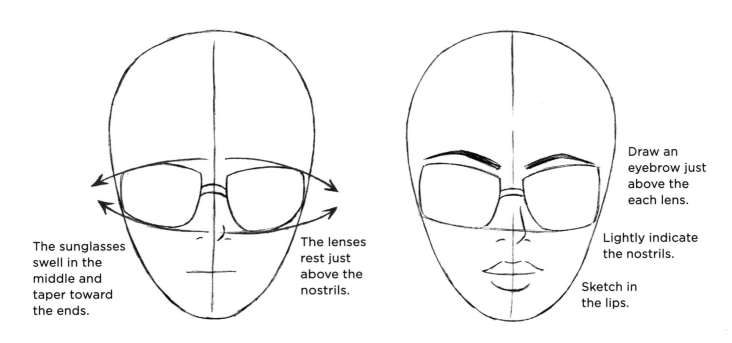

The sunglasses swell in the middle and taper toward the ends.

The lenses rest just above the nostrils.

Draw an eyebrow just above the each lens.

Lightly indicate the nostrils.

Sketch in the lips.

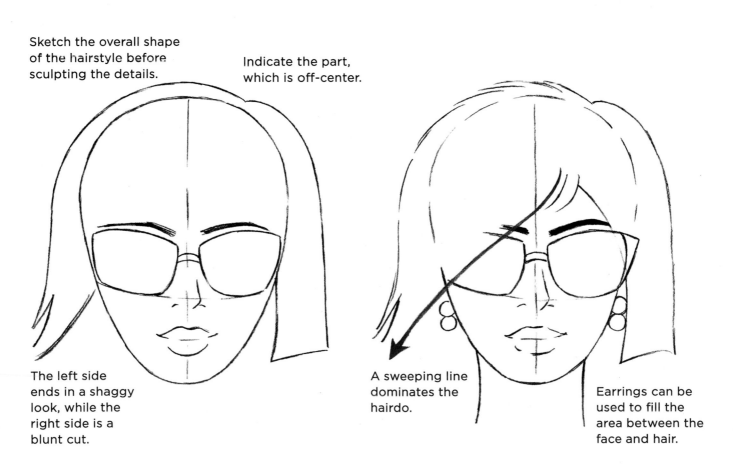

Sketch the overall shape of the hairstyle before sculpting the details.

Indicate the part, which is off-center.

The left side ends in a shaggy look, while the right side is a blunt cut.

A sweeping line dominates the hairdo.

Earrings can be used to fill the area between the face and hair.

Soften the hair on top of the head so that it's no longer a single, unbroken line.

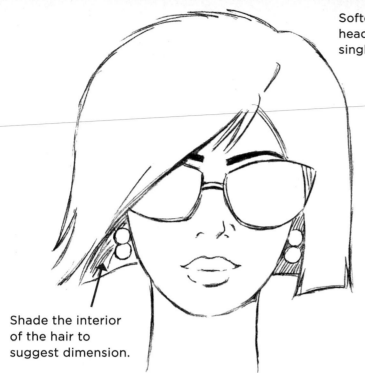

Shade the interior of the hair to suggest dimension.

KEEP DRAWING!
Change up her look by modifying her sunglasses, giving her different jewelry, or restyling her hair. (In the next lesson, we'll look at lots of hairstyle variations.)

In fashion illustration and commercial art, color can be used as accents on otherwise black-and-white images to produce a stylish effect.

No autographs, please.

Hairstyle Variations

A hairstyle says something about an individual. One hairstyle could be traditional while another could be trendy. All it takes is a single idea to begin to draw a hairstyle. To demonstrate this, I've taken the same character, at the same angle, and changed only the hair.

BASIC HEAD CONSTRUCTION

Let's start with the simple construction of the head and the placement of the features.

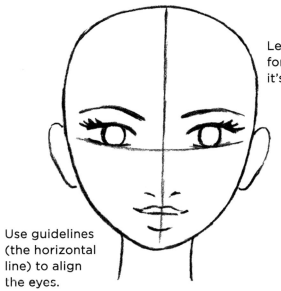

Leave a lot of the forehead empty—it's your canvas!

Use guidelines (the horizontal line) to align the eyes.

TIP
If you'd like more info on drawing hairstyles, there's a big chapter on them in my popular book *Cartoon Faces*.

BASIC HAIR CONSTRUCTION

All hairstyles flow from the top of the head. When it reaches the ears, it spreads out into any of several specific styles.

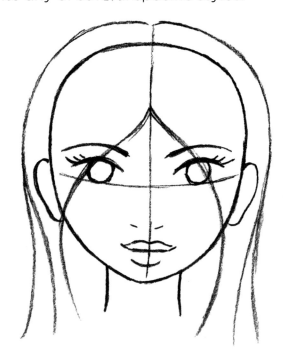

KEEP DRAWING!
You saw this one coming. Try adding your own touches to some of these hairstyles or design your own!

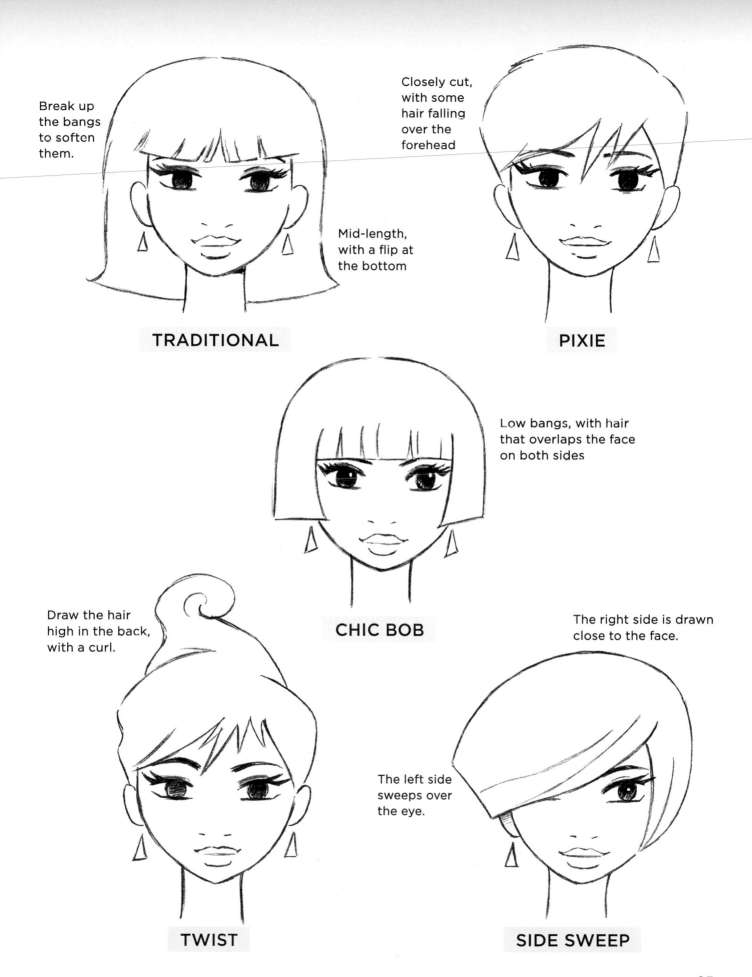

Break up the bangs to soften them.

Closely cut, with some hair falling over the forehead

Mid-length, with a flip at the bottom

TRADITIONAL

PIXIE

Low bangs, with hair that overlaps the face on both sides

CHIC BOB

Draw the hair high in the back, with a curl.

The right side is drawn close to the face.

The left side sweeps over the eye.

TWIST

SIDE SWEEP

85

Playing with Proportions

Cartoonists exaggerate proportions to create hilarious new characters. Here we'll take a character with a slight build and change him by inflating his proportions. This will result in an entirely new look—and a funny variation. But first, let's establish what normal proportions look like.

JOE AVERAGE

Although he is slight of build, his proportions are balanced.
No part of his physique overwhelms any other part.

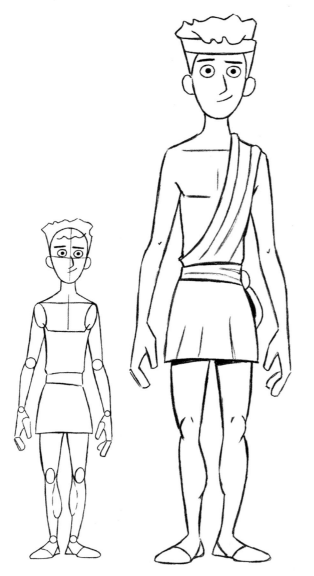

Get ready for a transformation.
This guy is about to hit the gym.

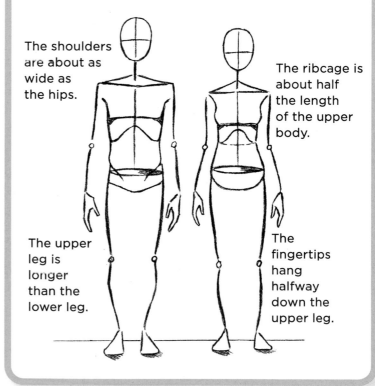

Standard Proportions

The most important thing to remember is that proportions are consistent for each character. For example, if an elbow appears at a certain height on one character, then both elbows should appear at that level (when the arm is relaxed).

The shoulders are about as wide as the hips.

The ribcage is about half the length of the upper body.

The upper leg is longer than the lower leg.

The fingertips hang halfway down the upper leg.

MR. MUSCLES

Building on the character we just drew, we'll inflate his proportions unevenly, resulting in a lopsided, and funny, physique. The head remains small compared to the width of the shoulders.

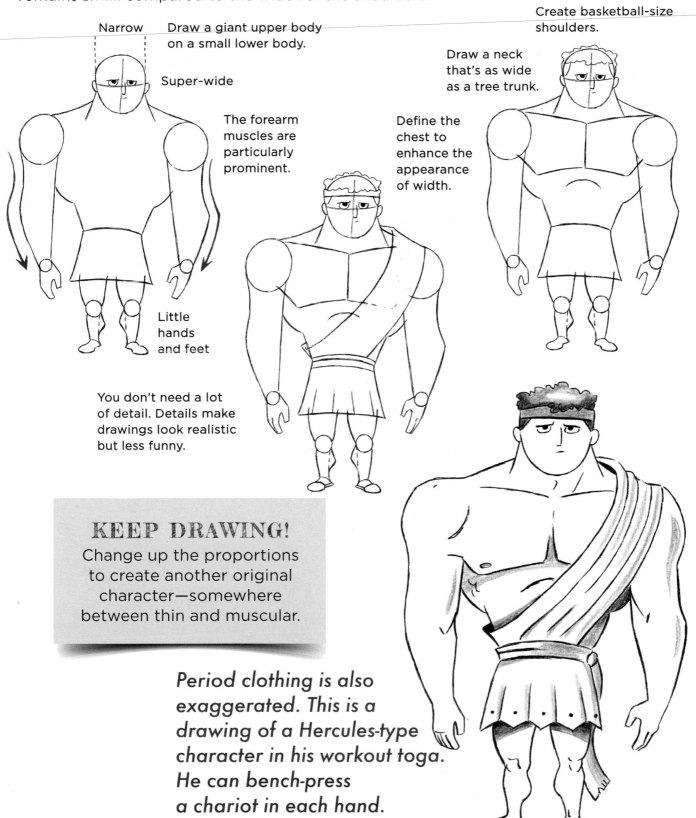

Narrow

Draw a giant upper body on a small lower body.

Super-wide

The forearm muscles are particularly prominent.

Little hands and feet

You don't need a lot of detail. Details make drawings look realistic but less funny.

Create basketball-size shoulders.

Draw a neck that's as wide as a tree trunk.

Define the chest to enhance the appearance of width.

KEEP DRAWING!
Change up the proportions to create another original character—somewhere between thin and muscular.

Period clothing is also exaggerated. This is a drawing of a Hercules-type character in his workout toga. He can bench-press a chariot in each hand.

The Key to Drawing Couples

Let's say you want to draw a couple. So, you sketch two characters standing and talking. But somehow, it doesn't look natural. The drawing may be good, so what's the problem? It may be that the postures of the two characters aren't working as a unit. The solution may be in the way the two postures face each other.

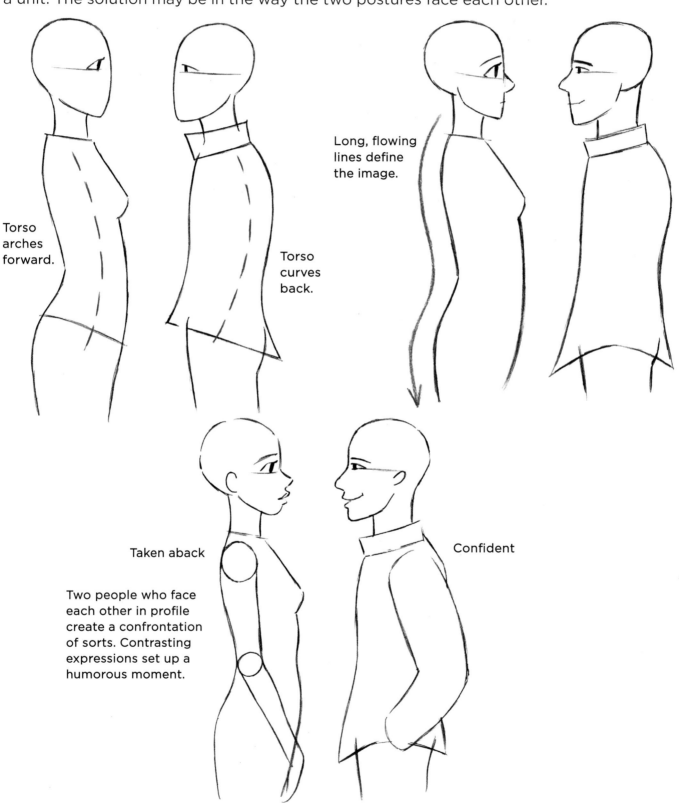

Torso arches forward.

Torso curves back.

Long, flowing lines define the image.

Taken aback

Confident

Two people who face each other in profile create a confrontation of sorts. Contrasting expressions set up a humorous moment.

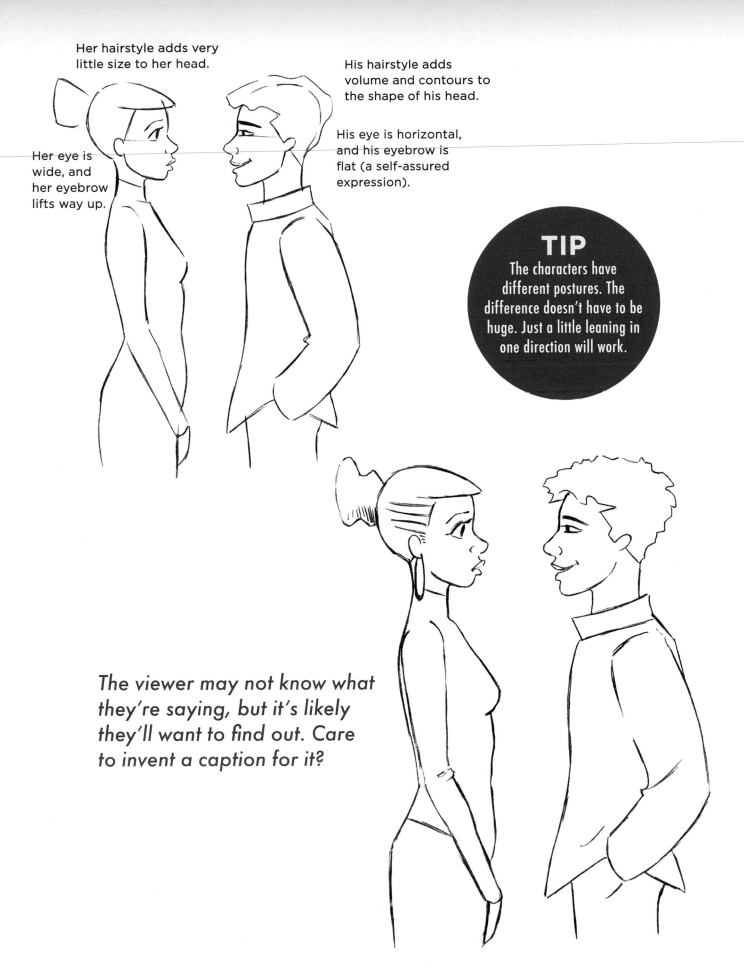

Her hairstyle adds very little size to her head.

His hairstyle adds volume and contours to the shape of his head.

Her eye is wide, and her eyebrow lifts way up.

His eye is horizontal, and his eyebrow is flat (a self-assured expression).

TIP
The characters have different postures. The difference doesn't have to be huge. Just a little leaning in one direction will work.

The viewer may not know what they're saying, but it's likely they'll want to find out. Care to invent a caption for it?

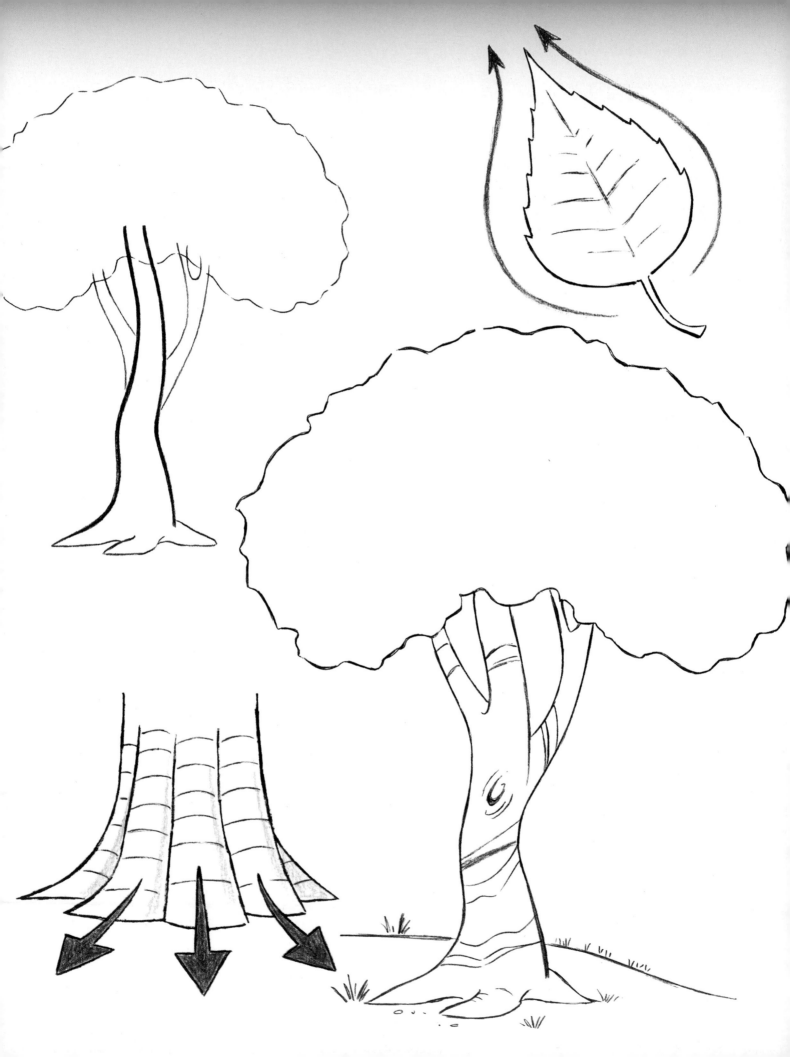

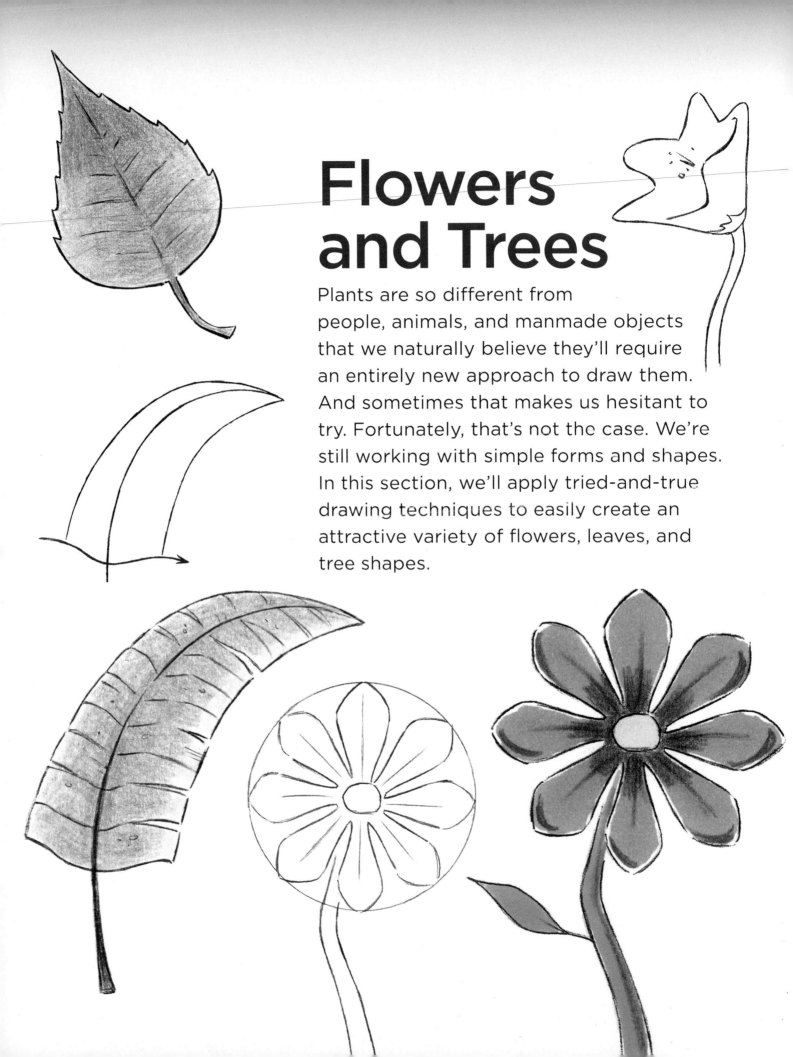

Flowers and Trees

Plants are so different from people, animals, and manmade objects that we naturally believe they'll require an entirely new approach to draw them. And sometimes that makes us hesitant to try. Fortunately, that's not the case. We're still working with simple forms and shapes. In this section, we'll apply tried-and-true drawing techniques to easily create an attractive variety of flowers, leaves, and tree shapes.

Basic Flower Shapes

When drawing a flower, begin by sketching the basic shape. Details, like the petals and coloring, will work better if you first establish the groundwork.

CONE-SHAPED FLOWERS

These flowers are shaped like funnels. The line around the rim serves as a guideline. Then the petals are defined within it.

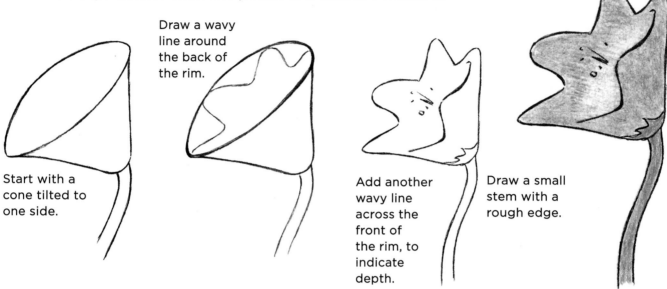

Draw a wavy line around the back of the rim.

Start with a cone tilted to one side.

Add another wavy line across the front of the rim, to indicate depth.

Draw a small stem with a rough edge.

CIRCULAR FLOWERS

Flowers based on circular shapes need to be symmetrical. If one petal is a bit long and another too short, you'll end up with a flower that can't decide what it wants to be when it grows up.

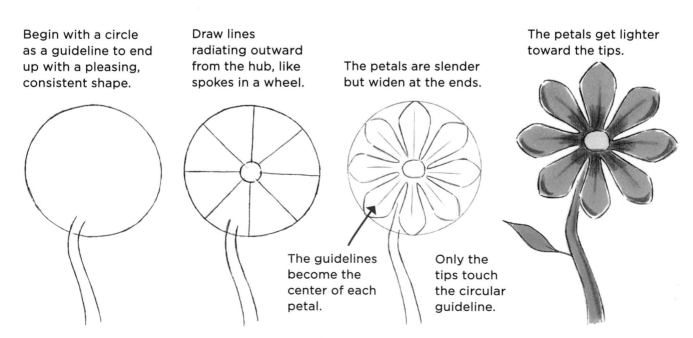

Begin with a circle as a guideline to end up with a pleasing, consistent shape.

Draw lines radiating outward from the hub, like spokes in a wheel.

The petals are slender but widen at the ends.

The petals get lighter toward the tips.

The guidelines become the center of each petal.

Only the tips touch the circular guideline.

STARBURST-TYPE FLOWERS

A starburst-type of flower is fun to draw because it evolves in unexpected ways. It starts with a plump-looking star shape. By adding a few lines to the interior, you quickly transform it into an exuberant flower.

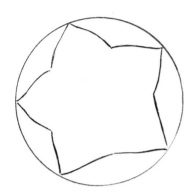

The circle acts as a guideline to keep all of the tips of the petals the same length.

Draw a disk in the middle. It can be circular or oval.

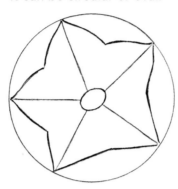

Draw five lines from the disk to the tips of the petals.

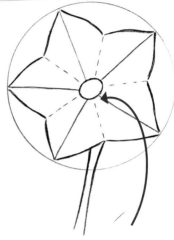

Draw four short dotted lines starting at the indentations between the petals and continuing to the disk at the center of the flower.

Draw some wispy lines from the disk at the center of the flower.

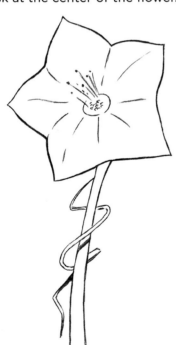

Add minimal markings on the tips of the petals.

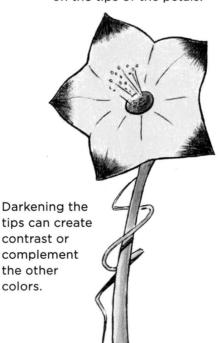

Darkening the tips can create contrast or complement the other colors.

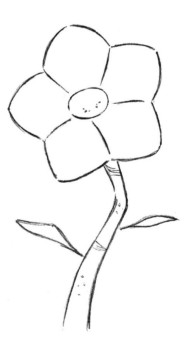

Here's another option that is also an appealing look: a rounded sunburst with defined petals.

Favorite Flowers

Tulips and lilies are two of the most popular cultivated flowers. Here's how to capture their appealing qualities.

TULIP

The tulip is a famous flower. It's drawn in the shape of an upside-down bell and has pleasing, swirling lines. If you keep it simple, it will catch the viewer's eye.

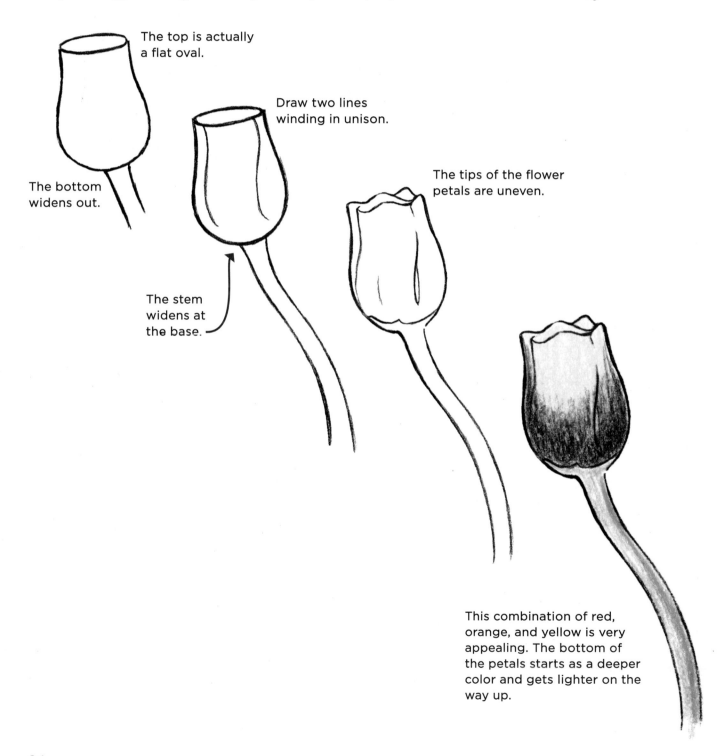

The top is actually a flat oval.

The bottom widens out.

Draw two lines winding in unison.

The stem widens at the base.

The tips of the flower petals are uneven.

This combination of red, orange, and yellow is very appealing. The bottom of the petals starts as a deeper color and gets lighter on the way up.

LILY

This flower adds a layer of complexity. It begins with a simple cone shape, but the rim of the cone becomes a flap that winds around the petal. It's an engaging effect that leads the eye in a swirling direction.

Draw a curved line that hugs the inside of the rim and crosses over.

The outer rim, which is a petal, follows the path of the inner rim.

The rim of the flower is a little wider than the cone shape underneath it.

KEEP DRAWING!
The lily comes in many different colors. You could also gradate the color so that it starts as white and transition to lavender, for example.

Draw a small point at the tip of the flower.

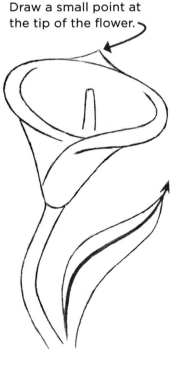

The leaf has a line, called a "midrib," down its center.

The projectile at the center is called a "stigma."

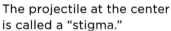

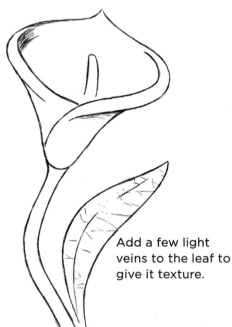

A lily's overlapping petals distinguish it from other flowers.

Add a few light veins to the leaf to give it texture.

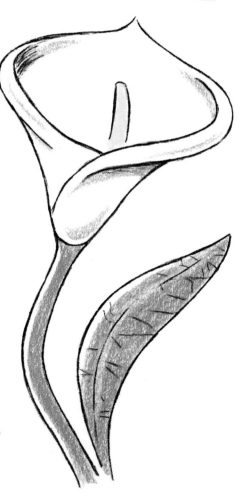

Stark white petals against the rich green stem is an eye-catching combination.

Leaves

To draw leaves, it helps to first figure out the overall shape and direction. They're designs as much as they are drawings. So let's get an overview before starting on the details.

JUNGLE LEAF

Plants in the jungle grow so big that the grooves in the leaves create patterns. And because of the length, they lead the viewer's eye from the base to the tip. To create a compelling image, draw the main artery of the leaf (the line in the center) along a curve.

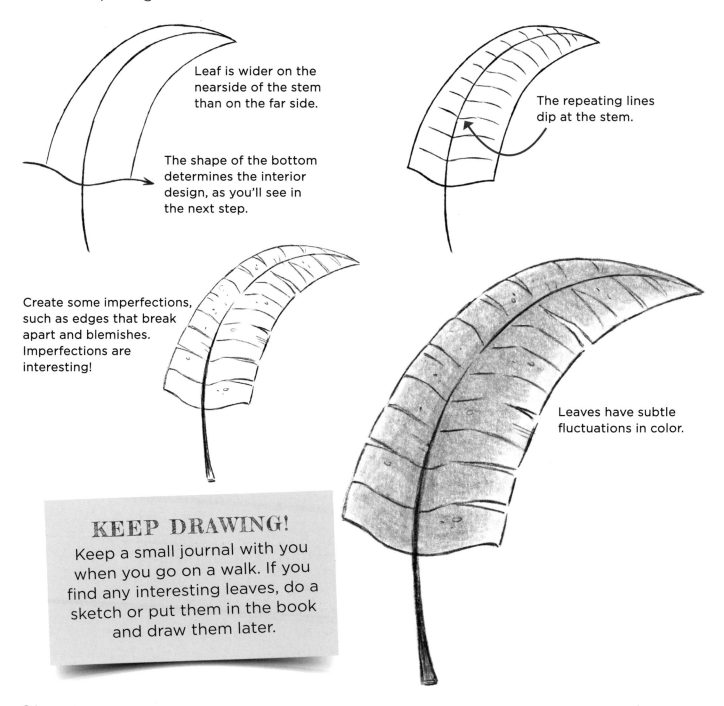

Leaf is wider on the nearside of the stem than on the far side.

The shape of the bottom determines the interior design, as you'll see in the next step.

The repeating lines dip at the stem.

Create some imperfections, such as edges that break apart and blemishes. Imperfections are interesting!

Leaves have subtle fluctuations in color.

KEEP DRAWING!

Keep a small journal with you when you go on a walk. If you find any interesting leaves, do a sketch or put them in the book and draw them later.

MAPLE LEAF

The maple is one of the prettiest trees and has an iconic leaf shape.

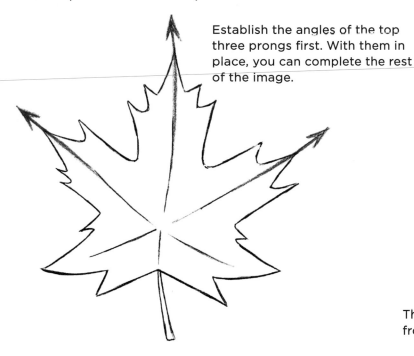

Establish the angles of the top three prongs first. With them in place, you can complete the rest of the image.

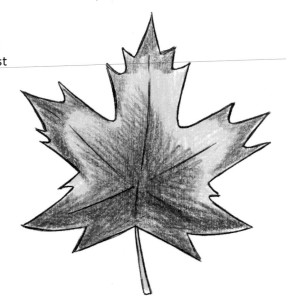

The maple leaf comes in a variety of colors, from green to yellow-orange to blazing red.

BIRCH LEAF

The birch leaf is a super-simple design—that's what makes it pleasing. The challenge is to make it symmetrical with the left side matching the right.

Leaf Ridges

Always check out the direction of the ridges. This leaf's ridges are facing forward, toward the tip.

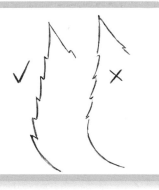

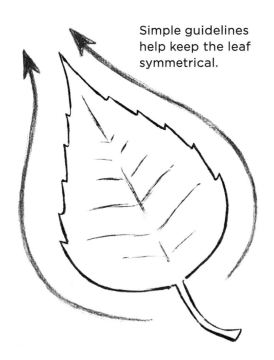

Simple guidelines help keep the leaf symmetrical.

There are some tiny jagged edges that are added once the shape is established.

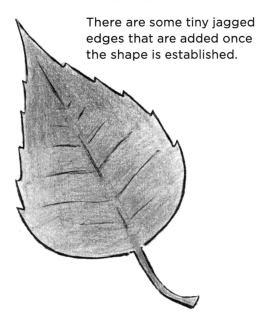

Treetops

It's the overall shape that, in large part, defines the look of a tree, not the individual leaves. To create a different type of tree, change the outline of the treetop, or crown. The stronger and more recognizable the shape, the fewer details you'll need.

CROWN SHAPES

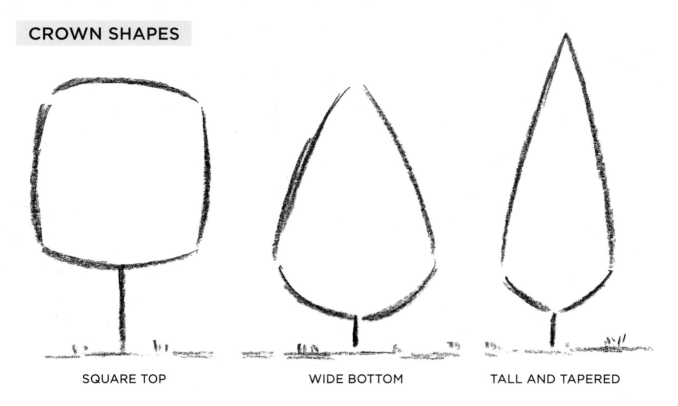

SQUARE TOP WIDE BOTTOM TALL AND TAPERED

BRANCHES AND TRUNKS

The trunk sprouts off into numerous branches inside of the treetop, giving it a lyrical feeling.

Swirling lines are a good look for animation-style backgrounds as well as children's picture books.

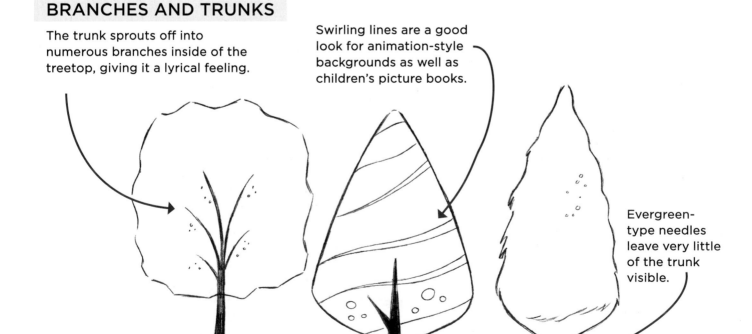

Evergreen-type needles leave very little of the trunk visible.

CHANGE IT UP

I've purposely drawn each tree on this page with a similar skinny trunk in order to demonstrate how different each tree can be made to look simply by changing the shape and size of its top.

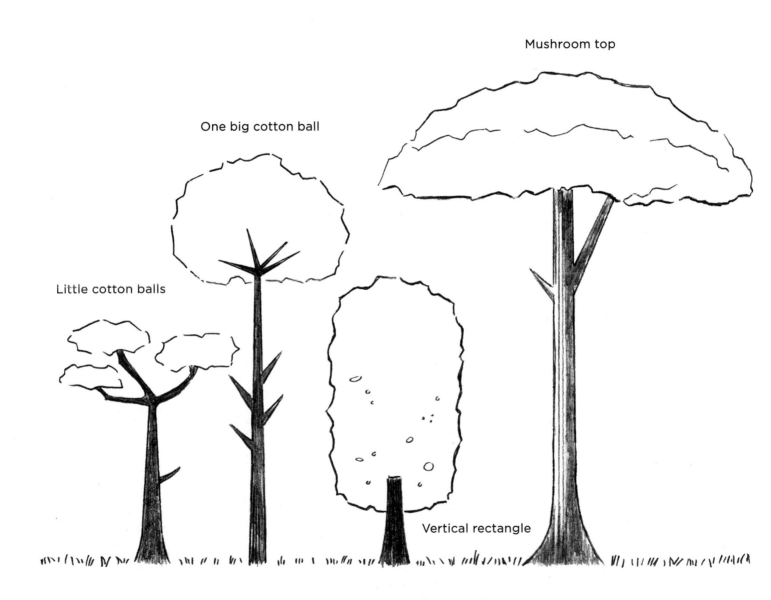

Mushroom top

One big cotton ball

Little cotton balls

Vertical rectangle

KEEP DRAWING!

Look in your own yard, a park, or in the woods to find other interesting shapes. Practice drawing them by starting with the basic shapes.

Tree Trunks

Most trees have a dominant column (trunk) with minor columns sprouting off of it. It creates an organic look, and gives the tree strength and balance.

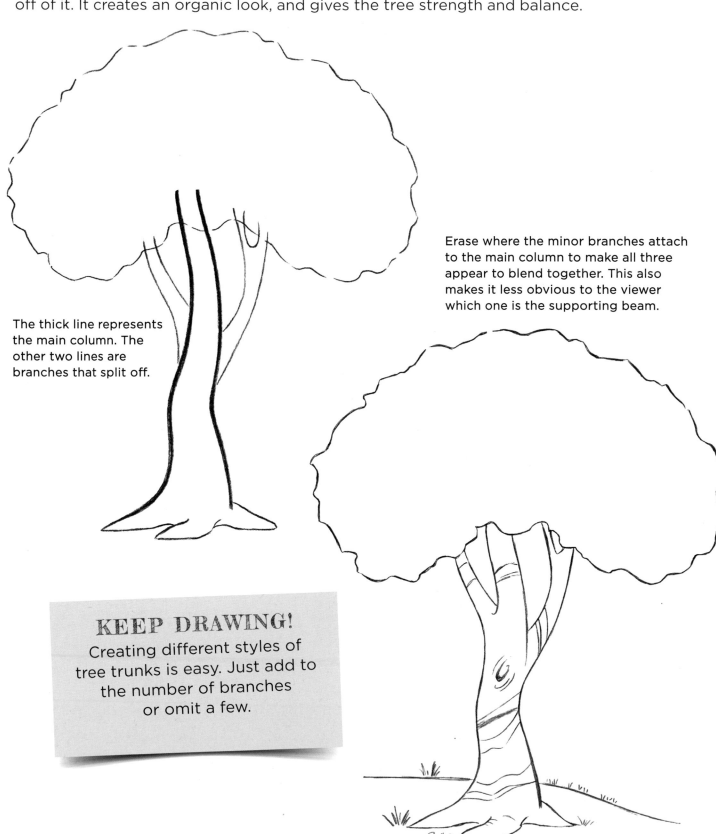

The thick line represents the main column. The other two lines are branches that split off.

Erase where the minor branches attach to the main column to make all three appear to blend together. This also makes it less obvious to the viewer which one is the supporting beam.

KEEP DRAWING!
Creating different styles of tree trunks is easy. Just add to the number of branches or omit a few.

TWIST AND TURN

We've taken the trunk and twisted it, but the principles remain the same.

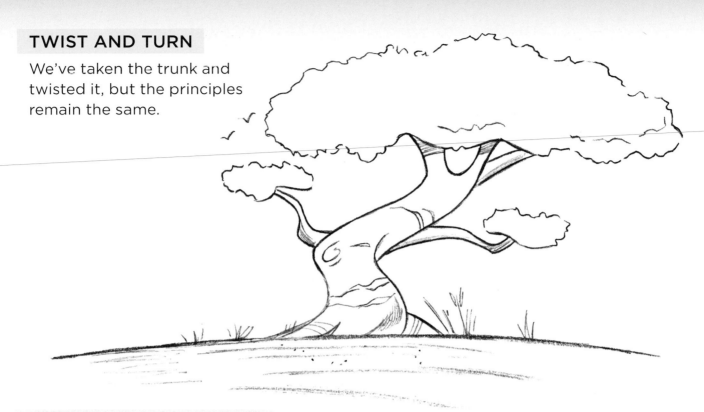

TREE TRUNK VARIATIONS

The average viewer notices how varied the tops of trees are without fully recognizing how varied the trunks are. But they will sense it anyway, which is what we want. Tree trunks add a lot of character. Let's check out a few types.

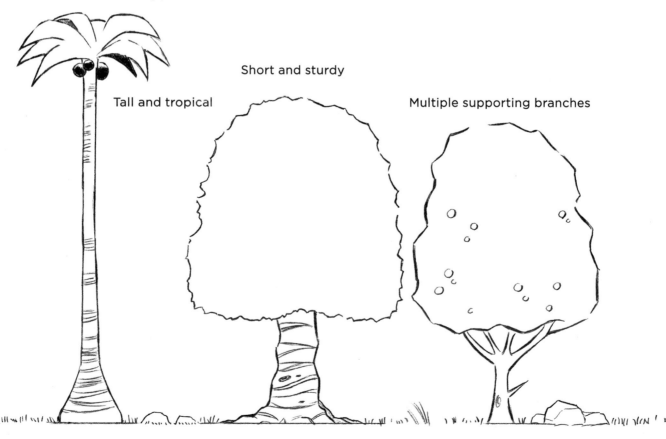

Tall and tropical

Short and sturdy

Multiple supporting branches

Tree Details

Now that we've got the trunk and the basic shape of the treetop down, let's look at the little details that make a tree come alive.

UPPER BRANCHES

Many of you will recognize this dilemma. You begin to draw a treetop and you're suddenly faced with a hard choice: to show the branches inside of the crown of leaves, or to allow the leaves to completely obscure the branches. Let's take a look at your options.

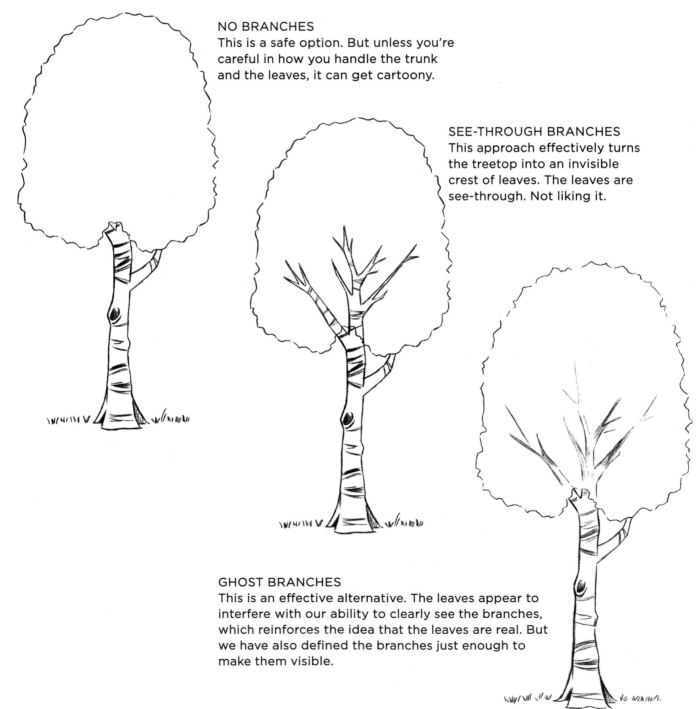

NO BRANCHES
This is a safe option. But unless you're careful in how you handle the trunk and the leaves, it can get cartoony.

SEE-THROUGH BRANCHES
This approach effectively turns the treetop into an invisible crest of leaves. The leaves are see-through. Not liking it.

GHOST BRANCHES
This is an effective alternative. The leaves appear to interfere with our ability to clearly see the branches, which reinforces the idea that the leaves are real. But we have also defined the branches just enough to make them visible.

TREE ROOTS

Don't overlook the roots, which add texture to the bottom of a tree. They also give a sense of direction and flow to the trunk. The roots can start farther up the tree than you might expect.

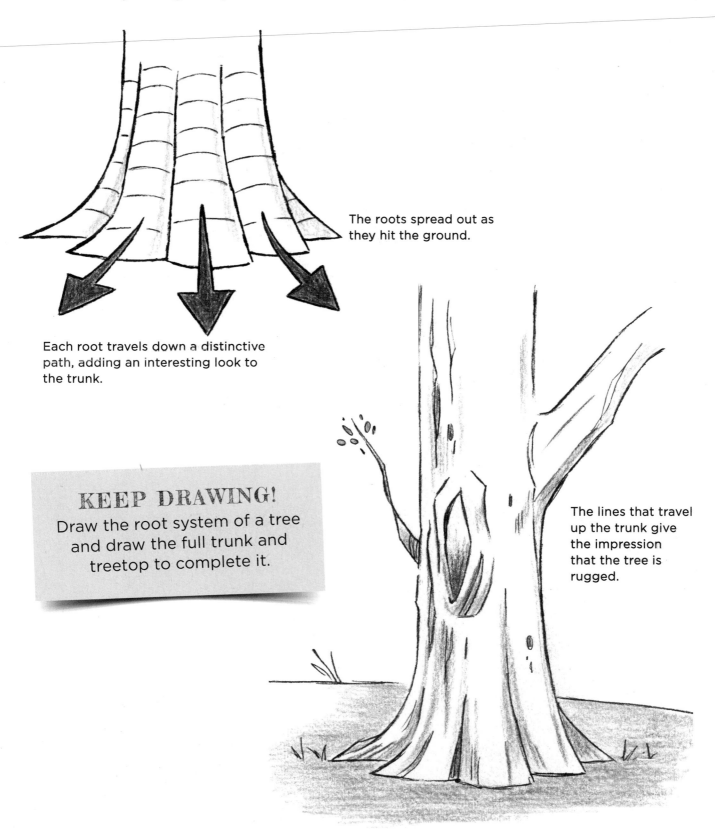

The roots spread out as they hit the ground.

Each root travels down a distinctive path, adding an interesting look to the trunk.

KEEP DRAWING!
Draw the root system of a tree and draw the full trunk and treetop to complete it.

The lines that travel up the trunk give the impression that the tree is rugged.

More Tree Tips

Before we leave this chapter, let's look at two more tree-related subjects that you can use effectively in your landscape drawings to make them more interesting.

DEAD WOOD

I'm not talking about that guy in the next cubicle, but actual dead wood. A dead tree is an interesting visual, which can contribute to an atmospheric background. You can use them for deserts and western scenes, the wetlands at the edges of suburbia, or even the environs around haunted castles.

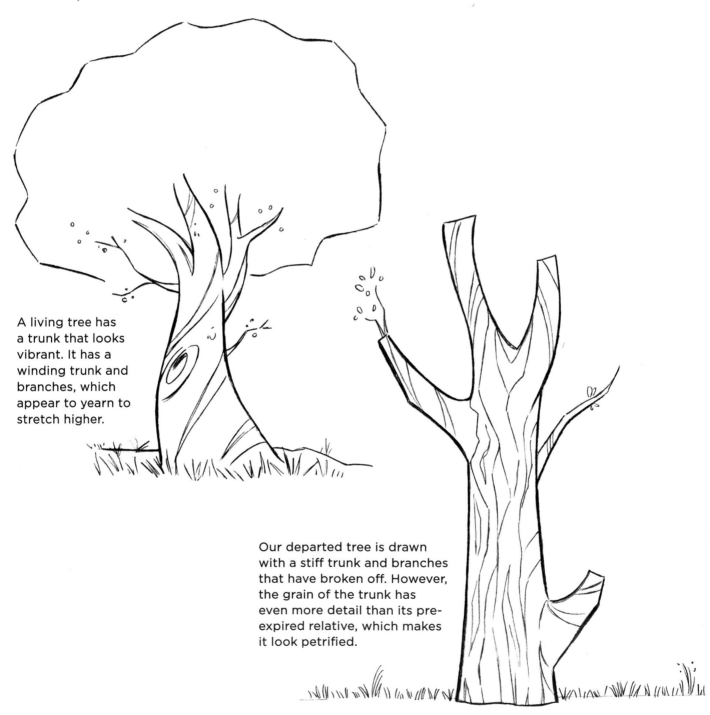

A living tree has a trunk that looks vibrant. It has a winding trunk and branches, which appear to yearn to stretch higher.

Our departed tree is drawn with a stiff trunk and branches that have broken off. However, the grain of the trunk has even more detail than its pre-expired relative, which makes it look petrified.

ASYMMETRY

Symmetry means that there are the same number of branches on both sides of the trunk. It works, but it's just okay. Draw a branch on the left side and another on the right side. Wake me up when you're done. Asymmetry, on the other hand, flows in unexpected ways without repeating itself.

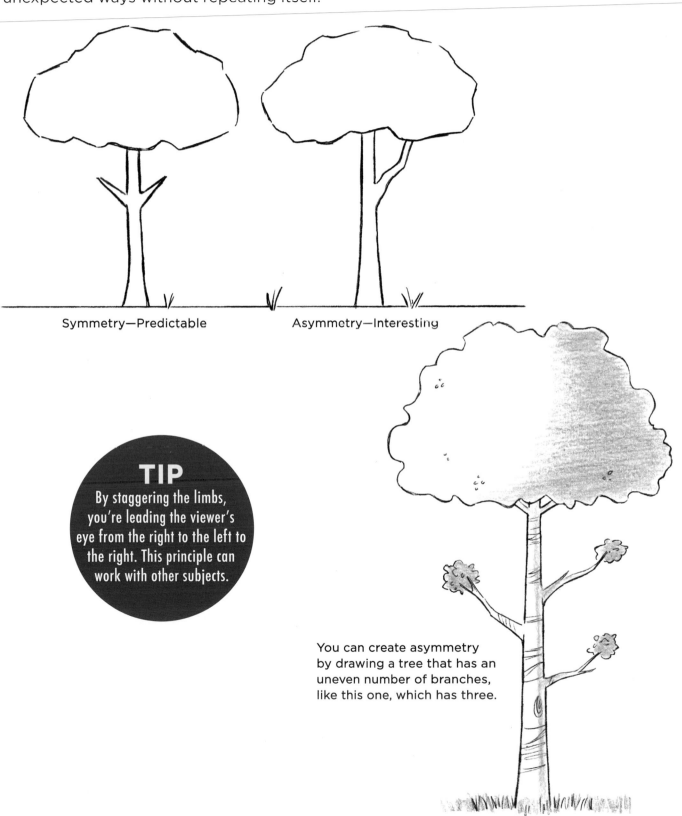

Symmetry—Predictable Asymmetry—Interesting

TIP
By staggering the limbs, you're leading the viewer's eye from the right to the left to the right. This principle can work with other subjects.

You can create asymmetry by drawing a tree that has an uneven number of branches, like this one, which has three.

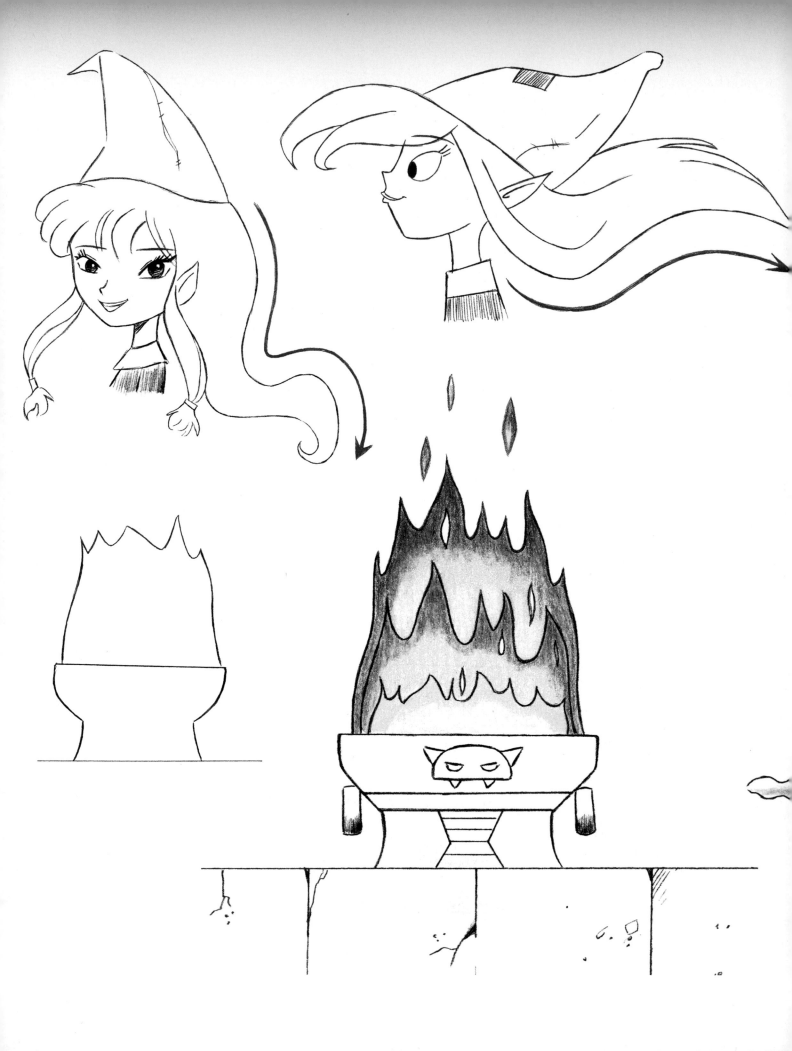

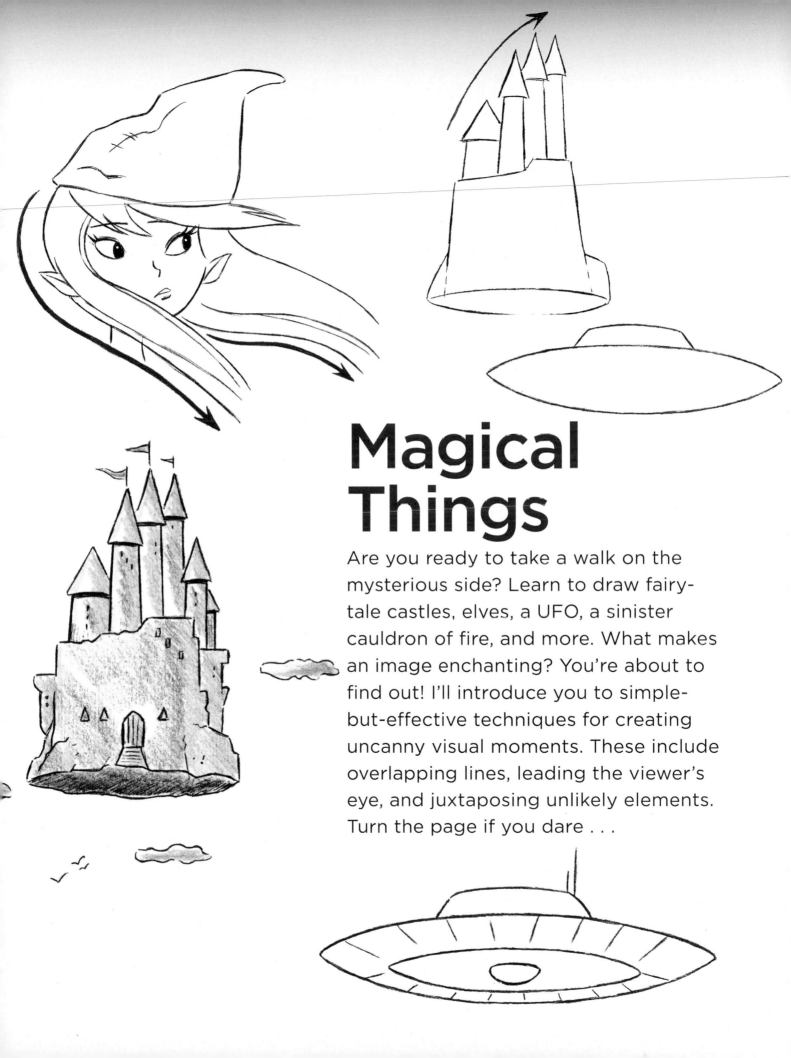

Magical Things

Are you ready to take a walk on the mysterious side? Learn to draw fairy-tale castles, elves, a UFO, a sinister cauldron of fire, and more. What makes an image enchanting? You're about to find out! I'll introduce you to simple-but-effective techniques for creating uncanny visual moments. These include overlapping lines, leading the viewer's eye, and juxtaposing unlikely elements. Turn the page if you dare . . .

Drawing a Castle Step by Step

In the Middle Ages, a castle was on the cutting edge of architectural design. It had all the latest amenities, too, such as no running water, no electricity, and no air conditioning.

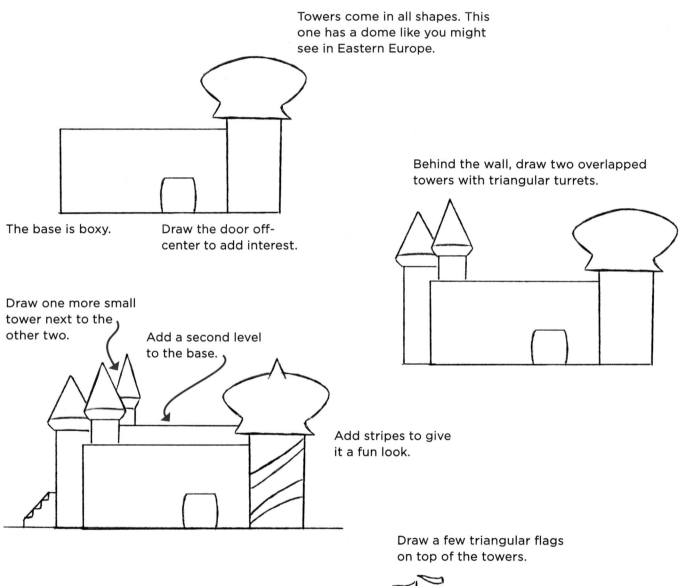

Towers come in all shapes. This one has a dome like you might see in Eastern Europe.

The base is boxy.

Draw the door off-center to add interest.

Behind the wall, draw two overlapped towers with triangular turrets.

Draw one more small tower next to the other two.

Add a second level to the base.

Add stripes to give it a fun look.

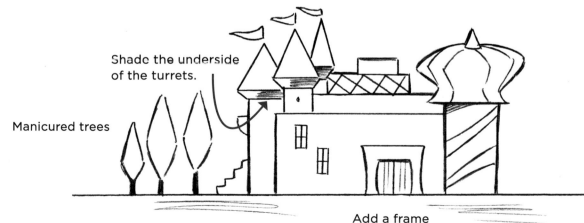

Draw a few triangular flags on top of the towers.

Shade the underside of the turrets.

Manicured trees

Add a frame around the door.

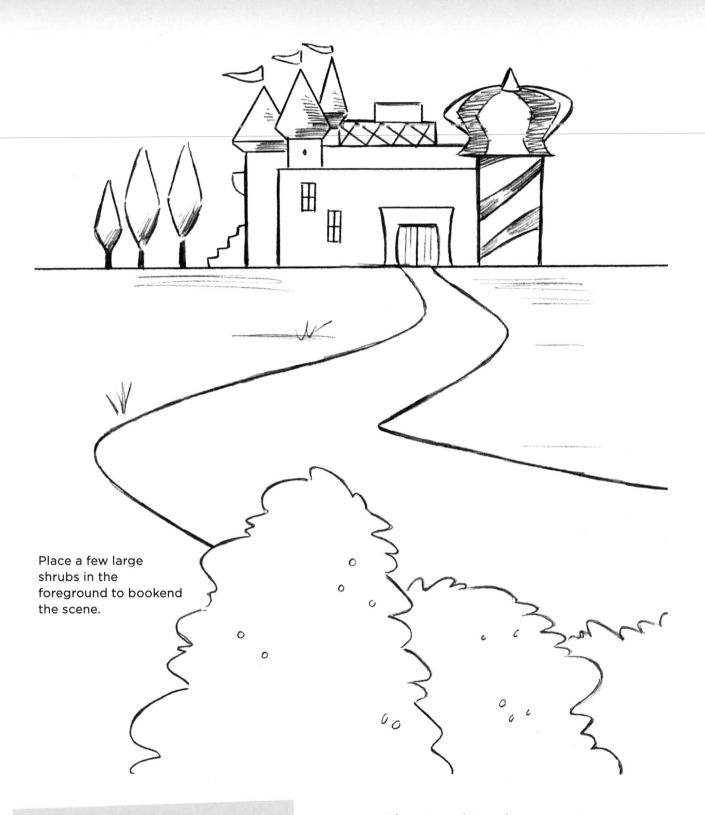

Place a few large shrubs in the foreground to bookend the scene.

KEEP DRAWING!
Take the basic elements of a castle and rearrange them to create your own custom castle.

*That's a big driveway.
I wonder who does their
snowplowing.*

Castle in the Sky

Stone castles remain amazingly popular. In the Middle Ages, everything was made of stone, from castles and bridges to bicycles and even golf carts. Sandwiches were also made with stone. The most popular was ham and cheese and onyx. If you want to give your castle an authentic look, it's got to have the look of stone.

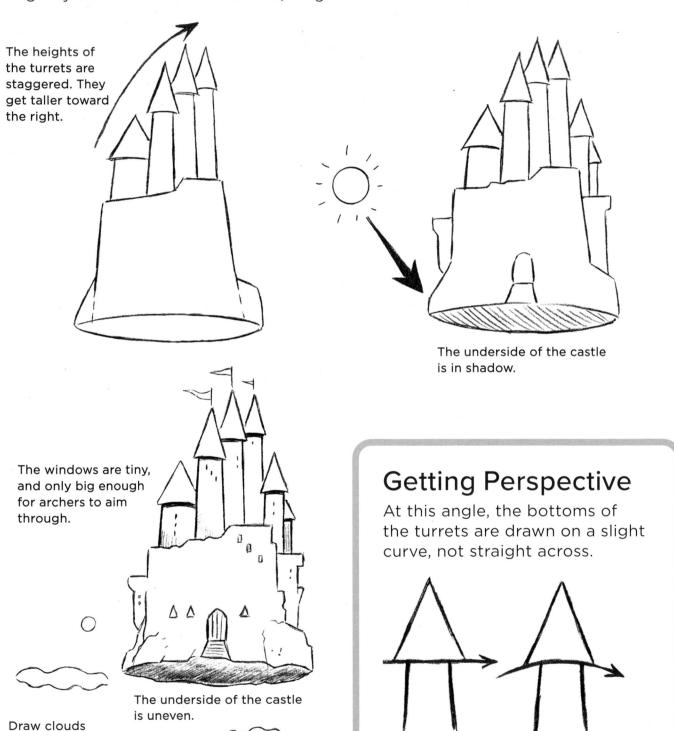

The heights of the turrets are staggered. They get taller toward the right.

The underside of the castle is in shadow.

The windows are tiny, and only big enough for archers to aim through.

The underside of the castle is uneven.

Draw clouds below it, reinforcing the idea that it's floating.

Getting Perspective

At this angle, the bottoms of the turrets are drawn on a slight curve, not straight across.

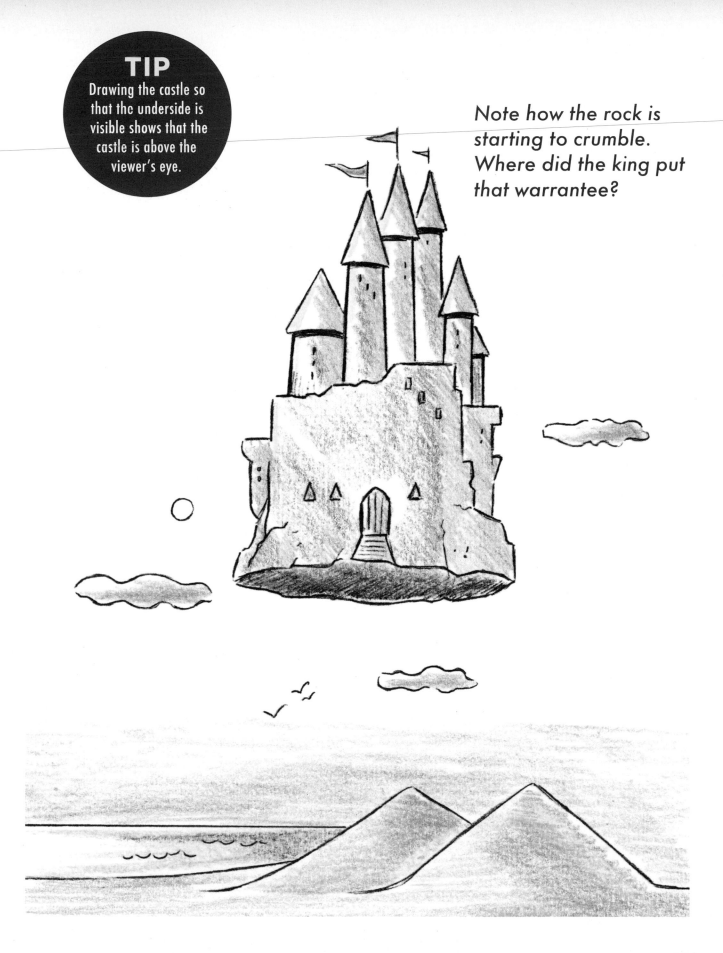

TIP
Drawing the castle so that the underside is visible shows that the castle is above the viewer's eye.

Note how the rock is starting to crumble. Where did the king put that warrantee?

Whimsical Nightscape

There's a method to our madness, especially when drawing landscapes. Overlapping hills require pacing so they'll read clearly and look pleasing. And this calls for strategic layering. Fortunately, the technique is simple: Draw the peaks directly over the valleys.

Each dip is directly below a crest of a hill.

Dip

Dip

Dip

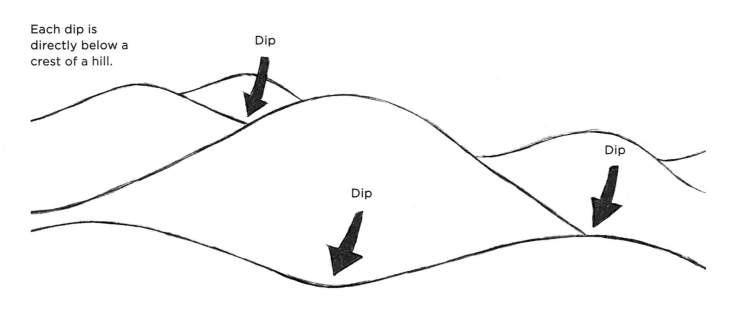

Classic Nightscape

Leave the faces off the moon and star and add some trees in the foreground for a more traditional landscape.

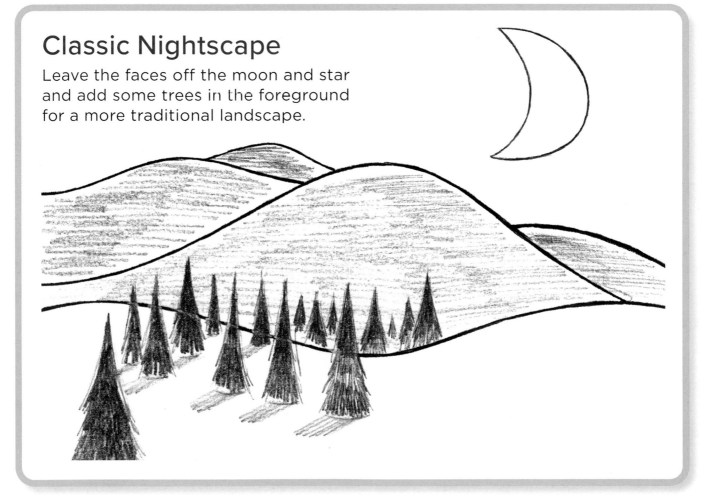

112

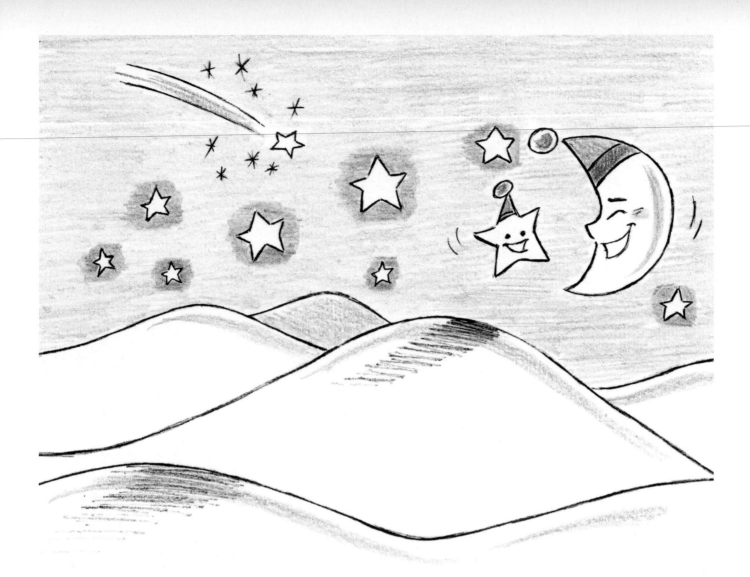

Add some fanciful stars, smiling faces, and a cute cap for a magical scene.

It's too bad these creatures only come out when we're sleeping.

TIP
Deepen the color around each star to create an unrealistic, but charming glow.

KEEP DRAWING!
Use the technique of overlapping hills to draw other hilly and mountainous landscapes—magical or more realistic.

Pixie

By drawing curvy lines side by side, you create a strong flowing effect. This technique can be applied to everything from water currents to cloud formations. But let's see how it works on a pixie.

Sketch a large dome for the top of the head.

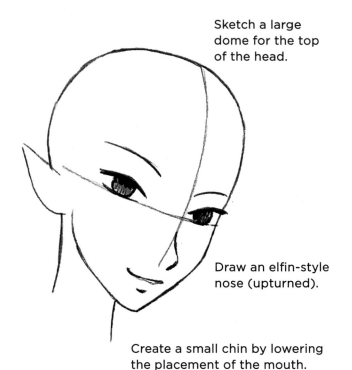

Draw an elfin-style nose (upturned).

Create a small chin by lowering the placement of the mouth.

Leave a good amount of space between the back of the hair and the back of the head.

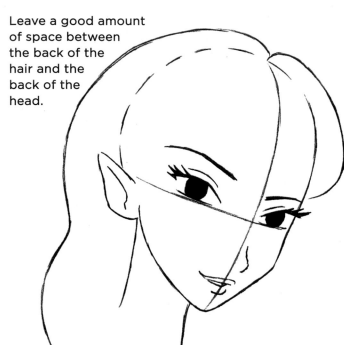

In front, add space between the forehead and the bangs.

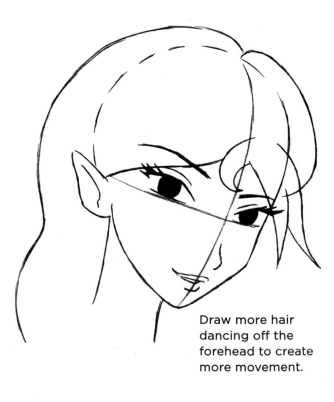

Draw more hair dancing off the forehead to create more movement.

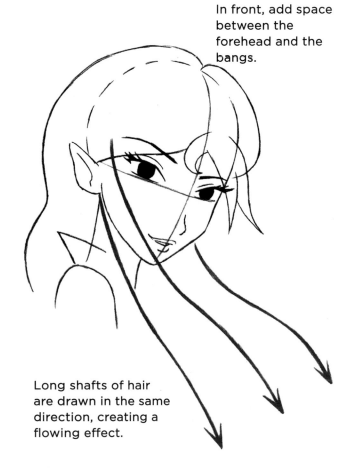

Long shafts of hair are drawn in the same direction, creating a flowing effect.

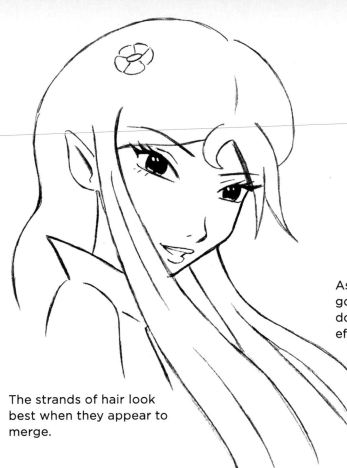

KEEP DRAWING!
Up for a challenge? Using the guidelines from the Drawing People chapter, make this pixie a full character!

As long as the flowing strands are going in the same direction, you don't need a lot of them to be effective. Give it a try!

The strands of hair look best when they appear to merge.

Go with the Flow

Here are three more ways to get a pixie's hair moving.

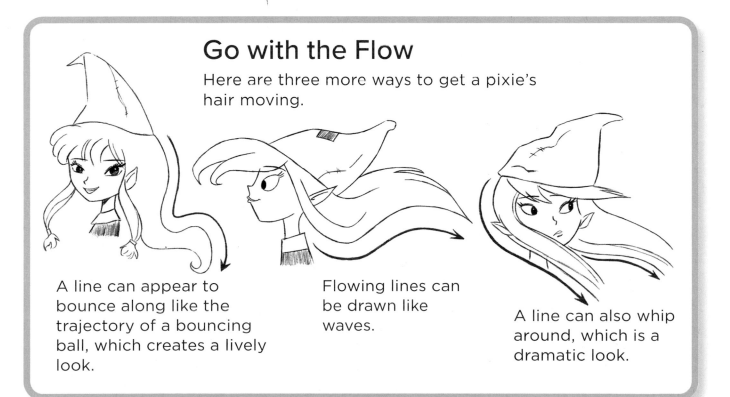

A line can appear to bounce along like the trajectory of a bouncing ball, which creates a lively look.

Flowing lines can be drawn like waves.

A line can also whip around, which is a dramatic look.

Surrender, Earthlings!

Have you ever seen an alien spaceship outside of your window and you try to warn your parents, but they don't believe you, so instead they send you to a doctor who just keeps asking you how you feel about things? Me neither.

The top is short.

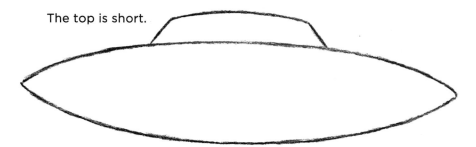

The base is shaped like a dish.

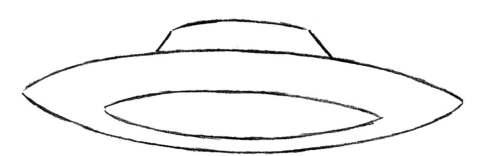

Repeat the dish shape inside the larger dish shape.

Draw short markings around the ring to give it an energetic look.

Objects look more awesome when drawn from the underside.

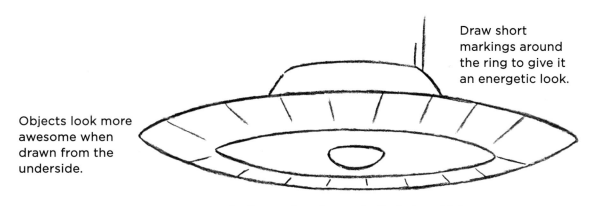

In the center, draw a half-circle, which will become the light source.

A dark sky provides needed contrast for the yellow light to cut through.

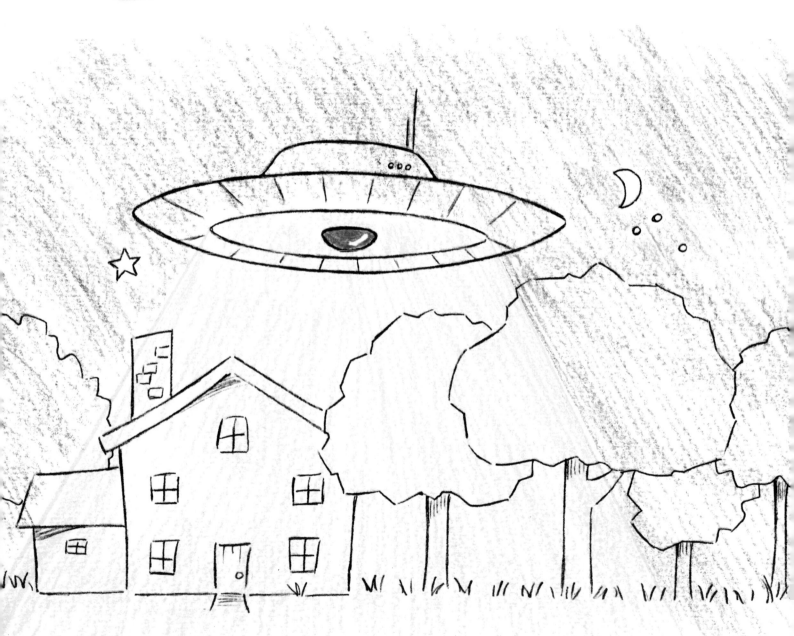

Alien vessels always hover. Hovering is a very important skill to develop if you want to get a flying license in another star system.

Mind Tickler

Place an ordinary object where it doesn't belong and you'll get a surreal image. Take it a step further by adding extreme perspective and you've got something strange and curious. Surreal images depend more on the framing of the picture and the juxtaposition of the elements than on the individual objects in it.

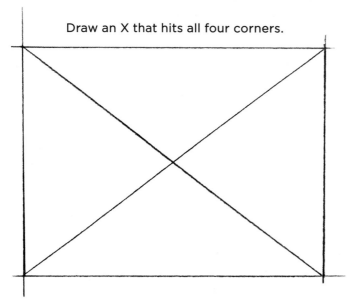

Draw an X that hits all four corners.

Begin with a rectangle (a square would work, too).

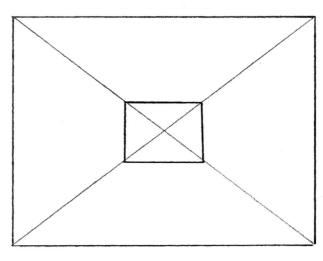

Draw a smaller rectangle (or square) in the middle. The X should also run through each of its four corners.

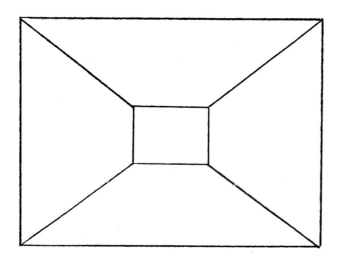

Erase the lines that ran through the small rectangle, or square, in the middle, so that it now appears empty.

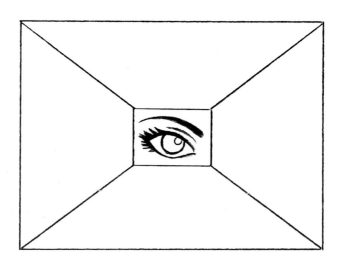

Draw an eye, but don't allow it to touch the box around it.

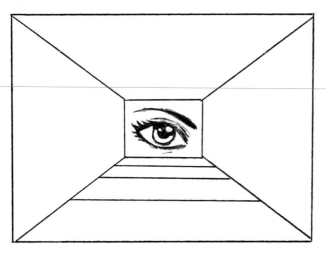

By drawing horizontal slats across the bottom, you create a feeling of incredible depth.

KEEP DRAWING!
You can draw receding slats on all four sides, but it may overwhelm the image of the eye. Try it, and see if you think it works.

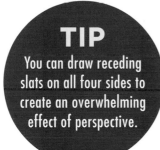

TIP
You can draw receding slats on all four sides to create an overwhelming effect of perspective.

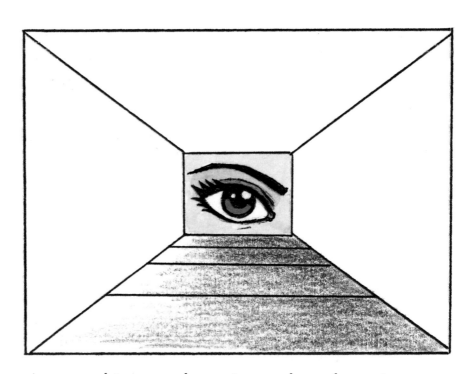

A surreal image doesn't need explanation. Remember that famous painting by Magritte, the one with the guy with an apple in front of his head? And he's so calm. I would be trying to swat it away.

Cauldron of Fire

If you find yourself in an underground cave, in a long line, with a cauldron of fire at the end, it is not a good sign. You can give away those Yankees tickets. You won't be needing them. Layering is an eye-catching way to depict a powerful fire.

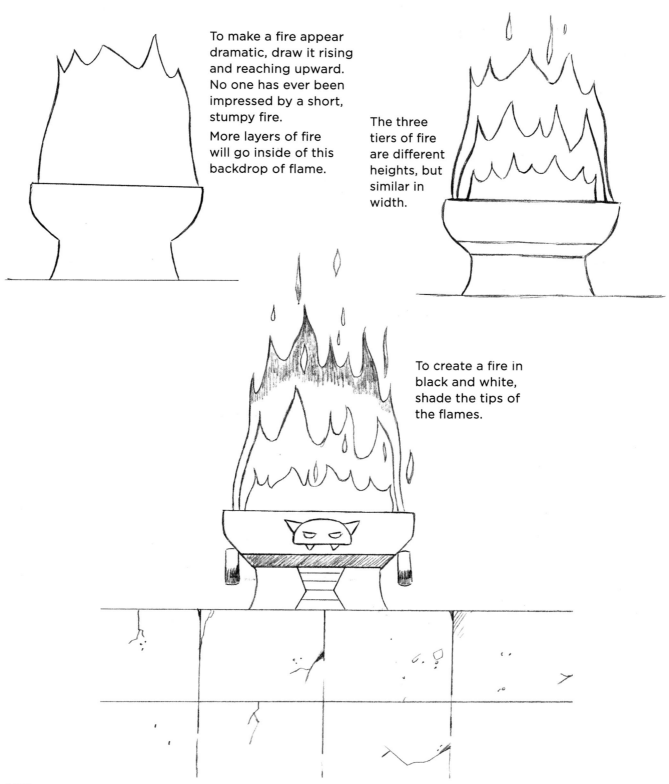

To make a fire appear dramatic, draw it rising and reaching upward. No one has ever been impressed by a short, stumpy fire.

More layers of fire will go inside of this backdrop of flame.

The three tiers of fire are different heights, but similar in width.

To create a fire in black and white, shade the tips of the flames.

The flames of any fire are random looking. Be spontaneous in creating them.

KEEP DRAWING!
Since this is a magical fire, the colors don't have to be realistic. Why not try blues, purples, or even greens? Design your own creepy emblem while you're at it.

Coloring the flames adds to the sinister, otherworldly quality.

The second and third layers introduce orange to the tips of the flames.

The bottom layer is the hottest section and is a combination of white and yellow.

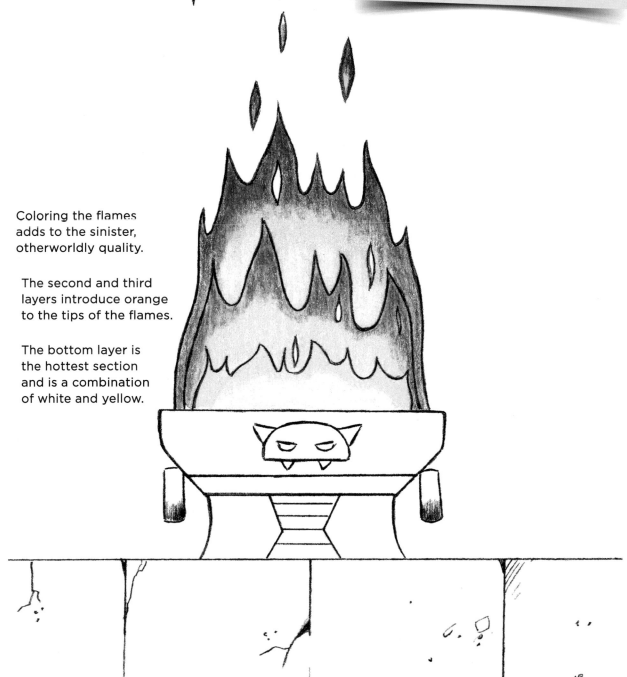

Imaginary Creature

Your imagination is your greatest tool. With it, you can turn something ordinary into something extraordinary. Allow ideas to bounce around in your head before you start. For example, I'm thinking of a magical creature. As I consider the possibilities, a unicorn comes to mind. Where would one live? In a forest, perhaps. What else lives in a forest? Deer. What if I combined the two?

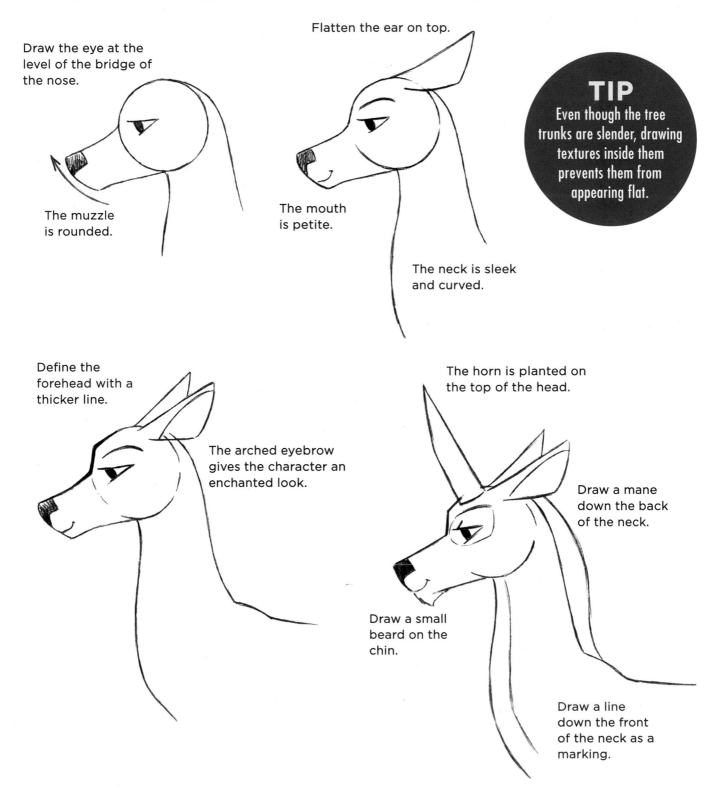

Draw the eye at the level of the bridge of the nose.

The muzzle is rounded.

Flatten the ear on top.

The mouth is petite.

The neck is sleek and curved.

TIP
Even though the tree trunks are slender, drawing textures inside them prevents them from appearing flat.

Define the forehead with a thicker line.

The arched eyebrow gives the character an enchanted look.

The horn is planted on the top of the head.

Draw a mane down the back of the neck.

Draw a small beard on the chin.

Draw a line down the front of the neck as a marking.

KEEP DRAWING!
What other kinds of creatures—real or imaginary—could you combine to create your own mythical creature?

Woodland scenes are easy to draw. Sketch random trees of different widths throughout the picture. Make them close together, without a lot of branches shooting off into various directions.

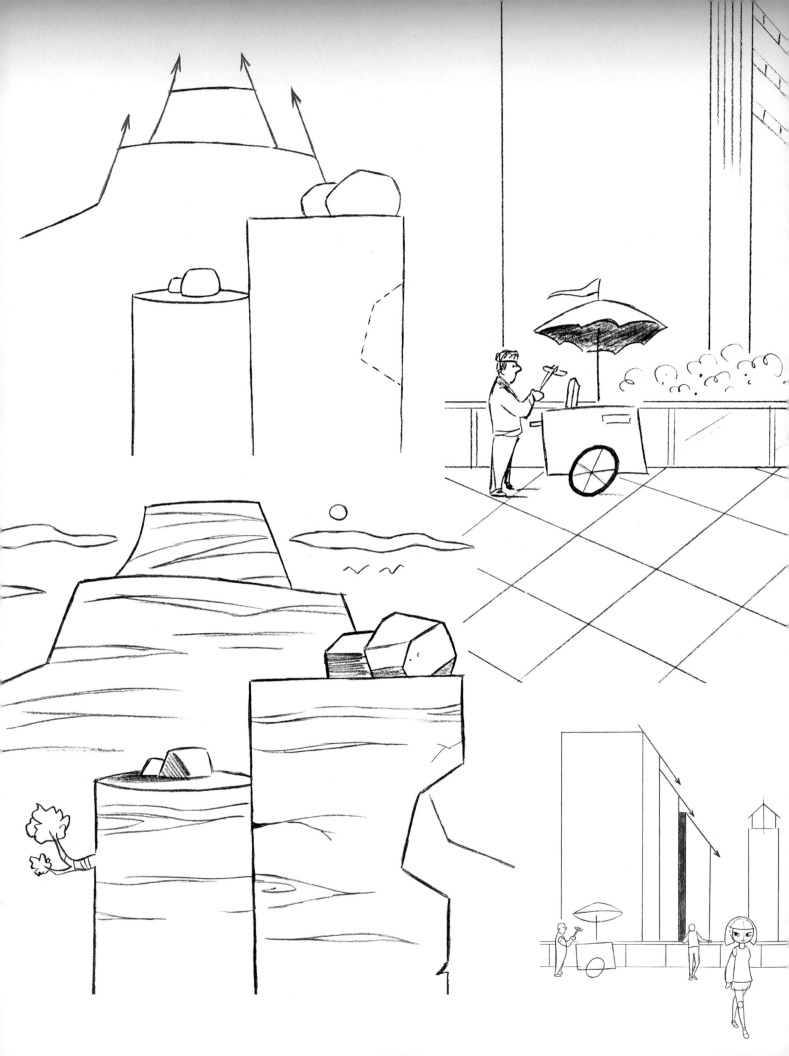

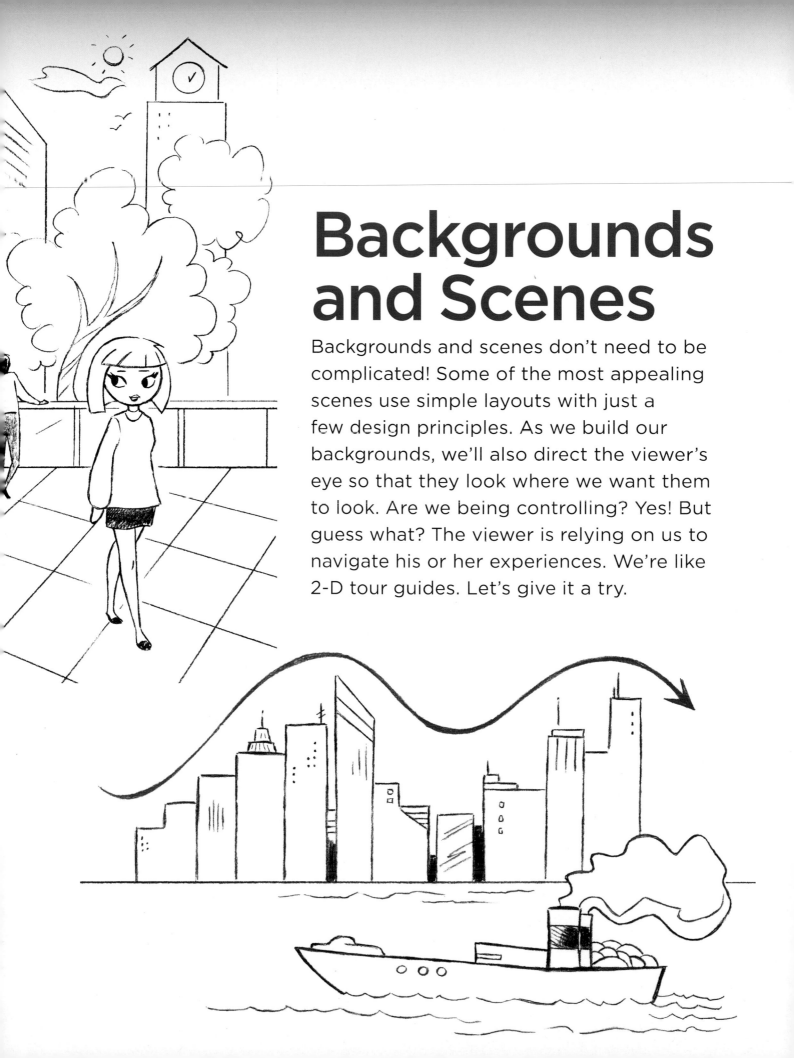

Backgrounds and Scenes

Backgrounds and scenes don't need to be complicated! Some of the most appealing scenes use simple layouts with just a few design principles. As we build our backgrounds, we'll also direct the viewer's eye so that they look where we want them to look. Are we being controlling? Yes! But guess what? The viewer is relying on us to navigate his or her experiences. We're like 2-D tour guides. Let's give it a try.

Large Bodies of Water

Large bodies of water can be made to look more interesting with the addition of zigzagging currents. These currents lead the eye from the viewer to the horizon, where a ship can be drawn. Once the ship sails past the horizon, it falls off the edge of the world, and ends up in outer space. On an unrelated note, I might have slept through most of science class.

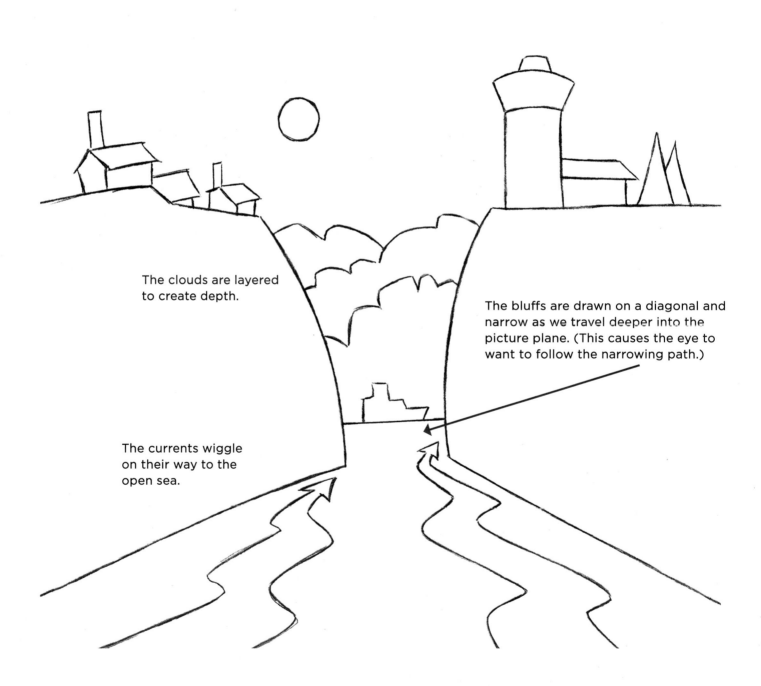

The clouds are layered to create depth.

The bluffs are drawn on a diagonal and narrow as we travel deeper into the picture plane. (This causes the eye to want to follow the narrowing path.)

The currents wiggle on their way to the open sea.

KEEP DRAWING!
To create a different feel for the scene, omit the houses and keep a single lighthouse.

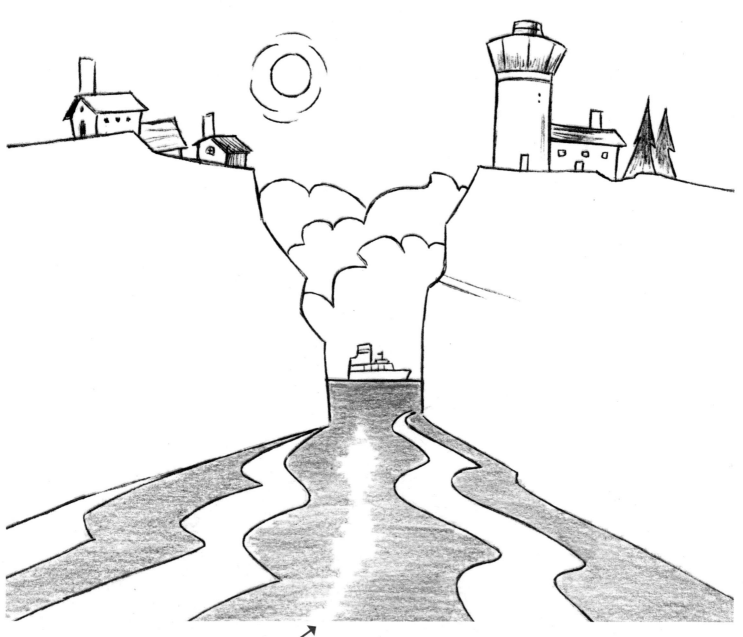

There's also a reflective shine between the currents, brought about by the sun.

Red Rocks

Rocks, mountain ranges, and cliffs are dramatic. But they also gain an aesthetic quality when punctuated by horizontal strips of sediments, which are richly colored in orange and brown. You can find wonderful examples of this in western areas, but especially in Sedona, Arizona.

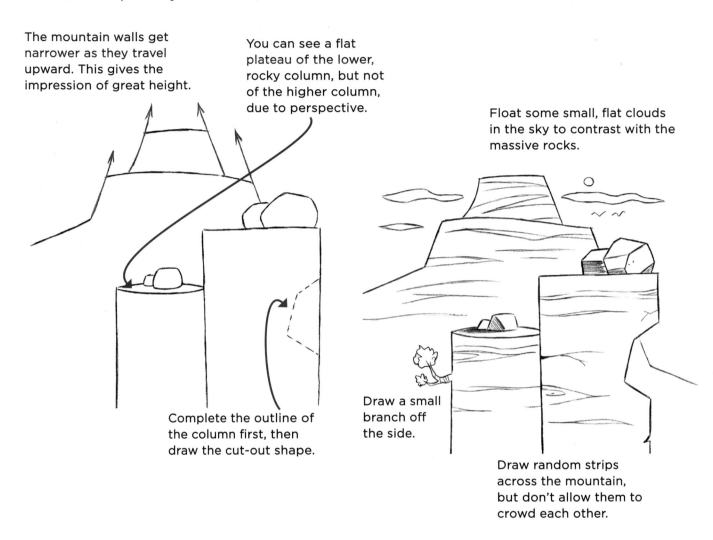

The mountain walls get narrower as they travel upward. This gives the impression of great height.

You can see a flat plateau of the lower, rocky column, but not of the higher column, due to perspective.

Complete the outline of the column first, then draw the cut-out shape.

Float some small, flat clouds in the sky to contrast with the massive rocks.

Draw a small branch off the side.

Draw random strips across the mountain, but don't allow them to crowd each other.

Rock Textures

Add some strips of different-colored rock and cracks to make your drawing more realistic.

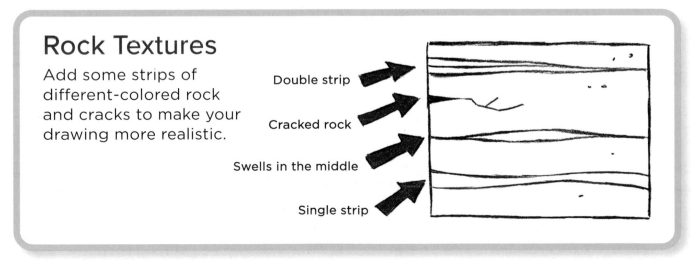

Double strip

Cracked rock

Swells in the middle

Single strip

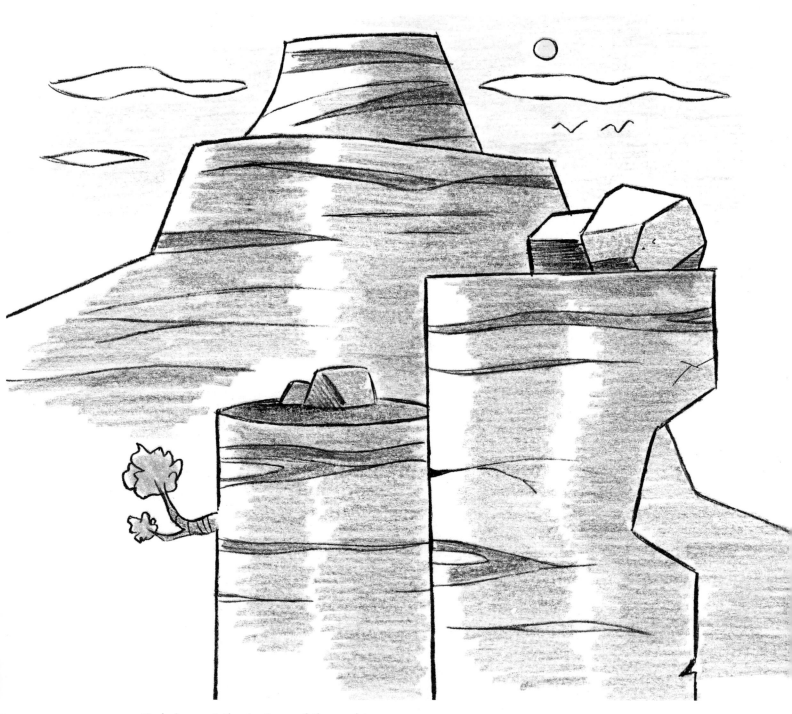

To bring out the texture of the rocks, use a slightly darker color for the strips.

129

Cabin in the Pines

In this layout, the hills and the lake run across the page in a horizontal direction. By layering them, one in front of the other, you convey a sense of distance. Distance is indicated when one thing overlaps another. Further, the thing that overlaps something else is always closer to the viewer.

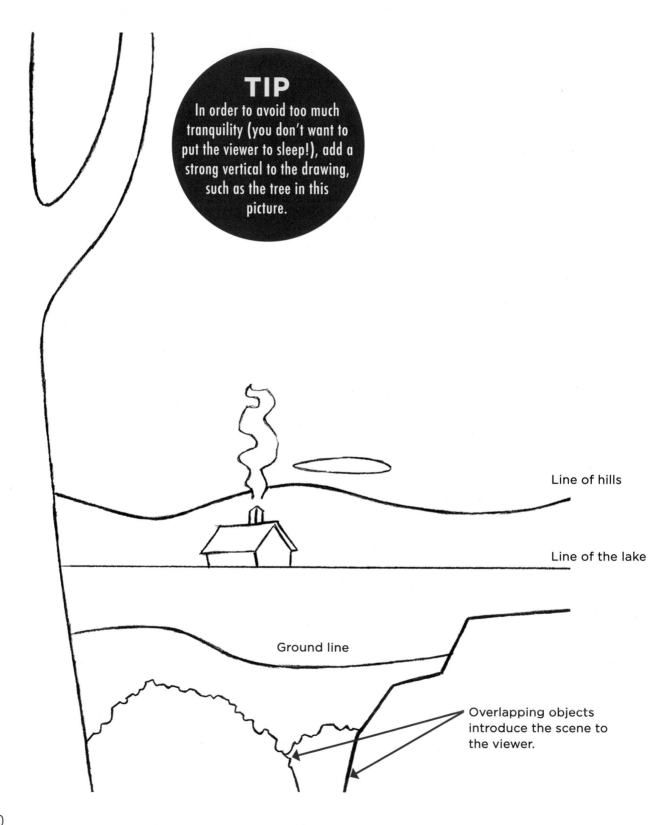

TIP
In order to avoid too much tranquility (you don't want to put the viewer to sleep!), add a strong vertical to the drawing, such as the tree in this picture.

Line of hills

Line of the lake

Ground line

Overlapping objects introduce the scene to the viewer.

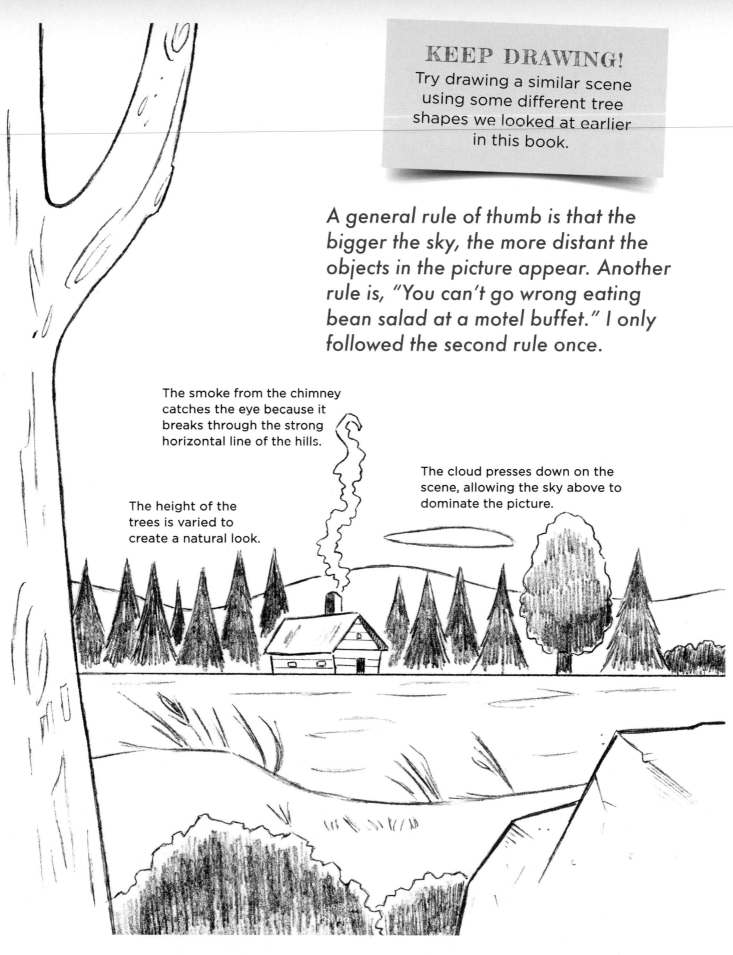

KEEP DRAWING!
Try drawing a similar scene using some different tree shapes we looked at earlier in this book.

A general rule of thumb is that the bigger the sky, the more distant the objects in the picture appear. Another rule is, "You can't go wrong eating bean salad at a motel buffet." I only followed the second rule once.

The smoke from the chimney catches the eye because it breaks through the strong horizontal line of the hills.

The cloud presses down on the scene, allowing the sky above to dominate the picture.

The height of the trees is varied to create a natural look.

Mom's Home!

First, we'll establish the angle. The dog is in a side view, which shows that he's looking in a specific direction. This works with the intention of the scene.
To suggest depth, let's give the background a little turn to the left, so the viewer can also see the door.

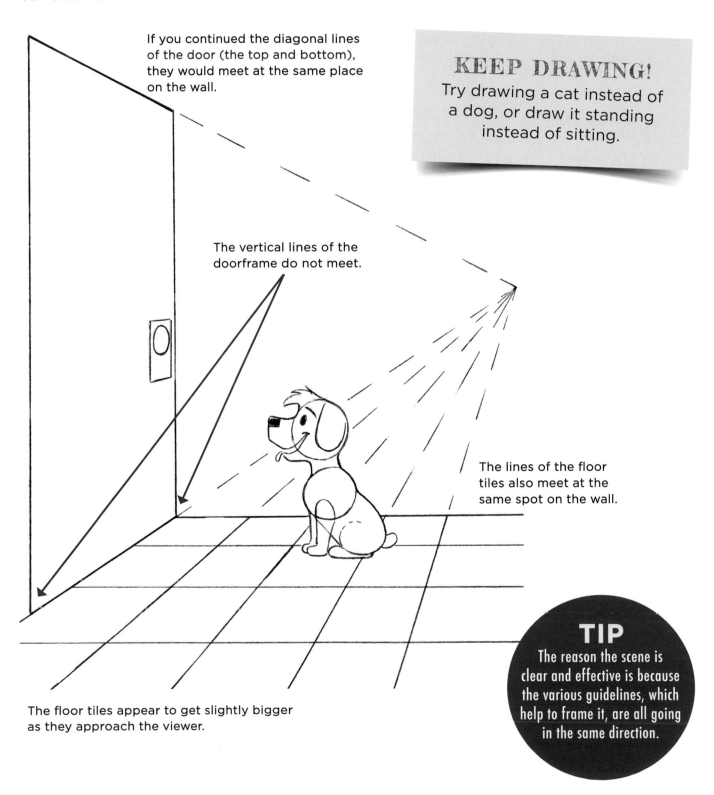

If you continued the diagonal lines of the door (the top and bottom), they would meet at the same place on the wall.

The vertical lines of the doorframe do not meet.

The lines of the floor tiles also meet at the same spot on the wall.

The floor tiles appear to get slightly bigger as they approach the viewer.

KEEP DRAWING!
Try drawing a cat instead of a dog, or draw it standing instead of sitting.

TIP
The reason the scene is clear and effective is because the various guidelines, which help to frame it, are all going in the same direction.

She's been gone for only ten minutes, but this impatient little guy is ready to jump all over her. It will be so adorable. For the first thirty seconds anyway.

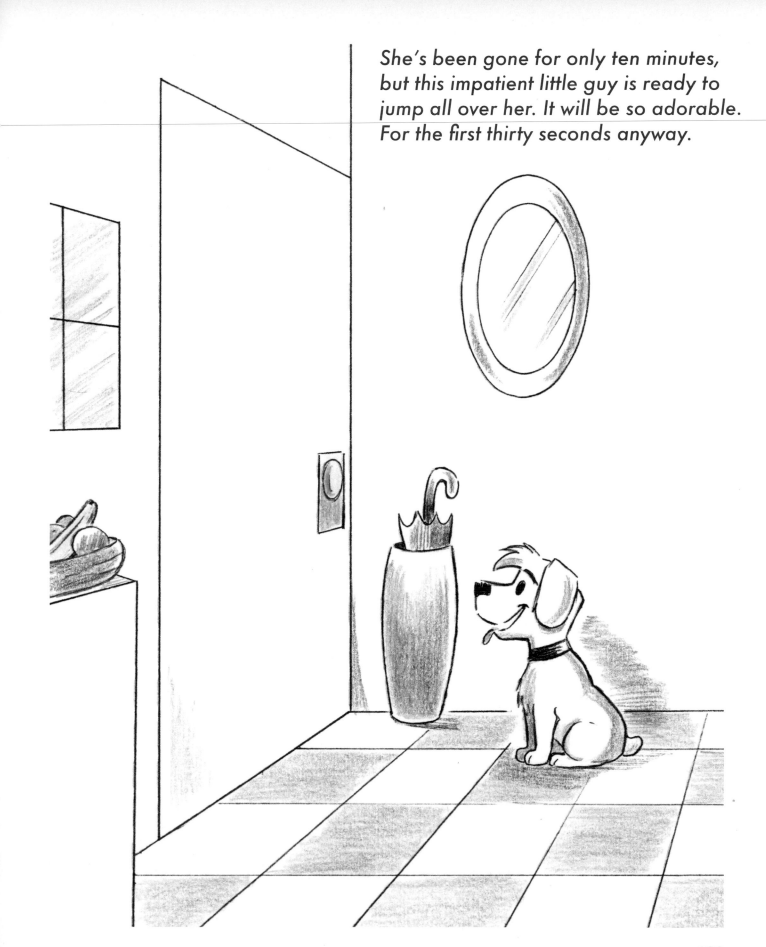

City Scene

Another organizing principle is to draw various elements, such as the buildings, so that they decrease in size at the same angle. It's straightforward, as you can see by the red arrows. If you were to extend each arrow into the distance, they would eventually meet.

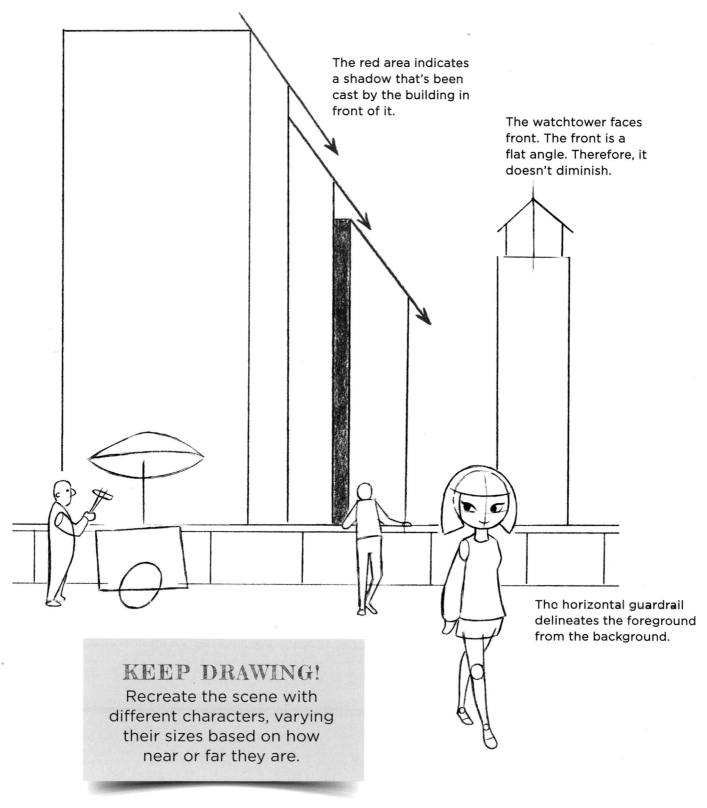

The red area indicates a shadow that's been cast by the building in front of it.

The watchtower faces front. The front is a flat angle. Therefore, it doesn't diminish.

The horizontal guardrail delineates the foreground from the background.

KEEP DRAWING!
Recreate the scene with different characters, varying their sizes based on how near or far they are.

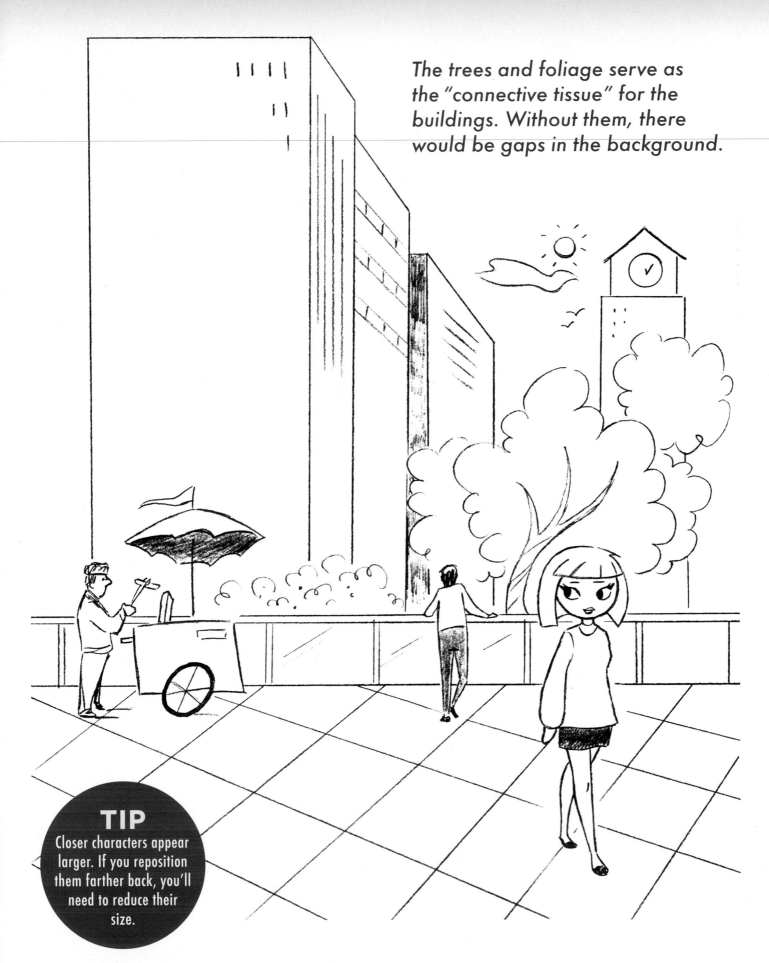

The trees and foliage serve as the "connective tissue" for the buildings. Without them, there would be gaps in the background.

TIP
Closer characters appear larger. If you reposition them farther back, you'll need to reduce their size.

Island Paradise

Let's leave the city behind and draw a different type of a setting. Instead of tall, vertical buildings, this will be a horizontal layout with wide vistas. But within the open space, we'll find ways to compose the elements so that the picture holds together as a unit.

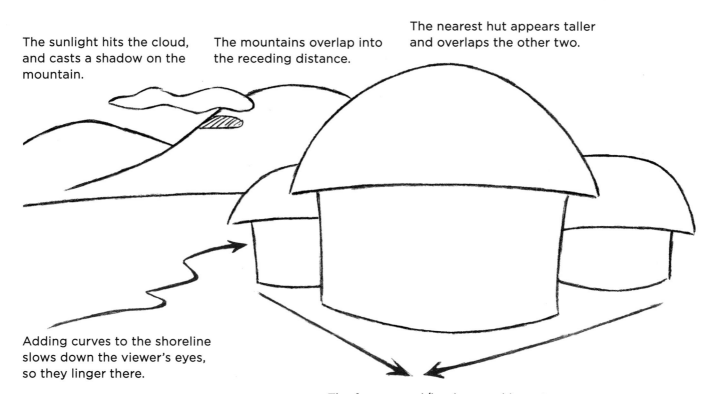

The sunlight hits the cloud, and casts a shadow on the mountain.

The mountains overlap into the receding distance.

The nearest hut appears taller and overlaps the other two.

Adding curves to the shoreline slows down the viewer's eyes, so they linger there.

The foreground/background layout is similar to the arrangement of pins in a bowling alley.

TIP
There are very few straight lines in this drawing. (Except the spear—curved spears don't work well.) This adds to the handbuilt look of the huts.

KEEP DRAWING!
Add some people or animals
to your scene to liven it up!

By using simple-but-effective principles to arrange the huts, shoreline, and mountains, we've created a final drawing in which the elements come together to produce a pleasing effect.

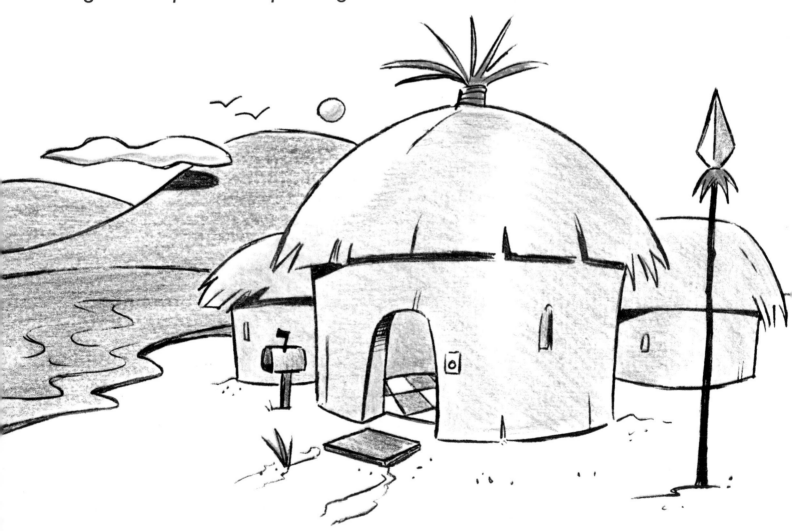

City Skyline

You could draw the most impressive skyscrapers, but if they're a jumble of buildings, they won't look appealing to the viewer. By using a flowing guideline as an organizing principle, you can create a cohesive presentation. And because it's the overall look that matters, you don't need as much detail.

You don't need to follow a guideline precisely—even your own! It's the general concept that makes it work.

Your guideline can be different from mine. Maybe yours rises on one side without dipping in the middle.

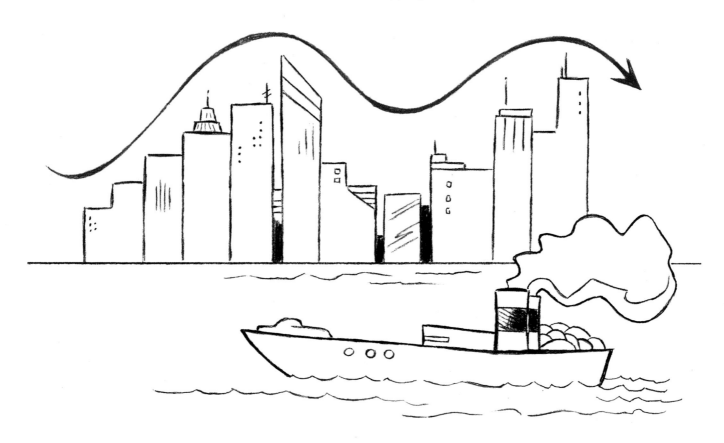

See if you can imagine what shape the flow line over these buildings would look like.

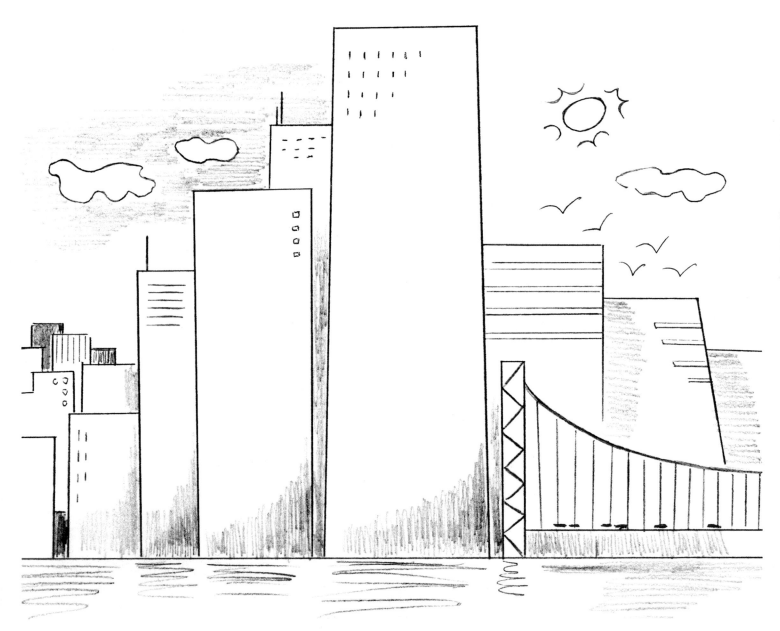

To make skyscrapers look tall, draw the waterline straight, without ripples or waves.

Jailhouse

In the Wild West, this is where you ended up if you robbed a bank or looked at a judge funny. The prisoners were fed a bowl of mush 365 days a year. And for dessert, fried mush. Old West jails are simple to draw. They're just boxes within boxes. You can still find them in ghost towns scattered about the Southwest.

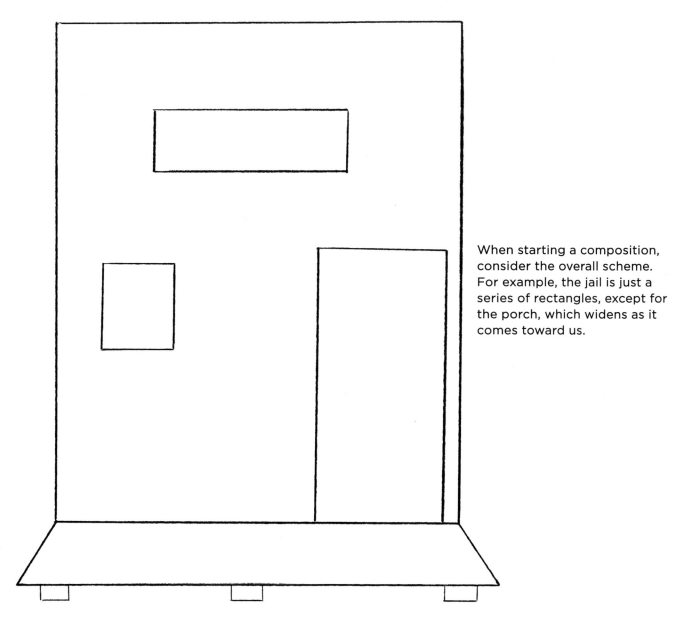

When starting a composition, consider the overall scheme. For example, the jail is just a series of rectangles, except for the porch, which widens as it comes toward us.

KEEP DRAWING!

Here are some more things you could add, or substitute, in the picture: a rocking chair, a tumbleweed, a wagon wheel, a pail of water, and a pesky scorpion.

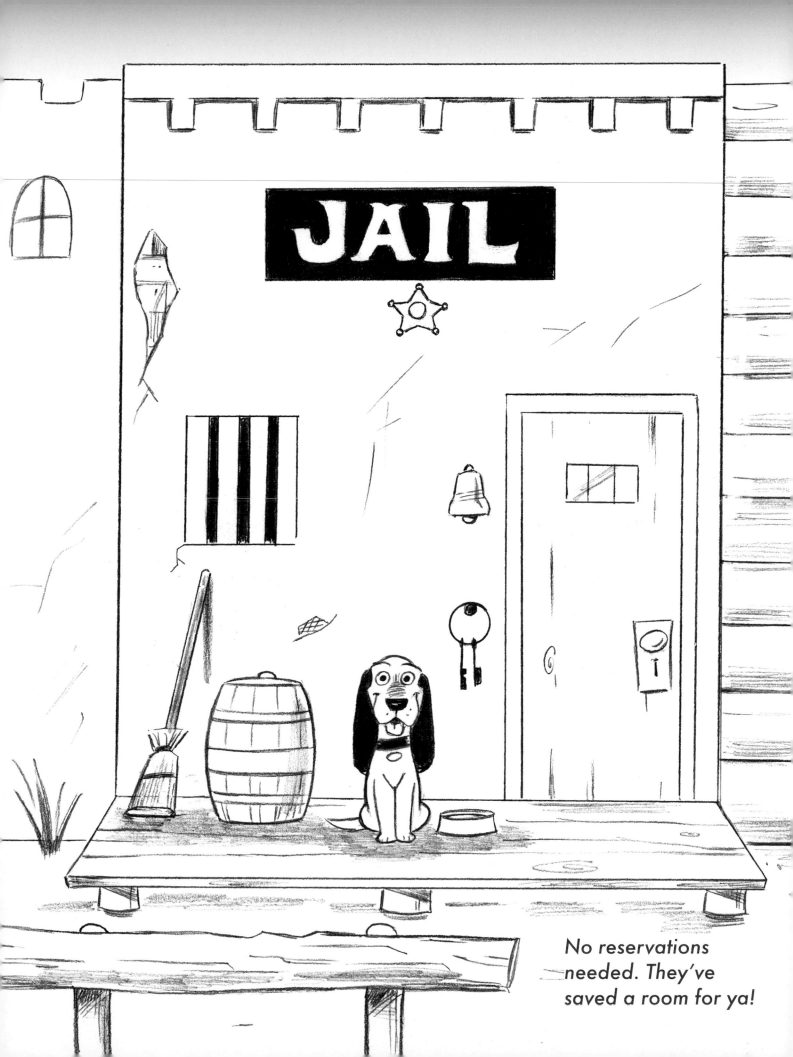

No reservations needed. They've saved a room for ya!

City Interior

Here's something cool that you don't usually see: a view of the city from inside one of its buildings. This simple-but-effective layout combines organic shapes (the figure) with geometric shapes (the buildings). To make it dramatic, we'll depict a powerful business person sizing up her options. And we'll frame her with a floor-to-ceiling window.

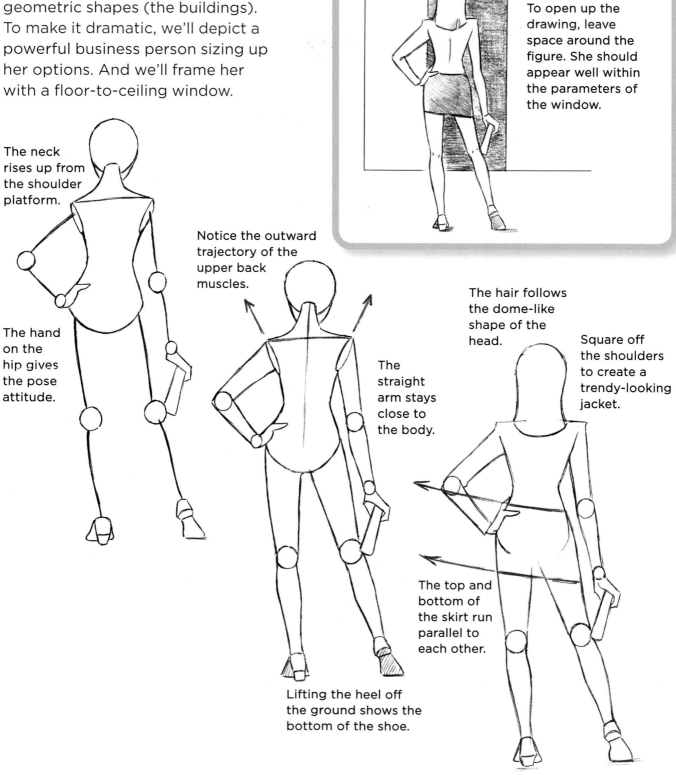

In the Frame

To open up the drawing, leave space around the figure. She should appear well within the parameters of the window.

The neck rises up from the shoulder platform.

The hand on the hip gives the pose attitude.

Notice the outward trajectory of the upper back muscles.

The straight arm stays close to the body.

The hair follows the dome-like shape of the head.

Square off the shoulders to create a trendy-looking jacket.

The top and bottom of the skirt run parallel to each other.

Lifting the heel off the ground shows the bottom of the shoe.

Much that we've covered in different chapters has come together here: basic techniques, figure drawing, and backgrounds— and this is just the beginning. Keep drawing, and I wish you the very best on your continuing adventures in art!

Index